SCYTHIA

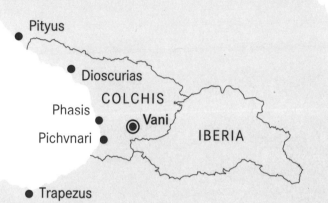

Pityus

Dioscurias

COLCHIS

Phasis

Vani

Pichvnari

IBERIA

Trapezus

*Caspian Sea*

URARTU

LURISTAN

# Wine, Worship, and Sacrifice:
# The Golden Graves of Ancient Vani

# Wine, Worship, and Sacrifice:
# The Golden Graves of Ancient Vani
## Darejan Kacharava and Guram Kvirkvelia

With essays by Anna Chqonia, Nino Lordkipanidze,
and Michael Vickers

Jennifer Y. Chi, Editor

Arthur M. Sackler Gallery, Smithsonian Institution
December 1, 2007 – February 24, 2008

Institute for the Study of the Ancient World at New York University
March 12, 2008 – June 1, 2008

Published by the Institute for the Study
of the Ancient World in association with
Princeton University Press

Published by the Institute for the Study of the Ancient World at New York University, 15 E. 84th Street, New York, NY 10028
nyu.edu/isaw

Distributed by Princeton University Press,
41 William Street, Princeton, New Jersey 08540
press.princeton.edu

The exhibition *Wine, Worship, and Sacrifice: The Golden Graves of Ancient Vani* and its accompanying catalogue was a three-way collaboration between the Georgian National Museum (GNM), the Freer Gallery of Art and Arthur M. Sackler Gallery at the Smithsonian Institution (FSG), and the Institute for the Study of the Ancient World at New York University (ISAW) and were made possible through the generous support of the Leon Levy Foundation.

Unless otherwise noted, all objects included in this exhibition were excavated at Vani, Republic of Georgia and are housed at the Georgian National Museum either at Tbilisi or Vani.

Managing Editor: Julienne Kim
Copy Editor: Sharon R. Herson
Designer: CoDe. New York Inc., Jenny 8 Del Corte Hirschfeld, Mischa Leiner, Uri Aran
Color Separations and Production: Professional Graphics Inc., Rockford, IL
Printer: Lifetouch Publishing, Loves Park, IL

Library of Congress Control Number: 2008920630
ISBN: 978-0-691-13856-5

Cover Illustrations: Gold Necklace with Turtle Pendants, Vani, mid-5th century B.C., GNM 10-975:56

The book was typeset in Berthold Corporate S and Adobe Bembo and printed on Sappi McCoy Matte Text 148gsm.

Printed and bound in the USA.

Georgian season

# Contents

# Letter from Roger S. Bagnall

The Institute for the Study of the Ancient World at New York University is a new center for advanced research and doctoral education in all disciplines concerned with the antiquity of the entire Old World. It has its roots in the passion that Shelby White and Leon Levy had for the art and history of the ancient world, which led them to envision an Institute that would offer an unshuttered view of antiquity across vast stretches of time and place. The Institute aims to encourage particularly the study of the economic, religious, political, and cultural connections between ancient civilizations. It will present the results of the research carried out by its faculty, visiting researchers, and students not only through scholarly publications but also through public exhibitions in the galleries in its home at 15 East 84th Street in New York City. It is our intention that these exhibitions will reflect the Institute's commitment to studying cross-cultural connections and significant areas of the ancient world often neglected in research, teaching, and public presentations.

The Caucasus and the entire region of the Black Sea are among the most interesting areas for such investigation, with their rich linkages in many directions, and we are delighted to have the opportunity for the Institute's first public exhibition to focus on Georgia. The same geographical characteristics that made Georgia a battleground for millennia also put it at the center of routes through which ideas, techniques, and art were diffused, from the Mediterranean, Central Asia, Iran, and Turkey. Georgia has in turn contributed from its own distinctive culture to those of its neighbors. Whether it be wine-making or metalworking, Georgia provides a fascinating laboratory for observing cultural interchange. In working with the Arthur M. Sackler Gallery and the Freer Gallery of Art to bring the material from Vani to an American public for the first time, we hope that we may contribute to a broader awareness of both the inherent interest and the cultural centrality of the Caucasus.

This exhibition is also intended, like others we will undertake, to be embedded in a larger context of ongoing research and publication.

We are honored and pleased by the opportunity to collaborate with our Georgian colleagues not only on this exhibition and its catalogue, but on other projects involving Vani and Georgian archaeology during the coming years. We hope to bring the results of this continuing work to the public in future exhibitions.

Completing this exhibition and catalogue in a short time-frame has been a challenge. In the process we have received much help from many people, who are recognized in the Acknowledgments. But above all, we are grateful to David Lordkipanidze for his deep commitment to this exhibition and to our work together; these have made the entire enterprise a stimulating and exciting experience for us. We also owe a great deal to Julian Raby and his team for having made it possible for us to undertake such an exhibition collaboratively earlier than we otherwise could have done on our own. Finally, I want to express my thanks to Jennifer Chi for doing a truly exceptional job in bringing the entire project together under time pressures far beyond the ordinary.

Roger S. Bagnall
Director
Institute for the Study of the Ancient World
New York University

# Letter from Jennifer Y. Chi

*Wine, Worship, and Sacrifice: The Golden Graves of Ancient Vani,* is a defining moment for the Institute for the Study of the Ancient World. As our inaugural exhibition, it embodies one of the key themes in ISAW's mission—to explore rich and complex cultures that have traditionally been underrepresented in the study of the Ancient World. Vani is a site near the eastern coastline of the Black Sea, in what was Ancient Colchis and is now the Republic of Georgia. Although systematic excavations have been conducted here since the 1940s, few have had access to this fascinating body of material, and we feel privileged to present a selection of the site's extraordinary finds to a wider audience.

Colchis lay to the east of the Greek world, to the north of the Assyrian and Persian Empires, and southeast of the nomadic Scythians. With ready access to the sea and protected by the Caucasus Mountains to its north, the region provided a trade route between Greece and Central Asia, continuing even beyond to India. Colchis also abounded in natural resources, from hemp for linen to timber and precious metals. As early as the eighth century B.C., the Greeks began establishing colonies along the shores of the Black Sea. The famous myth of the Thessalian Jason who traveled to Colchis in quest of the Golden Fleece and who married the local princess Medea is one of the best indicators of direct Greek interest in and exploration of this intriguing area.

At Vani, finds from its spectacular graves testify marvelously to a culture at the crossroads of many different civilizations. The objects on display were selected to emphasize Vani's unique identity as well as local reaction to strong external influences. Individuals interred here were frequently adorned with a vast array of gold jewelry, clearly reflecting local rituals, iconography, and craftsmanship. At the same time, grave goods from Attica, other Black Sea cities, and Persia indicate the prestige assigned to imported material by the local population. *Wine, Worship, and Sacrifice* provides compelling testimony to cultural individuality, interaction, and exchange.

There are many people to thank in Washington, D.C., New York, and the Republic of Georgia for inspiring our inaugural exhibition. A full list of all those who have devoted time to this project can be found in the Acknowledgments. Special thanks should be given here to all those who participated in the completion of our first catalogue, as it required the kind of dedication and support that went far beyond what is normally expected.

At the Freer and Sackler Galleries, Julian Raby, Director, provided ISAW with an initial and thoughtful outline. Cheryl Sobas, Head of Exhibitions, Paul Jett, Head of the Department of Conservation and Scientific Research, and John Tsantes, Head of Photography, gave admirable support. Michael Vickers, FSG's guest curator, wrote a historical overview of the site that is both informative and enriching.

At ISAW, Julienne Kim, our managing editor, ably oversaw all aspects of the catalogue's production. Sharon Herson, our copy editor, was accommodating to all our needs, enabling us to follow a rigorous writing schedule. Roberta Casagrande-Kim, our research assistant, dedicated much of her time to studying aspects of Vani's ritual life and to producing an extended bibliography. Mischa Leiner, of CoDe Communications and Design, understood the uniqueness of the material and designed a publication that reflects Vani's important place on the ancient map.

Most importantly, in Georgia, the hospitality and graciousness of the Vani excavation team and members of the Georgian National Museum staff will never be forgotten. Darejan Kacharava, Director of Excavations at Vani, and Guram Kvirkvelia, the site's Field Director, wrote the majority of the essays introducing the historical and social complexity of this crossroads city. Anna Chqonia and Nino Lordkipanidze demonstrate their commitment to Vani and Colchis in their respective essays "Colchian Goldwork" and "Medea's Colchis," a land very different from the one presented in Greek mythology. Mikheil Tsereteli, Deputy Director of the Georgian National Museum, worked tirelessly to provide the photographs

and imagery that greatly enrich the catalogue. Finally, David Lordkipanidze, General Director of the Georgian National Museum, immediately understood ISAW's broader mission and enthusiastically accepted a working relationship that we hope will extend far beyond this exhibition and catalogue. We look forward to future collaborations.

Jennifer Y. Chi
Associate Director for Exhibitions and Public Programs
Institute for the Study of the Ancient World
New York University

# Letter from David Lordkipanidze

Georgia is a country distinguished by its varied flora and fauna, magnificent landscapes, and climate zones that range from the Mediterranean on the Black Sea to the rural wetlands further east. The country's rich natural resources have provided uninterrupted human habitation for many thousands of years. A reflection of this is evidenced by the large number of significant archaeological monuments spanning many different periods.

The very beginnings of European human culture in the broadest sense are to be found in Georgia: at Dmanisi in 1991, a team of archaeologists uncovered the oldest hominid fossils discovered in Eurasia, dating back 1.8 million years—a breakthrough that revolutionized the study of early human history. These Stone Age discoveries were enriched by evidence of ancient land husbandry in the Marneuli region. Of special interest are the remains of seven-thousand-year-old grape cultivation suggesting that "Georgia is the cradle of wine-making."

Hardly anyone is unaware of the Golden Fleece myth. The voyage of Jason and the Argonauts described by Greek authors was extremely popular in the Classical period. Archaeological discoveries have provided evidence of an advanced culture in what is today western Georgia and proof that it and the mythical land of Colchis are one and the same.

To the Romans, whose legions raided the country, Georgia was known as Iberia. Today we use the term "Caucasian" or "Eastern" Iberia to distinguish it from the Iberian Peninsula at the western end of the Mediterranean. The Arsacids (Parthians) and Sasanians of Iran, with whom the Romans also fought, contested for control over the region.

Georgia accepted Christianity in the fourth century A.D., and soon after, the unique Georgian alphabet was created. The Middle Ages proved to be a time of construction—churches, monasteries, educational centers, academies—as well as of destruction through

war and natural disasters; many historic monuments and manu-scripts have survived, reflecting the richness of this period.

Because of its important geographic location, Georgia was naturally a crossroads for many powerful cultures. Nevertheless, the country has always preserved its own cultural identity with an unwavering aspiration toward the Western world. Georgia regained its independence in 1991 and now works toward re-establishing its worthy place on the world map.

In organizing its first international traveling exhibition, the Georgian National Museum is presenting new archaeological discoveries from Vani, a city in western Georgia, which functioned as a religious center as early as the fifth century B.C. Many of these masterpieces confirm that Colchis was a real country, rich in gold, and attest that Georgia's culture is an indispensable part of Western civilization. The kingdom of Colchis stands as one of the main pillars of Georgia's cultural identity.

The Georgian National Museum represents an old and traditional scientific institution, on the one hand, and modern management, on the other, trying to emerge from the Soviet past as a viable interactive center. We are extremely honored to be working with such esteemed partners and find it symbolic that one of our American hosts, the Smithsonian Institution, is an old, well-established cultural center, and the other, the Institute for the Study of the Ancient World (ISAW) at New York University, a newly founded institution.

We are grateful to an old and devoted friend of Georgia, Carole M. P. Neves, Director of Policy Analysis at the Smithsonian Institution, and to Julian Raby, Director of the Arthur M. Sackler Gallery and the Freer Gallery of Art, for arranging the Georgian exhibition in Washington, D.C., as well as for providing an excellent professional opportunity to the Georgian restoration specialists.

We are very thankful to Roger S. Bagnall, Director of ISAW, and to Jennifer Y. Chi, ISAW's Associate Director for Exhibitions and Public Programs, for all their efforts on the catalogue and the New York exhibition. The dedication of Dr. Chi inspired everyone, thereby ensuring the timely and successful completion of the myriad details that comprise organizing an exhibition and catalogue of this size.

Our special thanks go to Shelby White, whose unstinting care for the archaeology of antiquity provides an amazing example of leadership and demonstrates what philanthropy and public–private partnership can do.

Warm thanks to John Tefft, the United States Ambassador to Georgia, for his personal effort in strengthening Georgia's stance in the international community. Since Georgia's independence, the United States has provided us with generous assistance not only to support Georgia's economy and security but also to help Georgia showcase its European identity.

It is our hope that the current exhibition helps Georgia to introduce itself to the United States as a country with an ancient culture, a country whose heritage is its competitive advantage. We see this as an opportunity for the Georgian National Museum to enter the family of the world's great museums and to present one important aspect of Georgia's rich past.

David Lordkipanidze
General Director
Georgian National Museum

| | | | |
|---|---|---|---|
| Ⴇ | ა | *a* | *an* |
| Ⴁ | ბ | *b* | *ban* |
| Ⴂ | გ | *g* | *gan* |
| Ⴃ | დ | *d* | *don* |
| Ⴄ | ე | *e* | *en* |
| Ⴅ | ვ | *v* | *vin* |
| Ⴆ | ზ | *z* | *zen* |
| Ⴈ | ჱ | *ej* | *he* |
| Ⴌ | თ | *tʰ* | *tʰan* |
| Ⴈ | ი | *i* | *in* |
| Ⴉ | კ | *kʼ* | *kʼan* |
| Ⴊ | ლ | *l* | *las* |
| Ⴋ | მ | *m* | *man* |
| Ⴌ | ნ | *n* | *nar* |
| Ⴍ | ჲ | *j* | *je* |
| Ⴍ | ო | *o* | *on* |
| Ⴎ | პ | *pʼ* | *pʼar* |
| Ⴏ | ჟ | *ž* | *žan* |

Column 1: Asomtavruli alphabet used from 5th–7th century
Column 2: Mkhedrull alphabet used from 11th century to present
Column 3: Transcription
Column 4: Name of letter

# Letter from Julian Raby

The Arthur M. Sackler Gallery and its sister museum, the Freer Gallery of Art, have collections that range in origin from Turkey to Tokyo. Over the last few years our exhibitions have embraced this range, with shows dedicated to Ottoman Turkey and Edo Japan. But we have also tried to broaden our scope, treating these boundaries, both literally and metaphorically, with more latitude. Our exhibitions have included *Caravan Kingdoms: Yemen and the Ancient Incense Trade*, which looked at the art and culture of South Arabia over the course of more than a thousand years, from the eighth century B.C. to the sixth century A.D. This exhibition also touched on Yemen's contacts, fostered by its primary role in the incense trade, with other parts of the ancient world. Many visitors were surprised to see monumental bronze figural sculptures in a Hellenistic style, one of which was signed by a Greek artist and his South-Arabian colleague.

*Wine, Worship, and Sacrifice: The Golden Graves of Ancient Vani* continues this exploration of an ancient culture some way off the narrow latitudes that have traditionally defined the "Ancient World." If *Caravan Kingdoms* took us to the southern reaches of that world, *Wine, Worship, and Sacrifice* takes us to the northern. The finds of Vani present a culture that is barely represented, if at all, in North American collections, revealing a vibrant local Colchian artistic idiom. Yet the excavated objects also display influences from Achaemenid Iran and ancient Greece, and from the art of the steppes to the north; and they demonstrate how Achaemenid influence ceded to influence from an increasingly Hellenized world after the conquests of Alexander the Great. In planning an exhibition that highlights these issues, the Sackler Gallery found an ideal partner in New York University's newly founded Institute for the Study of the Ancient World (ISAW), as this institute is committed to broadening the study of the Classical *oikoumene* and to looking at cross-cultural exchanges.

I invited my former colleague, Professor Michael Vickers of the University of Oxford, to act as guest curator for the Sackler Gallery

venue, and we planned to expand the exhibition of gold jewelry and artifacts held in Germany and France in 2007 to include more of the archaeological finds in order to provide an excavation context for the gold as well as a richer picture of Colchian life. The idea was enthusiastically accepted by Roger Bagnall and Jennifer Chi of ISAW, and we owe a great debt to Jennifer for her hard work in choosing much of the additional material. Indeed, the ISAW show will include an even greater selection than our Washington venue.

None of this would have been possible, however, without the approval and generous support of the Ministry of Culture, Sports, and Monuments Protection of Georgia. Above all, we are indebted to David Lordkipanidze, Director of the Georgian National Museum, for his enthusiasm and commitment to this project, and for extending us Georgia's legendary hospitality. His staff, too, has been remarkably generous with scholarly and logistical support. The initial idea of bringing this exhibition to the Sackler came from my close colleague in the Smithsonian, Carole Neves. She first introduced me to David Lordkipanidze and has used her good offices at every stage of the process.

*Wine, Worship, and Sacrifice* is the product, then, of a fruitful collaboration, and it is very pleasing to know that these connections will have a life beyond the duration of the show. We are grateful to the Leon Levy Foundation for providing funding for this exhibition and for a five-year program on intercultural relations in the ancient world. Such support is increasingly vital, and I cannot adequately express my thanks to Liz Moynihan, John Bernstein, Jennifer Chi, and above all to Shelby White, the inspiration and driving force behind ISAW.

Julian Raby
Director
Arthur M. Sackler Gallery and Freer Gallery of Art
Smithsonian Institution, Washington D.C.

# Acknowledgments

*Wine, Worship, and Sacrifice* has been a three-way collaborative project among the Georgian National Museum, the Arthur M. Sackler Gallery, and the Institute for the Study of the Ancient World at New York University. We owe especial thanks to the Georgian National Muscum's Deputy Director, Mikheil Tsereteli; and to the Ministry of Culture, Sports, and Monuments Protection of Georgia, in particular to Minister Giorgi Gabashvili, to Deputy Ministers Nikoloz Vacheishvili and Levan Davituliani, and to Manana Muskhelishvili, Head of International Programs.

For their input into the scholarly concept for the exhibition, we are grateful to Darejan Kacharava, Guram Kvirkvelia, Anna M. Chqonia, and Nino Lordkipanidze. Curatorial assistance at the Georgian National Museum was provided by Zurab Tvalchrelidze, Temur Sharikadze, Mindia Jalabadze, Dimitri Akhvlediani, Germane Kazalikashvili, Nana Gogiberidze, Medea Tsotselia, Medea Sherozia, Omar Gabunia, Mavlina Kaladze, Erekle Koridze, and intern Nadia Pantel.

Project coordination was handled by Mikheil Tsereteli, Kakha Trapaidze, Maia Khachidze, Amiran Ananiashvili, Nino Bakanidze, and Omar Lanchava; financial management by Giorgi Bezarashvili and Nana Lomsadze; and illustration services by Sandro Kancheli, Irakli Khutsishvili, Nino Andriashvili, Archil Kachapuridze, Lika Gudushauri, Otar Jangavadze, and Sulkhan Kharabadze. The photographers were Marlen Avaliani, Guram Bumbiashvili, Amiran Kiladze, Gabriel Salniker, and Valeri Salniker. Technical support was provided by Zaza Meskhi.

At the Sackler Gallery, we would like to express our gratitude to the following departments that have played a leading role: Exhibitions, under Cheryl Sobas; Conservation, under Paul Jett; Photographic & Imaging Services, under John Tsantes; Design & Production, under Karen Sasaki; Web, under Sarah Sullivan; Education, under Claire Orologas; Collections Management, under Elizabeth Duley; and External Affairs, under Katie Ziglar. Professor Michael Vickers

acted as guest-curator for the exhibition in Washington, D.C.
Getrud Platz of the Altes Museum in Berlin provided valuable advice
at the outset of this project.

Conservation was a considerable task. We received wonderful
assistance and support from the team at the Smithsonian Institution's
Museum Conservation Institute, which included Robert J. Koestler,
Director; Paula T. DePriest, Deputy Director; and Robert J.
Speakman, Harriet F. Beaubien, and Carol A. Grissom. The Sackler's
team, led by Paul Jett, incorporated permanent staff as well as
Catherine Sweet, Catherine Valentour, and Kerith Koss; and
several Georgian colleagues, Nino Kalandadze, Tea Kintsurashvili,
with additional help from Irakli Bokeria, Nino Kebuladze, Vato
Khoshtaria, and Temur Parjanadze.

At the Institute for the Study of the Ancient World, we would like
to express our gratitude to the following members of the exhibition
team: Linda Stubbs, Consulting Registrar, for ably handling all
coordination and logistical aspects of the exhibition; Celia Imrey
and Tim Culbert of Imrey/Culbert LP for case and exhibition
design; Jenny 8 del Corte Hirschfeld and Mischa Leiner of CoDe.
Communication and Design for innovative graphics. William
Gagin and Fred Caruso headed our installation team. Lawrence
Becker of the Metropolitan Museum of Art and Michele Marincola
of the Conservation Center at the Institute of Fine Arts, New York
University, coordinated the conservation of additional material lent
to ISAW by the Georgian National Museum: we are grateful for
their advice and expertise. William R. Naugle, Administrative
Director at ISAW, provided administrative support.

Packing and transportation were handled by Frances Brady and
Peter Detlev of Hasenkamp Int. Transporte GmbH and by Giorgi
Koberidze of UMS (Universal Moving Service).

We received considerable help from H. E. Vasil Sikharulidze,
Georgian Ambassador to the United States, and from Otar

Berdzenishvili, First Secretary of the Georgian Embassy, Washington, D.C. We all owe a debt to Richard Lahne at the U.S. State Department for so nimbly processing our application for immunity from seizure. Informal but invaluable support was given by Boris Gagua, Director of the National Parliamentary Library of Georgia.

To all these dedicated individuals, we would like to express our thanks.

Roger S. Bagnall
Jennifer Y. Chi
David Lordkipanidze
Julian Raby

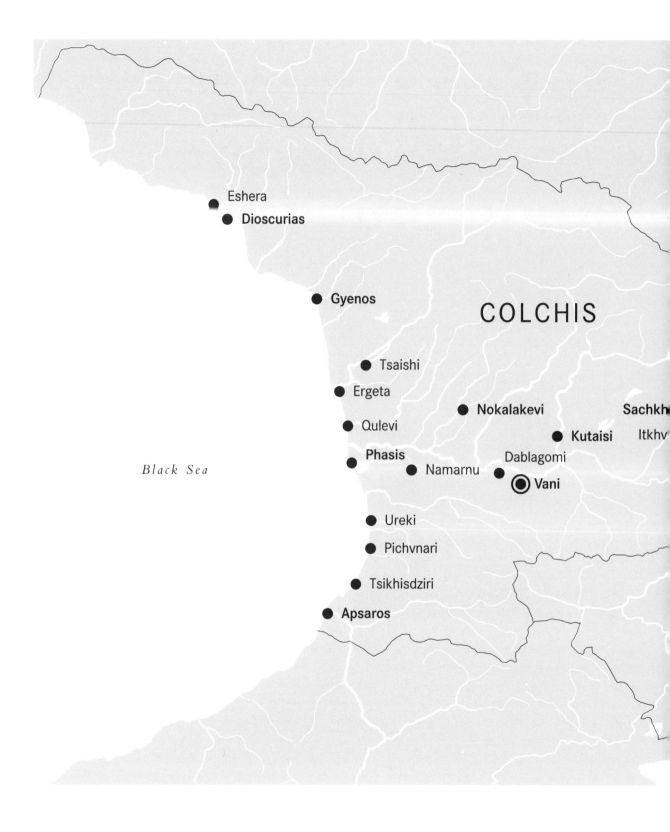

Eshera

● **Dioscurias**

● **Gyenos**

**COLCHIS**

● Tsaishi

● Ergeta

● **Nokalakevi**

**Sachkh**

● Qulevi

● **Kutaisi**   Itkhv

**Phasis**

Dablagomi

*Black Sea*

● Namarnu

◉ **Vani**

● Ureki

● Pichvnari

● Tsikhisdziri

● **Apsaros**

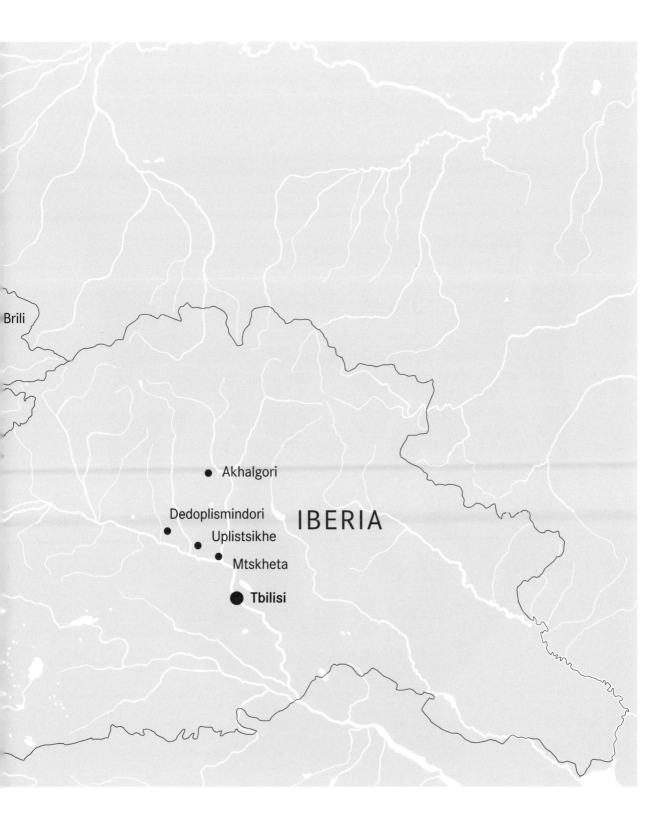

Brili

Akhalgori

Dedoplismindori

Uplistsikhe

IBERIA

Mtskheta

Tbilisi

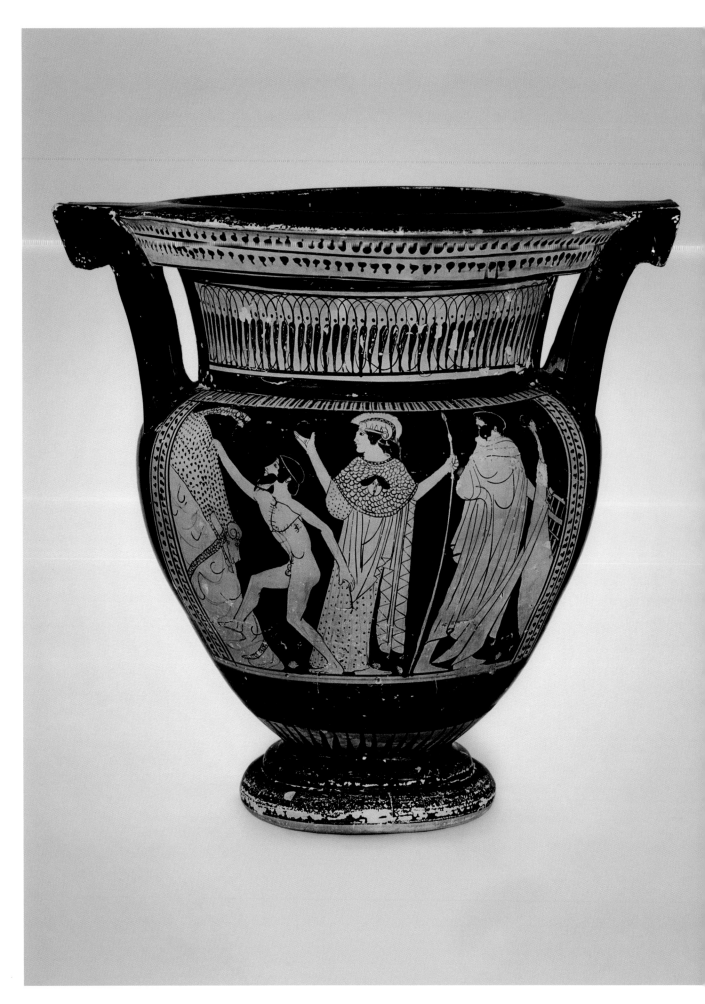

# Medea's Colchis Nino Lordkipanidze

*The original voyage to Phasis ordered by Pelias [and] the return voyage . . . contain an element of plausibility, as do also, I am sure, the wanderings which carried Jason still further—just as there is an element of plausibility in the wanderings of both Odysseus and Menelaus—as evidenced by things still to this day pointed out and believed in, and by the words of Homer as well. For example, the city of Aea is still shown on the Phasis, and Aeëtes is believed to have ruled over Colchis, and the name Aeëtes is still locally current among the people of that region. Again, Medea the sorceress is a historical person; and the wealth of the regions about Colchis, which is derived from the mines of gold, silver, iron and copper, suggests a reasonable motive for the expedition.*[1]

The myth stands out from other mythological cycles because of its particular attitude toward a remote country—Aea/Colchis. This very aspect is precisely what made the myth of the Golden Fleece of such special interest in Greek historiography. The desire of the Greeks—the fulfillment of their own objectives by sailing to a remote country—was in reality manifested in the phenomenon of Greek colonization in the eighth and seventh centuries B.C.

The major feat of the Argonauts, which probably spurred the creation of a mythological cycle about them, was already famous in Book 12 of Homer's *Odyssey*:

*On one side beetling cliffs shoot up, and against them pound the huge roaring breakers of blue-eyed Amphitrite— the Clashing Rocks they're called by all the blissful gods. Not even birds can escape them, no, not even the doves that veer and fly ambrosia home to Father Zeus: even of those the sheer Rocks always pick off one and Father wings one more to keep the number up. No ship of men has ever approached and slipped past— always some disaster—big timbers and sailors' corpses whirled away by the waves and lethal blasts of fire. One ship alone, one deep-sea craft sailed clear, the Argo, sung by the world, when heading home from Aeëtes' shores. And she would have crashed against those giant rocks and sunk at once if Hera, for love of Jason, had not sped her through.*[2]

According to the *Iliad*, this important event must have taken place prior to the Trojan War, for the participants in that war were the sons of the Argonauts. Thus, the Argonauts deserved Homer's attention because they were the first to overcome the obstacle of the Clashing Rocks and opened the way to the Black Sea. Later on, almost all subsequent authors consider the expedition of the Argonauts, led by Jason (fig. 1), as the beginning of navigation on the Black Sea; for this accomplishment Pindar even calls them demigods (*Pythian Ode* IV.203). That the opening up of the Black Sea was of vital importance for

1. Jason stealing the Golden Fleece, Red-figure column krater by the Orchard Painter. H. 29.2 cm. 470–460 B.C. The Metropolitan Museum of Art, Harris Brisbane Dick Fund, 1934 (34.11.7).

the Greeks as far back as the Mycenaean period (second half of the second millennium B.C.) or during the Trojan War is attested by recent discoveries in Troy. This archaeological material provides further support for an earlier hypothesis that the Trojan War was a struggle for approaches to the Black Sea.[3] The ongoing interest in the Black Sea was manifested later, in the eighth and seventh centuries B.C., in Greek emigration and the colonial movement in the Black Sea region.

Although many ancient cities linked with Classical heroic traditions, such as Mycenae, Thebes, and Tiryns, have proven to be real and have been brought to light, there is no direct material evidence regarding a Greek presence on the Black Sea littoral during the Mycenaean period or before the Trojan War.[4] Nevertheless, linguistic arguments should also be borne in mind. The ancient Greek name of the fleece, *koas* [κῶας], attested in Homer and earlier in Mycenaean texts in the form *ko-wo*, is not of Indo-European origin but is linked with the west Georgian or Colchian word *tqav/tqov* (skin). This does not rule out Greek-Colchian contacts in the Mycenaean period or the rise of the myth in this period (second millennium B.C.).[5] But what was going on at this time in Colchis, on the territory of modern western Georgia? To what extent did the situation there support the assumption that the Greeks were interested in this region as related in the myth of the Golden Fleece? Who were the Colchians?

The Colchians and their country are mentioned for the first time in ancient Near Eastern written sources when the Assyrian king Tiglath-Pileser I (1115–1077 B.C.) calls himself the "conqueror of the land of Cilkhi [Colchi] up to the Great Sea [Black Sea]." In a still earlier source, the inscriptions of the Assyrian king Tukulti-Ninurta I (1245–1209 B.C.), considered to be documentary evidence of the existence of a great confederation of the Black Sea Colchian tribes in the thirteenth century B.C., the Black Sea is mentioned under the name "Upper Sea" and "40 kings of the countries lying on its shore."[6] Thus, in the late second millennium B.C., the period when Greek mythological tradition is linked to the Argonauts' expedition to Colchis, the latter country is visible in the historical arena. This is also attested by linguistic evidence—glottochronology—and, even more importantly, by archaeological remains.

The language of the ancient Colchians belongs to the group of Kartvelian languages, denoted in linguistics as Colchian or Zan. Today this language, which has no written alphabet, is represented by the Megrelian and Tchan (Laz) dialects, spoken in Megrelia (western Georgia) and by the Laz, who inhabit Turkish territory. In general, linguists hypothesize the origin of Kartvelian proto-language around the fourth to the third millennium B.C. It is assumed that the people speaking this language held the western and central part of the Lesser Caucasus. First the Svan separated from the common Kartvelian language, and from the end of the third millennium B.C., the Svan-speaking population gradually spread into the territory of western Georgia. At the next stage of the ethnic development of the Georgians, from the early second millennium B.C., the numerous and powerful Megrel-Tchan ethnic mass separated from the Georgian-Zan unity, settling in the southeastern Black Sea littoral and adjoining foothill zone and in modern western and southwestern Georgia. It is to the spread of

the Megrel-Tchan population into the territory of western Georgia—on the Colchian lowland—that the creation of a highly developed Bronze Age culture is linked, established in the specialist literature under the name of Colchian Culture.[7]

Before I touch upon the main elements of this culture, it should be noted that in western Georgia the Colchian Culture was preceded by a fairly well developed Early and Middle Bronze Age, the so-called proto-Colchian period. The most pronounced elements of Colchian Bronze Age culture, which embraced the second half of the second millennium and the early part of the first millennium B.C., are diverse bronze items: predominantly battle, household, and ritual axes, the so-called Colchian axes, are decorated with geometric ornaments, astral signs, and representations of animals. Farming tools, weapons, jewelry (bracelets, fibulae, belts, plaques), and anthropomorphic and zoomorphic (including rams) miniature sculptures abound. The bulk of these items have come down to us as treasures. At the same time, it should be noted that mining and metallurgical centers have been brought to light in Georgia.

Another major factor in Colchian Culture is the new type of pottery from this period; it is exemplary in its functionality and typologically differing forms and diverse ornamentation. Besides bronze agricultural tools and pottery, the progress in farming is attested by stone querns, baking stones, and fragments of grains of wheat and millet and grape pips. The deep river Rioni, called Phasis by the Greeks, especially favored the development of agriculture in the Colchis lowlands. High-quality metallurgy, the manufacture of

metals and pottery, advanced farming and cattle-breeding, in turn, imply the existence of a highly developed society, whose proprietary and legal distinctions are attested by the archaeologically substantiated topography of dwellings and the phenomenon of treasures. According to Otar Lordkipanidze, Colchian Bronze Age Culture, which took shape during the second half of the second millennium and early in the first millennium B.C., was the result of a definite political consolidation, perhaps headed by a political leader. This type of political structure comes close to a chiefdom, a transitional stage from a pre-state to a state system. The main point here is that a society of this type is not attested archaeologically in any other region of the Black Sea.[8]

And still the two-part question remains: did the Argonauts' expedition to the mythical Aea take place? And were the Greeks interested in Colchis in the Mycenaean period? This perennial query can probably be answered best in the words of Johann Jakob Bachofen, one of the outstanding scholars of Greek mythology: "The rejection of historicity does not belittle the significance of myth. What could not have taken place, was at any rate thought."[9]

In the case of the myth of the Argonauts, this thought was most clearly expressed in Greek literature, and also in early art. A graphic example is a representation of the sorceress Medea, attested by the Etruscan inscription METAIA, and the Argonaut winners of the games held on the island of Lemnos. The scene is depicted on a seventh-century B.C. Etruscan olpe, probably conveying the Lemnian episode described in Pindar's *Fourth Pythian Ode*.[10] The choice of the Lemnian theme

and the peculiar manner of conveying it—such as
the inclusion of the image of Daedalos—reveal
the reality that prompted the Etruscan noble to
order the item for his grave. Such commissions
were widespread in the Greek and Roman worlds.
This reality must be suggestive of lively Greek
and Etruscan interest in a search for metals.[11] It
should be noted here that in this period (eighth–
sixth centuries B.C.), when Greek literature and
art paid special attention to Colchis, the latter
country was particularly rich in metal and was
the only settled territory in the Black Sea region.
In the 8th century B.C., Urartian sources even
refer to the state of Qulha or Qolha. Nor is it
fortuitous that contacts between Colchis and the
Hellenic world are attested archaeologically, too,
for example, by Greek objects discovered in
Colchis and Colchian objects brought to light on
Samos, such as miniature bells, plaques, and a
statue of a female rider with a child.[12]

Thus, it may be assumed that the advent of
Greeks in the Black Sea area in the Mycenaean
period cannot be ruled out. Several scholars link
Mycenae with Colchis on the basis of linguistic
evidence.[13] Later, in the eighth and seventh
centuries B.C., before this drive of the Greeks was
realized in the form of the great Greek colonization,
Colchis was the only densely populated region
in the western and northern Black Sea area with
a highly developed society and the status of a
powerful state. It is this that must have prompted
the Greek world to adopt a completely different
attitude toward Colchis, as reflected in the myth
of the Argonauts in Classical culture.

Otar Lordkipanidze Center for Archaeological
Studies

## Notes

**1.**
Strabo, 1.2.39; English trans. H. L. Jones, *The Geography of Strabo*, vol.1, Loeb Classical Library (Cambridge, Mass.), 1989.

**2.**
Homer, *The Odyssey*, 12. 66–80 in the English translation by Robert Fagles, introduction and notes by Bernard Knox (New York, 1996), 273.

**3.**
For the connections to the Mycenaean world, see in detail O. Lordkipanidze, *At the Sources of Ancient Georgian Civilization* (Tbilisi, 2002) [in Georgian], 150; S. Hiller, "The Mycenaeans and the Black Sea," in *Thalassa, l'Egée préhistorique et la mer: Actes de la troisième Rencontre égéenne internationale de l'Université de Liège, Station de recherches sous-marines et océanographiques (StaReSO), Calvi, Corse, 23-25 avril 1990*, ed. R. Laffineur and L. Basch (Liège, 1991), 207–15.

**4.**
The discovery of Mycenaean pottery in Mashat (northeastern Turkey) is a very important fact in this regard. The excavator, archaeologist Tahsin Özgüç, believes, however, that Mycenaean pottery found its way there through the continental route. Machteld J. Mellink does not rule out the sea route (*AJA* 88 [1984]: 445; *AJA* 89 [1985]: 558); for a more detailed discussion, see O. Lordkipanidze, "La geste des Argonautes dans les premières épopées grecques sous l'angle de premiers contacts du monde grec avec le littoral pontique," in *Sur les traces des argonautes, Actes du 6e Symposium de Vani* (Paris, 1996), 36.

**5.**
T. Gamkrelidze and V. Ivanov, *The Indo-European Languages and the Indo-Europeans* [in Russian], vol. 2 (Tbilisi, 1984), 504–9.

**6.**
G. Melikishvili, "The Black Sea in Assyrian Cuneiform Sources of the 13th–12th centuries B.C. [in Russian], in *Questions of the History of Caucasian Peoples* (Tbilisi, 1966), 31.

**7.**
Ancient Greek, Roman, and Byzantine authors, such as Strabo and Procopius, refer to the west-Kartvelian tribes "Laz" and "Tchans" as "Sanes," while the Svans (an ancient Kartvelian tribe) call the Megrels (Mingrelians) "Zanar"; see O. Lordkipanidze, *Archäologie in Georgien, von der Altsteinzeit zum Mittelalter* (Weinheim, 1991), 9, 93–94.

**8.**
Lordkipanidze, *Archäologie in Georgien,* 95–105.

**9.**
J. J. Bachofen, "Die innere Wahrheit des Mythos," in *Wege der Forschung* 20, *Die Eröffnung des Zugangs zum Mythos*, ed. K. Kerényi (Darmstadt, 1967), 125.

**10.**
M. A. Rizzo and M. Martelli, "Un incunabolo del mito Greco in Etruria," *Annuario della Scuola Archeologica di Atene* 50/51 (1988-90) (Rome, 1993): 7-56; *LIMC* 6 (1992), s.v. "Medeia," no. 2 (M. Schmidt).

**11.**
Rizzo and Martelli, "Un incunabolo del mito Greco," 46-47; E. Simon, *Etruskische Keramik des 7. Jhs. v. Chr. mit figürlicher Ritzung und ihre beziehung zum Orient* (Heidelberg, 1997), 2-4; N. Lordkipanidze, *The Representation of the Myth of the Argonauts in Early Greek Art* (Tbilisi, 2004), 20-31 [in Georgian].

**12.**
O. Lordkipanidze, *At the Sources of Ancient Georgian Civilization*, 154, 327; 188-90.

**13.**
Hiller, "The Mycenaeans and the Black Sea," 207-15; P. Lévêque, "La Colchide dans l'élan de la colonisation grecque," in *Il dinamismo della colonizzazione greca*, ed. C. Antonetti (Naples, 1997), 11-23.

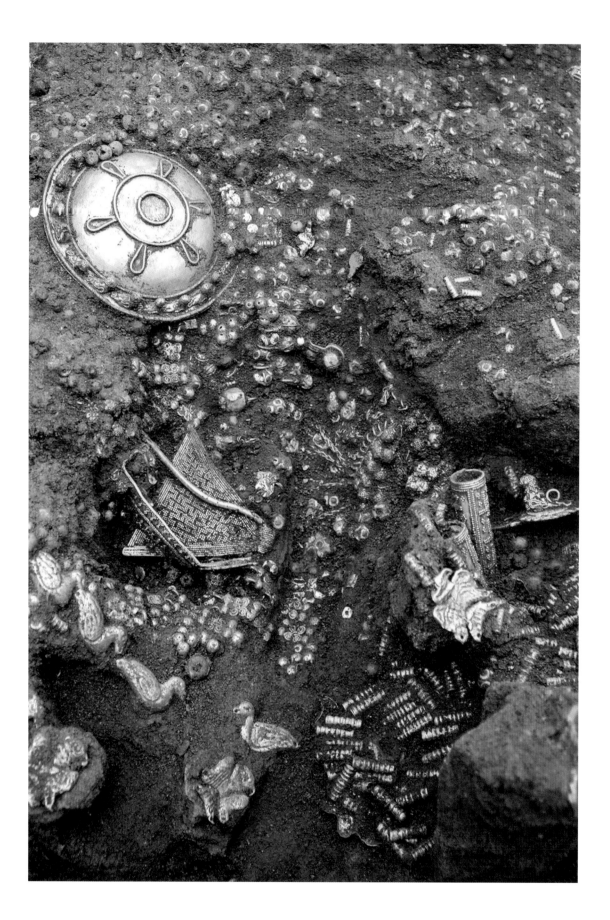

# Vani, Rich in Gold Michael Vickers

When Alexandre Dumas was traveling through western Georgia in 1859, he was told by a local dignitary that a certain ruined castle had been built in ages past by "a man named Jason, who had come from another part of the world, whose aim was to acquire a fleece of golden wool." Dumas's informant professed not to believe the tale, on the grounds that every countryman applied the same story to any ruin. He was surprised to learn that Dumas already knew the story, having learned it as a schoolboy in France.[1] The tale of Jason's voyage with the Argonauts from Iolcus in Thessaly in search of the Golden Fleece, and the help he received from Medea, daughter of Aeëtes, king of Colchis, has indeed survived the centuries.[2] It was told in antiquity, in its canonical form by Apollonius of Rhodes, and lives on today in the name of the Georgian TV channel Ayeti, in the Garden of Medea at Vani, and in the colossal bronze statue of Medea erected at the Georgian seaside resort of Batumi in 2007.

Scholars have tried to rationalize the tale of the Argonauts, seeing in the Golden Fleece itself a reflection of the system used for extracting gold dust from rivers in the mountains of northwestern Georgia.[3] The Roman geographer Strabo describes how sheepskins would be left in streams and their lanolin would attract specks of the metal.[4] It used

to be thought that this practice had parallels in the modern ethnographic record, but this is not definitive.[5] Another possibility is that the story originated in tales of rich supplies of metal in "Colchis rich in gold," where iron was smelted at a very early period and where there were long traditions of working both precious and base metals.[6]

Scholars, mostly Georgian, have been zealously studying ancient Colchis for the past century or so, and nowhere has this research been conducted more intensively than at Vani, a site nestled in the foothills of the Lesser Caucasus, to the south of the river Rioni, the ancient Phasis. Much of the literature has been in Georgian or Russian, and although specialists have long known of the remarkable discoveries made at Vani (fig. 1), and exhibitions have been mounted in France and Germany, it is an index of the degree to which the Western public has been largely unaware of Colchian archaeology that the present publication is one of the first extended discussions of Vani to appear in English.[7]

The potential importance of the site has been clear ever since nineteenth-century newspaper reports told of the riches to be found on the hill named for the Akhvlediani family. Thus, on the front page of the Tbilisi journal *Droeba* for 28 May 1876 (fig. 2),

1. Grave 24, detail of contents in the course of excavation, autumn 2004. Second half of the 4th century B.C.

29

# დროება

გამოდის კვირაგზით, ოთხშაბათობით და პარასკევობით

**რედაქცია**
ველიამინოვის ქუჩაზ, არტემ ჩაჩიკაშვილის სახ...ში.

**ხელ.-მოწერა**
რედაქცია...ში... სხ... მოლ...მემის სტ...ში.
ძალი... გოძ... მ...ნის...: Въ Тифлисъ. Въ
редакцiю газеты „Грузiя"

**გაზეთის ფასი**
წელიწადში 8 — მან., ნახევარ წელიწადში —
4 მან. და 50 კაპ., თვეში — 1 მან.
...

**განცხადება**
...ის ქართულის, რუსულის, სომხურ... და ფრ...
...ის ...

**განცხადების ფასი**
პირვ... ...

## საქართველო

### დღიური

[body text — faded, largely illegible]

## ფელტონი

### ჩვენში გლდიში რა სათირია

[body text — faded, largely illegible]

we read that "[e]very time it rains, the water brings into the yards of the Akhvlediani so many pieces of jewelry, so many gold chains, so many coins and all sorts of other objects. . . . The inhabitants of the place sell surreptitiously one or other of the ancient objects. One sold a gold cup, another a sieve in gold. Someone bought some gold rings, one of which had a stone of garnet [probably carnelian], with the engraved image of an admirable female face. . . . It seems that one can find many ancient objects in this place. Who knows how many precious historical objects have been found and lost on account of the ignorance of their owner, and who knows what the entrails of this extraordinary hill still guards?"

Over the years, the scientific community became increasingly interested in Vani and its treasures. In 1880, the Georgian writer Giorgi Tsereteli wrote a report on the archaeological finds at Vani and the need for their proper study. A local inhabitant, he notes, "a certain Akhvlediani nobleman," had found "in a tumulus a whole treasure of objects in gold and in copper." Reports written on behalf of the Archaeological Society of Moscow in 1889 indicate that Alexandre Stoïanov, a local ethnologist who conducted excavations at Vani, found "tombs of the ancient Greek period and that the objects in gold that are dug up there appear to be of considerable scientific interest." In the same year, a French mission discovered the remains of a church and of a medieval tomb, adding to the general interest of this very promising site. Later, in 1896, the Georgian scholar Ekvtime Takaishvili (fig. 3) began what have been called the first scientific excavations at Vani, and produced the first publications of its antiquities. He also provided more information about material that had been

discovered by chance in the 1870s but subsequently lost: "According to the inhabitants, they have found here a very rich tomb, with a large number of gold bracelets, rings, earrings, coins, a diadem, harness for a horse with decoration in gold, a gold scepter, a bronze cauldron, and other objects, but no one knows where they have disappeared." Speaking of the Akhvlediani hill at Vani, Takaishvili made a significant prediction: "I do not doubt that after future excavations at this remarkable site, they will make great discoveries."[8] His prediction did come true, and "Vani, rich in gold" indeed revealed more of its treasures in due course.[9] Takaishvili's excavations were discontinued at the beginning of the twentieth century; nevertheless, casual finds of gold jewelry found their way to the State Museum of Georgia between 1929 and 1940.

In 1936, exploratory work was carried out under the direction of the Academician Niko Berdzenishvili. The site was surveyed in 1938 and again in 1946. As a result of these surveys, the need for comprehensive excavations became obvious. For this purpose, a group of archaeologists from the Institute of History of the Georgian Academy of Sciences established the Vani Archaeological Expedition. Nino Khoshtaria (fig. 4), a former student of Berdzenishvili and the first Georgian woman archaeologist, led twelve campaigns between 1947 and 1963. The data collected from the excavations allowed Khoshtaria to securely date the site from the sixth to the first century B.C., arguing that its destruction was the result of one of Pompey's campaigns in the region. Later excavations extended the date back to the eighth century.

From 1966, Otar Lordkipanidze (fig. 5) was in charge of the expedition. It is because of his

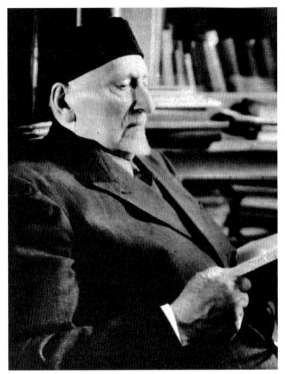

leadership, administrative skills, and scholarship that Vani has reasserted its place on the map of the ancient world. There have been annual campaigns, usually devoted to excavation, sometimes to the study of finds. A series of monographs by Lordkipanidze and his team has been published: nine volumes of *Vani: Archaeological Excavations* have appeared (in Georgian) since 1972. Many books and articles devoted to Vani and its place in the Colchian, Black Sea, and Mediterranean worlds have issued from Lordkipanidze's pen. It was thanks to his efforts that the Vani Archaeological Museum was built in 1985, and to his initiative that the Vani Symposia, where scholars of Black Sea archaeology gather from all over the world, have been held every three or four years since 1977. After Otar Lordkipanidze died in 2002,

his baton passed to Darejan Kacharava, who has worked at Vani since 1967.[10]

Since 2002 the Vani expedition has been granted funds from both the Gerda Henkel Foundation (Germany) and the Ministry of Culture of Georgia, contributing enormously to the eminent success of the last seasons of excavations. The most recent campaign, conducted in 2007, was marked by the extraordinary finds of what have been so far interpreted as a temple inventory deposited in a rock-cut pit probably during the last phase of the city's history.[11] The 2008 Symposium has already been announced, and work on the scientific publication of the recent important discoveries is in hand. The team members' energy, devotion to their work, and love of Vani deserve the highest

3. Scholar Ekvtime Takaishvili (1853–1963).

4. Archaeologist Nino Khostaria (1902–1969).

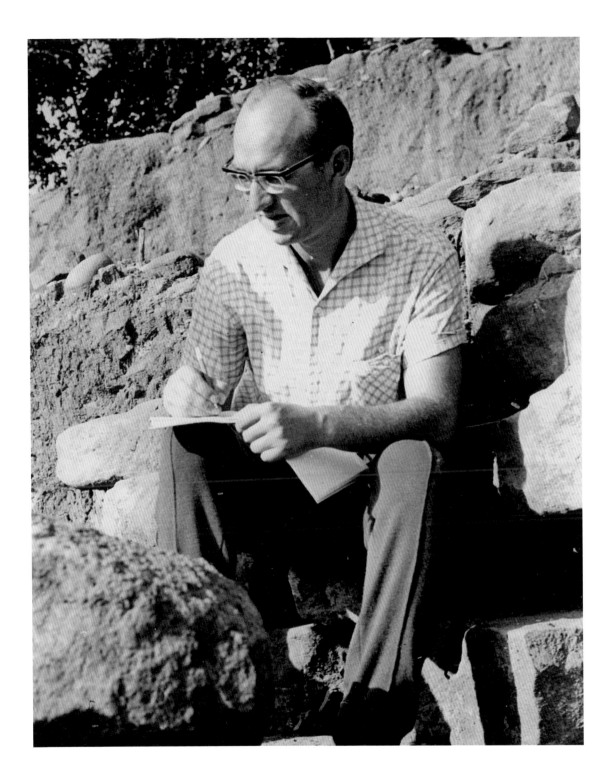

5. Archaeologist Otar Lordkipanidze (1930–2002).

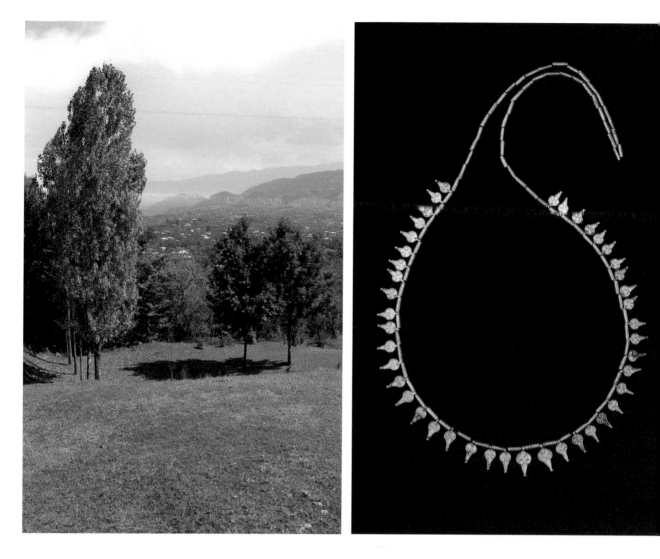

praise. A recent initiative at Vani is the planting of the Garden of Medea on the upper terrace of the Akhvlediani hill (fig. 6). Oaks, poplars, laurels, cornelian-cherries, and vines are mentioned in a late-Roman author as having populated the garden of the legendary princess, and these have fittingly been planted in a plot overlooking the site of Graves 22 and 24, which were indeed rich with gold finds (fig. 7).

But what kind of place was Vani in antiquity? What role did it play in Colchian public life beyond being a place where people who were clearly from the upper echelons of society chose to be buried? In the almost total absence of any literary or epigraphic evidence, we can only sketch out some possibilities.

The ancient name of Vani is not known with certainty. It might have been Surium (mentioned

6. Akhvlediani hill, "Garden of Medea," overlooking the site of Graves 22 and 24.

7. Gold necklace with leaf-shaped pendants, from Grave 24. Second half of the 4th century B.C. Georgian National Museum.

in a disputed passage of Pliny)[12] or Leucothea (a Colchian shrine mentioned by Strabo), or something else altogether. It is, nevertheless, a fact that the city effectively came to an end in the mid-first century B.C. We read in Strabo of the sanctuary of Leucothea—which may indeed have been Vani's name in antiquity—suffering from successive invasions of Colchis, the first by Pharnaces of Bosphorus in 49 B.C. and the second by Mithridates VII two years later.[13] Evidence of two destructions within a short time of each other has been found at Vani; thus, even if Vani was not Leucothea, it evidently shared the same fate.

Only scanty traces remain of the first occupation of the site: a ritual complex seems to point to Vani as a cultic center in the eighth century.[14] More information is available on the nature of the occupation from the sixth to the fourth century B.C. Indeed, the results of the archaeological excavations and records from the written sources indicate that during this time the city became a political and administrative center, that is, a "sceptuchy" (a kingdom ruled over by a "scepter-bearing" king), overseeing the local economy, which was based mainly on the agricultural exploitation of the region.[15] Terracotta tiles stamped in Greek (ΒΑΣΙΛΙΚΕ) indicate some kind of official control of supplies of building materials as well (fig. 8).[16] The leading aristocracy chose the city center as their residence both in life and in death, as is demonstrated by the numerous rich graves found there. The influence of Vani on the region's politics, culture, and economy must have been significant.[17]

Some, but not all, scholars maintain that ancient Vani was a sanctuary city between the third and first centuries B.C.[18] The evidence that is adduced

is a sacred law, a fragment of which survives in a bronze inscription in Greek that refers to three deities, Ge (Earth), Helios (Sun), and Meis (Moon) (figs. 9a, b).[19] The city was protected by solid ramparts, towers, and fortified gateways (fig. 10).[20] Within the walls, there were no human dwellings, say the excavators, but only structures for gods and goddesses. At least, no houses of the period have yet been found inside the city. People seem to have lived outside the ramparts, in the valley. The principal deity at Vani appears to have been a goddess. A graffito scratched on a statue base at one of the city's gateways has been taken to read: "I pray thee, ruler-goddess" (figs. 11a, b).[21] Which goddess was intended—if indeed it does say that—remains uncertain, although Leucothea is a strong candidate.

8. Fragment of a terracotta tile with a royal control stamp in Greek letters. 3rd century B.C. Georgian National Museum.

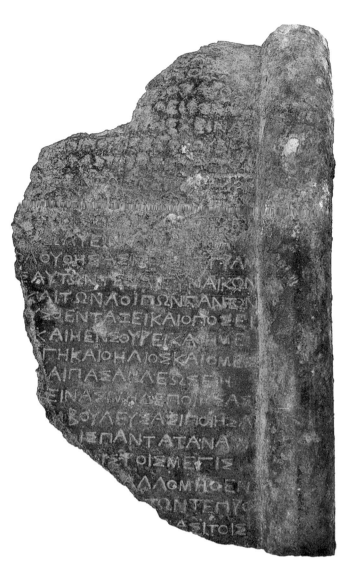

ΕｉＡＳ
ΡΟΝＡＥ
ΦΑΝＴΙΟＳＡ
ΑＹΓΟΝＴＡ
ＮＴΙΟＴＡΦΟＳＥ
ΠΟΛＥΙΦΘＥＮＡ
ΠΟＮＥＸＥΙＮＡ
ΓΚＥΙΝΟＹＥＳΚΓΟΙ·ΟＹＳＫＡΙ
ＡＮΙＡＳΤΟＹＳΕΙ ΗＮＡＹΙＳＮ
ΟＹΘＥΙＮΤΟΙＳΓＥΓΡＡΜΜＥ
ΦΙＳＡΡＡΙΤΗＮＳＴΗΛΗＮ
ΙＥＮΟΙＳΜΗＤＥＡＮΕΠΙΧＥΙ
ＡＮΩΛＹＥΙＮＫＡΤＡＤＹＮＡ
ΡΛΟＹΘΗＳＡＳΙΤΟΙＳΓＥΓΡＡＭ
ΞＡＹΤΩＮΤＥＫＡΙΓＹＮＡΙＫΩＮ
ＫΑΙΤΩＮΛΟΙΠΩＮΠＡＮΤΩＮ
ＹＳΟＥＮΤＡΞΕΙＫＡΙΟΠΟＳΕΙ
ＫＡΙΗＥＮＳΟＹΡΕΙＫＡΘΗΜＥ
ΓΗＫＡΙΟΗΛΙΟＳＫＡΙΟΜＥΙＳ
ＡΙΠＡＳＡΠΛΕΩＳΕΙΗ
ΕΙＮＡＳΙΜΗＤΕΠΟΙΗＳＡΙ
ＨΒΟＹΛＥＹＳＡＳΙΠΟΙΗＳＡΙ
ΙＳΠＡＮΤＡΤＡＮＡＮ
ΝΙＳΤΟΙＳΜΕΓΙＳ
ＡΛΛΟΜΗΘＥＮ
ΤΩＮΤΕΠΡΟ
ＡＳΙΤΟΙＳ
ΑΙ

9a, b. Fragmentary tablet with inscription in Greek that refers to Ge, Helios, and Meis. Bronze, H. 28 cm, W. 15 cm, Th. 1 cm. End of 4th–beginning of 3rd century B.C. Found on the central terrace. Georgian National Museum.

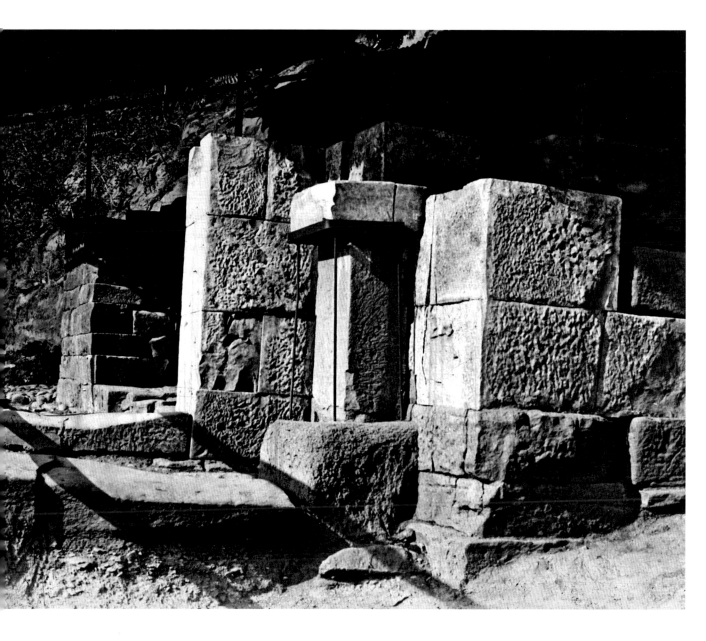

10. Vani city gateway, showing worn steps and a statue base.
2nd–1st century B.C.

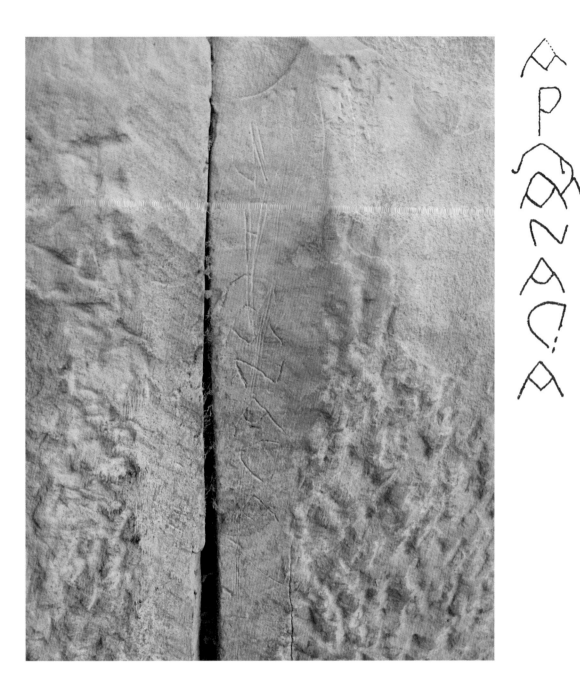

11a, b. Graffito on statue base reading "I pray thee, ruler-goddess." Vani city gateway. 2nd–1st century B.C.

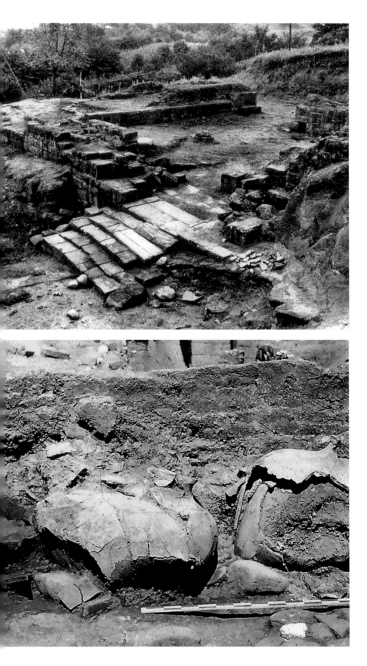

Several religious buildings have been excavated that belong to Vani's latest period (third–mid-first century B.C.). One of particular interest is the so-called Temple-Propylaea, which occupies an area of more than 800 square meters on the lower terrace (fig. 12).[22] Terribly damaged by fire, the complex had walls of well-cut stone below and adobe above, and once consisted of a tower, a "sacrificial place," a "hall of columns," a staircase leading perhaps to a wooden altar, and a "hall of offerings." A large number of broken pottery vessels for containing and consuming wine—amphorae and cups, both local and imported—were found in the floor of the sacrificial place, together with bones of cattle and pigs, as well as horns of aurochs.[23] The objects were *in* the floor because the debris had been periodically covered with a layer of clay that was smoothed over to provide a new surface. A channel in the floor of the hall of columns led outside into a ravine; though its purpose is uncertain, it may have been for some kind of ritual. The most remarkable finds were in the hall of offerings, where all the vases were full of cereals (fig. 13). According to a specialist's report, there were five varieties of millet or wheat, two of which were of Italian origin.[24] The others included local types that have been found at other, earlier sites in Georgia. There was also a deep square pit nearby (2 x 2 meters) of uncertain depth and purpose. The archaeologists stopped digging when they reached 22 meters, but they were able to establish that it was contemporary with the temple complex.

Less than 100 meters to the north was a Round Temple whose rock-cut grooves for sacrificial blood and libations suggest a chthonic cult (fig. 14).[25] The sacred character of Vani in this latest period

12. Entrance to the Temple-Propylaea. 2nd–1st century B.C.

13. Shattered vessels filled with cereal grains, found on the floor of the hall of offerings in the Temple-Propylaea. 2nd–1st century B.C.

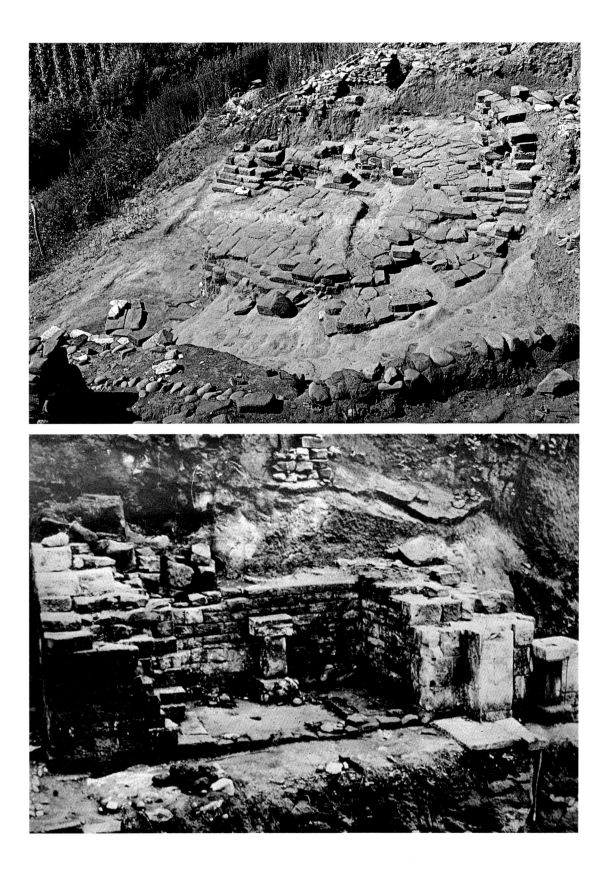

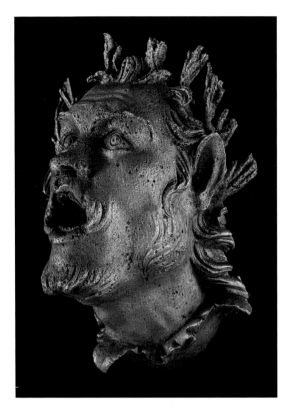

of the wine-god is entirely appropriate in a land where wine is thought to have been invented. The claim that wine was first made in Georgia is a powerful one. Residues on the inner surfaces of 8,000-year-old ceramic storage jars found at Shulaveri sixty miles southeast of Tbilisi in 2003 were analyzed at the University of Pennsylvania Museum and shown to have come from resinated red wine, the earliest known wine anywhere.[29] Grape pips of cultivated vines have been found in Georgia from as early as 7000–5000 B.C. Even today there are more than five hundred grape varieties known. The words used in most European languages for wine — *oinos, vinum, vino, vin, Wein* (not to mention "vine") — all come from a common root, believed to be a non-Indo-European loan word. Georgian is a non-Indo-European language, and its word for wine is *gvino*.[30] Apollonius of Rhodes describes the astonishment of the Argonauts before the vine arbors and wine fountain in the palace of Aeëtes, but this probably reflects the practice of his own day, in the third century B.C., rather than that of the Bronze Age.

is attested above all by the presence throughout the city of large and small stone altars and other ritual objects (fig. 15).[26] One of the most striking is an altar with twelve steps, the first six of which are straight and the last six of which are semicircular.[27] Numerous offerings were found nearby, including some two hundred pyramidal clay loom-weights, Colchian storage jars and amphorae, clay cups and jugs, incense burners, a silver-gilt medallion of a goddess, and statuettes of Apollo.

Dionysos was also present at Hellenistic Vani.[28] A series of bronze heads in high relief, appliqués from a vessel, representing members of the circle of Dionysos — Ariadne, satyrs, Pan, maenads — have been found there (fig. 16). The prominence

Wine plays a central role in Georgian feasting today, with one individual elected as toastmaster — *tamada* — at the beginning of the meal.[31] It is an office that has much in common with the "master of the drinking" — *symposiarchos* — elected at the beginning of a Greek banquet.[32] It was his role to decide the proportion of water to wine and to lead the toasts. The reclining banqueter on the silver belt from Grave 24 at Vani may not be a symposiarch, but he is clearly drinking (fig. 17). He holds a cup — a *phiale* of Persian type — to be filled by the servant holding a ladle, of a kind like the one also found in Grave 24. Colchian drinking practices resembled those of Persia more

14. Round Temple. 2nd–1st century B.C.

15. Vani city gateway, showing altar. 3rd–1st century B.C.

16. Appliqué of a Pan. Bronze, H. 13 cm, W. 9.8 cm. Second half of the 2nd century B.C. Georgian National Museum.

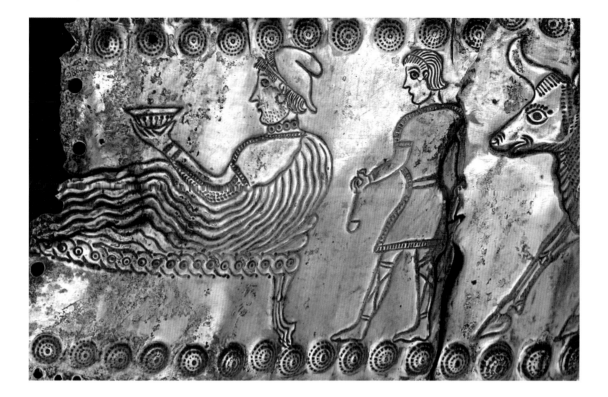

closely than those of Greece since the size of the wine serving bowls found suggests that wine was drunk neat, whereas the Greeks added water.

Visitors to Vani today can see facilities for the making of wine in a way that has scarcely changed since antiquity. In western Georgia, it was traditional until recently to use a *marani*, a hollowed-out log in which several men would stand, pressing the grapes with their feet. Until the nineteenth century, the *marani* was the place where various religious rituals, such as sacrifices or baptisms, were performed; it thus possessed a certain sacred character. The as-yet unfermented grape juice would be drained into a series of large *kvevrebi*, terracotta jars that could hold

more than four hundred gallons. These resemble the storage jars, *pithoi*, of antiquity, and provide yet another link with the past.[33]

But it is the rich burials for which fifth–and fourth-century Vani is famous. Although the wooden houses of the Colchian aristocracy have not survived, graves of the Vani nobility have been found all over the site.[34] Their rich contents constitute the major part of this exhibition. The deceased was usually laid to rest wearing a vast array of gold and silver jewelry and sometimes wore a shroud sewn with innumerable small appliqués, roundels, and beads of gold (fig. 18). Necklaces abound. Most jewelry is distinctively Colchian in character, but gold bracelets are usually of Achaemenid Persian inspiration if not execution.

17. Reclining banqueter holding a Persian-type phiale, detail of a silver belt, from Grave 24. H. 10.8 cm, L. 85.2 cm. Second half of the 4th century B.C. Georgian National Museum.

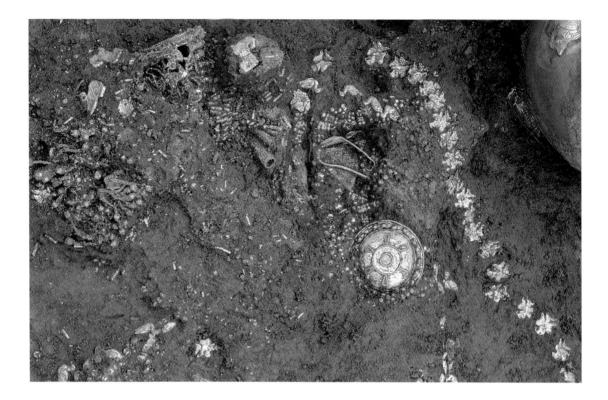

The deceased did not always go alone into the next world; household slaves or servants and horses were often killed and buried with them (figs. 19a, b), a practice that has parallels in the Scythian world to the north of the Greater Caucasus. Herodotus (4.71) describes the more elaborate but rather gruesome Scythian royal burial customs:

*The graves of the kings are in the land of the Gerrhi* [inland up the Dnieper]. . . . *There, when their king dies, they dig a large square hole in the ground; and having gotten this ready, they take up the corpse* . . . [and carry it round all their provinces back to the land of the Gerrhi]. *And then, when they have placed the corpse in the grave on a bed of leaves, having fixed spears on each side of the dead body, they lay*

*pieces of wood over it, and cover it with mats. In the remaining space in the grave they bury one of the king's concubines, having strangled her, and his cup-bearer, a cook, a groom, a page, a courier, and horses . . . and golden drinking cups. . . . Having done this, they all heap up a large mound, striving and vying with each other to make it as large as possible.*

The custom of burying servants, having presumably sacrificed them first, is attested elsewhere in Georgia, at Sairkhe and Sachkere, and horse burials have been found at both these places as well as at Eshera and Gyenus.[35]

The Hellenistic metalwork discovered at Vani was clearly influenced by Greek aesthetic sensibilities. Numerous fragments, large and small, of bronze

18. Grave 24, detail of contents in the course of excavation, autumn 2004. Second half of the 4th century B.C.

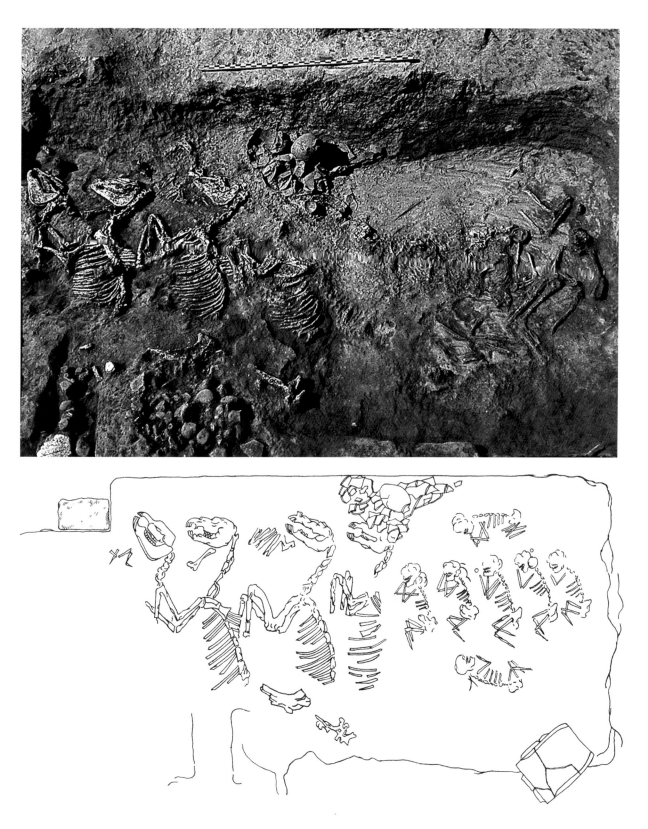

19a, b. Burial of servants and horses that accompanied the
deceased in Grave 12. 3rd century B.C.

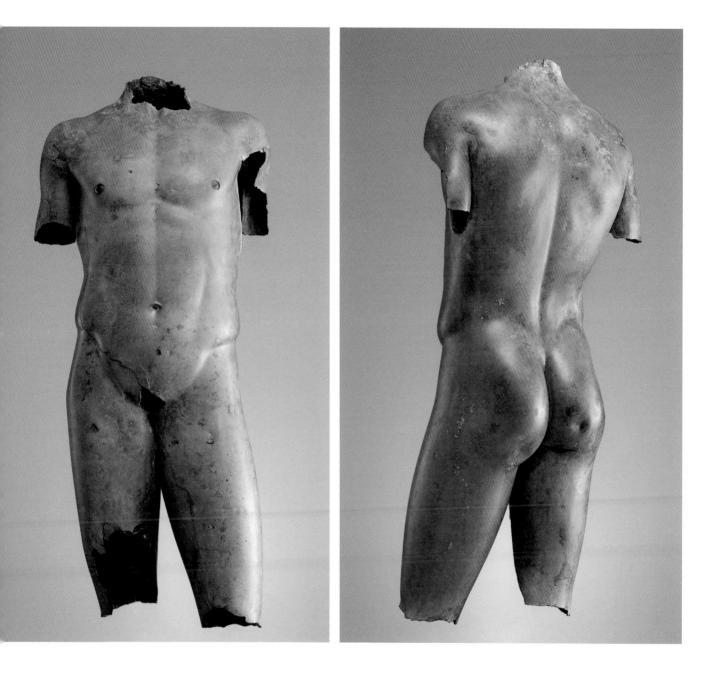

20a, b. Torso of a youth. Bronze, H. 105 cm.
2nd century B.C. Georgian National Museum.

statues, as well as a bronze foundry, have been found. Many pieces, notably a torso of a youth, are of extremely high quality and demonstrate the skill of Vani craftsmen (figs. 20a, b).[36] This fragmentary statue was found in a level belonging to the final sack of the city, and was sorely hacked about by the attackers before being cast on the remains of a destroyed building. The damage made it possible to see with relative ease how the statue had been made, using a variant of the lost wax technique over a clay core supported on an iron framework. The pose is one familiar from Greek sculpture of the fifth century B.C., and at first it was thought that the torso might date from that period. But the idiosyncratic method of manufacture, completely unlike anything known from the fifth century, convinced scholars that it was made later, and probably produced locally. The tin-rich metal would have shone like gold when new (the ancients did not idealize patina on bronze, and the statue would have been kept highly polished). Tiny patches visible on the surface show the lengths to which bronze sculptors went to rectify small imperfections, and similar patches are extant among the fragments of scrap metal found in the area of the foundry.[37] Any lingering doubts as to whether the statue could have been made in such a remote place as Vani are dissipated by the recent discovery of a cache of equally magnificent late Hellenistic bronze vessels, lamps, and statuettes.[38] Pieces of drapery, hooves, snakes, altars, fingers, curls of hair, and the like—excavated in the area of the foundry—enable us to extend the sculptors' repertoire, if only in our imaginations. They, and the torso and the new finds, also indicate the degree to which the figural arts at Vani had become Hellenized, compared with earlier times.[39] A particularly beautiful fragment consists of a delicately rendered hand clutching an animal skin, perhaps Herakles dispatching the Nemean lion. These examples, and others, of exquisite bronze working are exhibited at the Georgian National Museum in Tbilisi and at the Otar Lordkipanidze Archaeological Museum at Vani.

Vani today is a town struggling, with some success, to recover from decades of Soviet-period disfigurement. The setting is splendid, with extensive views across the valley of the Phasis to the snow-capped peaks of the Greater Caucasus to the north (fig. 21). Scholars from Georgia and abroad have in the past found the city a rich source for the study of ancient Colchis, and recent finds suggest that this will continue to be the case into the future.

University of Oxford

46

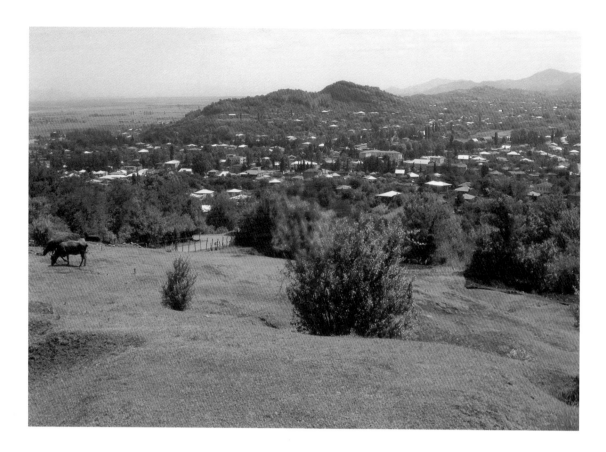

21. View across the valley of the ancient Phasis River
(today called the Rioni River).

## Notes

I owe much to the publications of Otar Lordkipanidze: "La civilisation de l'ancienne Colchide aux Ve–IVe siècles (à la lumière des plus récentes découvertes archéologiques)," *Revue Archéologique* 1971, no. 2, 259–89; "Vani: An Ancient City of Colchis," *Greek, Roman, and Byzantine Studies* 32 (1991); 151–95; *Vani, une Pompéi géorgienne* (Paris, 1995); "Vani, ein antikes religiöses Zentrum im Lande des goldenen Vlieses (Kolchis)," *Jahrbuch des Römisch-Germanischen Zentralmuseums, Mainz* 42 (1996): 353–401; to Darejan Kacharava, "Recent Finds at Vani," *Hommage à P. Lévêque*, ed. J. Annequin, *Dialogues d'histoire ancienne*, Supplement 1 (2005), 291–309; and to Anna Chqonia, Darejan Kacharava, Nino Lordkipanidze, and Guram Kvirkvelia, authors of the Berlin exhibition catalogue *Medeas Gold: Neue Funde aus Georgien, Einführung der Staatlichen Museen zu Berlin mit dem Georgischen Nationalmuseum, Georgien, Berlin, Altes Museum, 15. März–3. Juni 2007* (Tbilisi, 2007). I am grateful to Darejan Kacharava and Guram Kvirkvelia for many discussions about Vani over the years, and to Manana Odisheli for showing me photo-graphs of the very recent important finds.

1.
A. Dumas, *Au Caucase* (Paris, 1969), 269–70.

2.
The tale of the Argonauts and its reading as evidence for the earliest Greek presence in Colchis is thoroughly studied in O. Lordkipanidze, "La geste des Argonautes dans les premières épopées grecques, sous l'angle des premiers contacts du monde grec avec le littoral pontique," in *Sur les traces des Argonautes. Actes du 6e symposium de Vani (Colchide), 22–29 septembre 1990,* ed. O. Lordkipanidze and P. Lévêque (Paris, 1996), 21–50.

3.
O. Lordkipanidze, "The Golden Fleece: Myth, Euhemeristic Explanation, and Archaeology," *Oxford Journal of Archaeology* 20, no. 1 (2001): 1–38.

4.
Strabo, 11.2.19: "It is said that in their country gold is carried down by the mountain torrents, and that the barbarians obtain it by means of perforated troughs and fleecy skins, and that this is the origin of the myth of the golden fleece—unless they call them Iberians, by the same name as the western Iberians, from the gold mines in both countries." The passages of Strabo's *Geography* are from H. M. Hamilton's translation of 1854.

5.
The anthropological fieldwork was directed by Luba Botchorishvili in the 1940s. See L. Botchorishvili, "Okromtchedloba svanetshi," *Soobshcheniya Akademii Nauk Gruzii* 7, no. 5 (1946): 283–89. Otar Lordkipanidze, among others, considers the ethnographer's results reliable, most recently in O. Lordkipanidze, *Vani, une Pompéi géorgienne*, 60. In contrast, David Braund has warned of the fallibility of such field-work: *Georgia in Antiquity: A History of Colchis and Transcaucasian Iberia, 550 B.C.–A.D. 562* (Oxford, 1994), 24.

6.
D. Khakhutiashvili, *Iron-making in Ancient Colchis* (Oxford, in press): a translation of a monograph published in Russian in Tbilisi, 1987.

7.
European exhibitions include: A. Miron and W. Ortmann, eds., *Unterwegs zum Goldenen Vlies–Archäologische Funde aus Georgien* (Saarbrücken, 1995); I. Gambaschidze, A. Hauptmann, R. Slotta, and Ü. Yalçin, eds., *Georgien–Schätze aus dem Land des Goldenen Vlies–Katalog der Ausstellung des Deutschen Bergbau-Museums Bochum* (Bochum, 2001); *L'Or de la Toison d'Or: Trésors nationaux de la Géorgie*, exhibition at Musée des Arts asiatiques de Nice, June–September 2007; Chqonia, Kacharava, Lordkipanidze, and Kvirkvelia, *Medeas Gold: Neue Funde aus Georgien* at the Staatliche Museen zu Berlin, Altes Museum, Antikensammlung.

8.
E. Takaishvili, *Mogzauroba da arkeologiuri chanatserebi* [Travels and Archaeological Notes] (Tbilisi, 1907), quoted by O. Lordkipanidze, in *Vani, une Pompéi géorgienne*, 16–17.

9.
We have clear evidence that Colchis has been called "rich in gold" since antiquity. Indeed, a fourth-century B.C. anonymous epitaph in honor of the legendary King Aeëtes addresses him as the "possessor of Colchis rich in gold"; and Strabo (1.2.39), talking about the journey of the Argonauts, insists on the well-known presence of precious metals in the area: "Medea the sorceress is a historical person; and the wealth of the regions about Colchis, which is derived from the mines of gold, silver, iron, and copper, suggests a reasonable motive for the expedition, a motive which induced Phrixus also to undertake this voyage at an earlier date."

10.
For a history of the excavations up to 1995, see O. Lordkipanidze, *Vani, une Pompéi géorgienne*, 15–34 and his "Vani: An Ancient City of Colchis," 151–54.

11.
Many of these finds are discussed elsewhere in this volume.

12.
Pliny, *HN* 6.13: "Today the only town on the Phasis is Surium, which itself takes its name from a river that enters the Phasis at the point up to which we said that it is navigable for large vessels."

13.
Strabo, 11.2.17: "Above the aforesaid rivers in the Moschian country lies the temple of Leucothea, founded by Phrixus, and the oracle of Phrixus, where a ram is never sacrificed; it was once rich, but it was robbed in our time by Pharnaces, and a little later by Mithridates of Pergamum."

14.

V. Tolordava, "Un complexe cultuel des VIIIe–VIIe siècles à Vani," in *Le Pont-Euxin vu par les Grecs: Sources écrites et archéologie. Symposium de Vani (Colchide), septembre–octobre 1987*, ed. T. Khartchilava and É. Geny (Paris, 1990), 243–48.

15.

The presence of "sceptuchies" in the Colchian kingdom is attested in Strabo 11.2.18: "The great fame this country had in early times is disclosed by the myths, which refer in an obscure way to the expedition of Jason as having proceeded as far even as Media, and also, before that time, to that of Phrixus. After this, when kings succeeded to power, the country being divided into 'sceptuchies,' they were only moderately prosperous; but when Mithridates Eupator grew powerful, the country fell into his hands; and he would always send one of his friends as sub-governor or administrator of the country."

16.

D. Akhvlédiani, "Les tuiles estampillées de Vani," in *Le Pont-Euxin vu par les Grecs*, 283–85.

17.

O. Lordkipanidze, "Vani dans la structure du royaume colchidien," in *Le Pont-Euxin vu par les Grecs*, 189-318, esp. 293.

18.

D. Braund, *Georgia in Antiquity*, 146–47, expresses reservations.

19.

T. S. Qaukhchishvili, "Grecheskaya nadpis' na bronzovoy plitye is Vani," in *Mestnye etno-politicheskiye ob'yedinenya prichernomor'ya v VII-IV vv do n.e.: materialy IV simpoziuma, Tskhaltubo-Vani 1985* (Tbilisi, 1988), 248–63.

20.

C. Balandier, "Les défenses de la terrasse nord de Vani (Géorgie). Analyse architecturale," in *Pont-Euxin et Polis: Polis Hellenis et Polis Barbaron. Hommage à Otar Lordkipanidzé et Pierre Lévêque. Actes du 10e Symposium de Vani (Colchide), 23-26 septembre 2002*, ed. D. Kacharava, M. Faudot, and É. Geny (Besançon, 2005), 245–64.

21.

For the cult of the Mother Goddess in Vani and in Colchis, and its possible reflection on metalwork production, see A. M. Čkonia, "Le culte de la Grande Déesse dans l'orfèvrerie colchidienne," in *Religions du Pont-Euxin. Actes du 8e Symposium de Vani (Colchide)*, 1997, ed. O. Lordkipanidze and P. Lévêque (Besançon, 1999), 115–28.

22.

Lordkipanidze, *Vani, une Pompéi géorgienne*, 83–90.

23.

The pottery from the site of Vani, both Colchian productions and Greek imports, has been the subject of numerous studies. Among the most recent articles, see the following contributions to the 1987 Vani Symposium: M. Pirtskhalava, "La céramique colchidienne de Vani aux VIe–IVe siècles," 257–60; R. Poutouridze, "Les vases céramiques de Vani aux Ve–IVe siècles," 273–74; D. Kacharava, "L'importation de céramique peinte et de céramique noire lustrée à Vani (VIe–IVe siècles)," 275–78.

24.

Z. Januchevich, quoted by O. Lordkipanidze, in *Vani, une Pompéi géorgienne*, 89.

25.

Lordkipanidze, *Vani, une Pompéi géorgienne*, 47–49.

26.

G. A. Lordkipanidze, "Les autels du lieu-dit de Vani," in *Histoire et culture du monde antique*, ed. M. M. Kobylina (Moscow, 1977), 104–12.

27.

For a fuller discussion and photographs, see D. Kacharava and G. Kvirkvelia, "The Archaeology of Vani," in this volume.

28.

Lordkipanidze, *Vani, une Pompéi géorgienne*, 34–44.

29.

P. McGovern, *Ancient Wine: The Search for the Origins of Viniculture* (Princeton, 2003), 23-24; D. Cavalieri, P. E. McGovern, et al., "Evidence for *S. cervisiae* Fermentations in Ancient Wine," *Journal of Molecular Evolution* 57 (2003): 226.

30.

McGovern, *Ancient Wine*, 33–34.

31.

D. Goldstein, *The Georgian Feast: The Vibrant Culture and Savory Food of the Republic of Georgia* (Berkeley and Los Angeles, 1999), 26-28.

32.

E. Pellizer, "Sympotic Entertainment," in *Sympotica: A Symposium on the Symposion*, ed. O. Murray (Oxford, 1990), 178–79.

33.

P. Dupont, *Kvevri: Regards sur la culture du vin en Géorgie* (Ambériau, 2000), 15–17.

34.

G. Kipiani, "L'architecture des Ve-IVe siècles à Vani," in *Le Pont-Euxin vu par les Grecs*, 267–68.

35.

Braund, *Georgia in Antiquity*, 56, 130.

36.

Lordkipanidze, *Vani, une Pompéi géorgienne*, 117–22 and "Vani, ein antikes religiöses Zentrum," 395–97, pls. 86.6-87; C. Mattusch, *Classical Bronzes: The Art and Craft of Greek and Roman Statuary* (Ithaca, N.Y., 1996), 206–16, fig. 6.4, pl. 9.

37.

Mattusch, *Classical Bronzes*, 207–8.

38.

For a recent study of Vani's craftsmanship, see A. M. Čkonia, "L'artisanat d'art dans le développement des villes colchidiennes-Vani," in *Pont-Euxin et Polis*, 265–70.

39.

The interrelation between Colchian and Greek artistic production is studied by B. Deppert-Lippitz, "Interrelations between Greek Jewellery of the 6th and 5th centuries B.C. and Gold Finds from the Black Sea Region," in *Sur les traces des Argonautes*, 195–202.

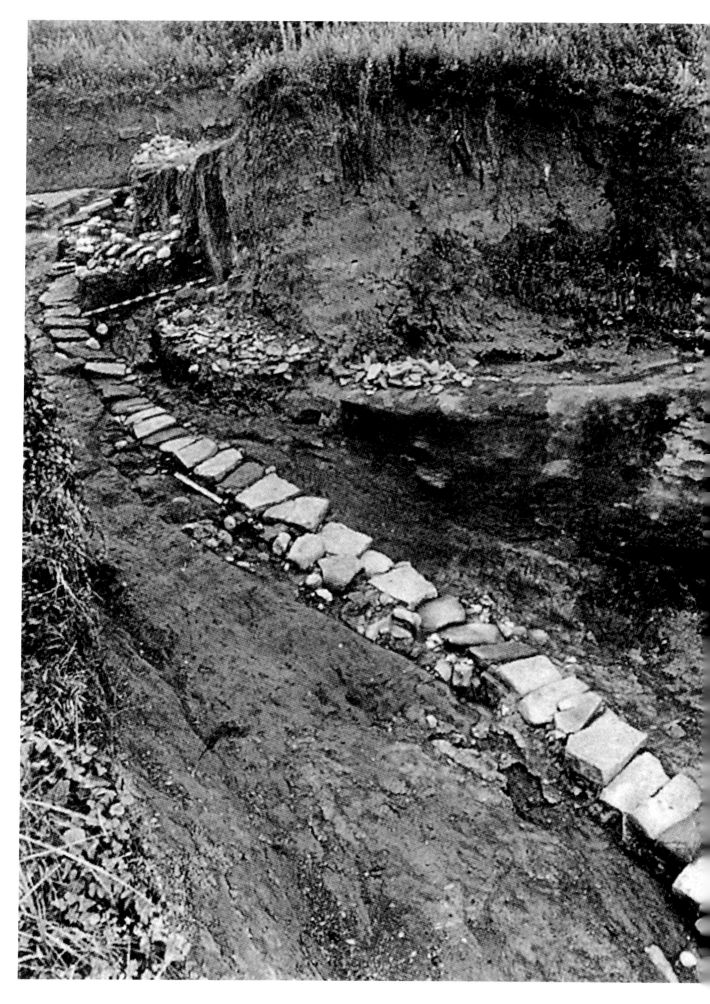

# The Archaeology of Vani
## Darejan Kacharava and Guram Kvirkvelia

Although the primary aim of this catalogue is to discuss the objects presented in the exhibition, this is also the appropriate context in which to introduce the archaeological finds unearthed at Vani from 1947 to the present. Indeed, because most of the existing reports have been written in Georgian with Russian summaries, this exhibition provides the occasion to make the information available to a much wider audience.

The site of Vani, in western Georgia, the ancient land of Colchis, is situated thirty kilometers northeast of Kutaisi, the country's second largest city. Located near the confluence of the Sulori and Rioni Rivers, the latter known in antiquity as the Phasis, the ancient town spread over three terraces (fig. 1) on a 200-meter-high hill with a commanding view over the fertile valley below and controlled the trade routes in the vicinity. Deep ravines, flanking the hill on two sides, served as natural defenses. The name of the hill comes from the family name of the nobles Akhvlediani who settled the area in the seventeenth century. Vani's ancient name is not known with certainty; scholars have argued that Surium/Sourion, mentioned respectively by Pliny (*HN* 6.11.13) and Ptolemy (*Geog.* 5.9.6), could have been the original name for the site.

This identification is mainly based on the phonetic similarity between the modern Sulori River and the Surium/Sourion reported by ancient writers. The occurrence of the name Souris in a Greek inscription dated to the end of the fourth or the beginning of the third century B.C., discovered during the 1985 excavations, increases the likelihood of the identification of Vani with Surium/Sourion, even if conclusive evidence has yet to be found.[1]

Large-scale archaeological excavations conducted at Vani since the 1940s have revealed architectural structures and noteworthy objects that confirm the long history of the site,[2] which was occupied uninterruptedly from the eighth century to the mid-first century B.C. (fig. 2). Its complicated and fascinating interrelationships with other cultures, its peculiar burial practices, and its religious life make it the paramount site for the study of Colchian history and culture.

In the early 1970s Professor Otar Lordkipanidze was able to identify, on the basis of collected data, four main phases in the development of Vani, each of them characterized by specific economic activities, burial rites, and relations with the outside world.[3] Thus far, his periodization has been confirmed by the ongoing excavations.

1. Sandstone slab pathway on the slope of the central terrace, connecting the lower and central terraces.

1. Ceremonial altar, 3rd–1st century B.C.
2. Remains of cult building, 2nd–1st century B.C.
3. Defensive walls, 2nd–1st century B.C.
4. Graves 12–14, 4th–3rd century B.C.
5. Remains of wooden temple, 5th–beginning of the 4th century B.C.
6. Defensive walls, 2nd–1st century B.C.
7. Graves 1–4, 3rd century B.C.
8. Sanctuary I, 3rd century B.C.
9. Sanctuary II with a pithos burial (Grave 18), 3rd century B.C.
10. Grave 17, second half of the 4th–beginning of the 3rd century B.C.
11. Grave 16, second half of the 4th–beginning of the 3rd century B.C.
12. Sanctuary III, 3rd century B.C.
13. Sanctuary IV with four metal figurines, 3rd century B.C.
14. Graves 20–24, 26, and 28, second half of the 4th century B.C.
15. "Smithery," late Hellenistic period.
16. Building with counterforts, 2nd–1st century B.C.
17. Temple complex, 2nd–1st century B.C.
18. Grave 25, first half of the 3rd century B.C.
19. Remains of buildings, 4th–3rd century B.C.
20. Remains of buildings, 4th–3rd century B.C.
21. Remains of a cult building with an altar, sacrificial pit, and Grave 27, 3rd century B.C.
22. Rock-cut pits of undefined function, 2nd–1st century B.C.
23. Sacrificial pits, 3rd–2nd century B.C.
24. Sacrificial pits, 2nd–1st century B.C.
25. Remains of buildings, 3rd–2nd century B.C.
26. Ceremonial altar, 2nd–1st century B.C.
27. Remains of wall, 3rd–1st century B.C.
28. Defensive wall, 4th–3rd century B.C.
29. Sanctuary paved with cobblestones, 4th–3rd century B.C.
30. Remains of paved road, 2nd–1st century B.C.
31. Ritual niches, 3rd–2nd century B.C.
32. Remains of building, 2nd–1st century B.C.
33. Pit with hoard from temple inventory, mid–1st century B.C.
34. Remains of defensive walls, 2nd–1st century B.C.
35. Remains of defensive walls, 2nd–1st century B.C.
36. Shaft, 2nd–1st century B.C.
37. Temple complex, 2nd–1st century B.C.
38. Channel, 2nd–1st century B.C.
39. Water-gate, 2nd–1st century B.C.
40. Remains of defensive walls, 2nd–1st century B.C.
41. Grave 11, mid–5th century B.C.
42. Sacred barn, 2nd–1st century B.C.
43. Grave 19, second half of the 4th century B.C.
44. Building with apse, 2nd–1st century B.C.
45. Grave 9, third quarter of the 4th century B.C.
46. Remains of building, 3rd–2nd century B.C. (with Grave 15)

47. Grave 10, second half of the 4th century B.C.
48. Monumental platform built of stone blocks, 2nd–1st century B.C.
49. Remains of buildings, 3rd–2nd century B.C.
50. Defensive walls, 2nd–1st century B.C.
51. Tower, 2nd–1st century B.C.
52. Tunnel cut in the bedrock, late Hellenistic period.
53. Defensive wall, mid–1st century B.C.
54. Round Temple, 2nd–1st centuries B.C.
55. Architectural complex of gate, 2nd–1st century B.C.
56. Defensive system with towers, a curtain wall, and barracks, 2nd–1st century B.C.
57. Graves 6–8, second quarter of the 5th–first half of the 4th century B.C.

2. General plan of the Vani site.

N

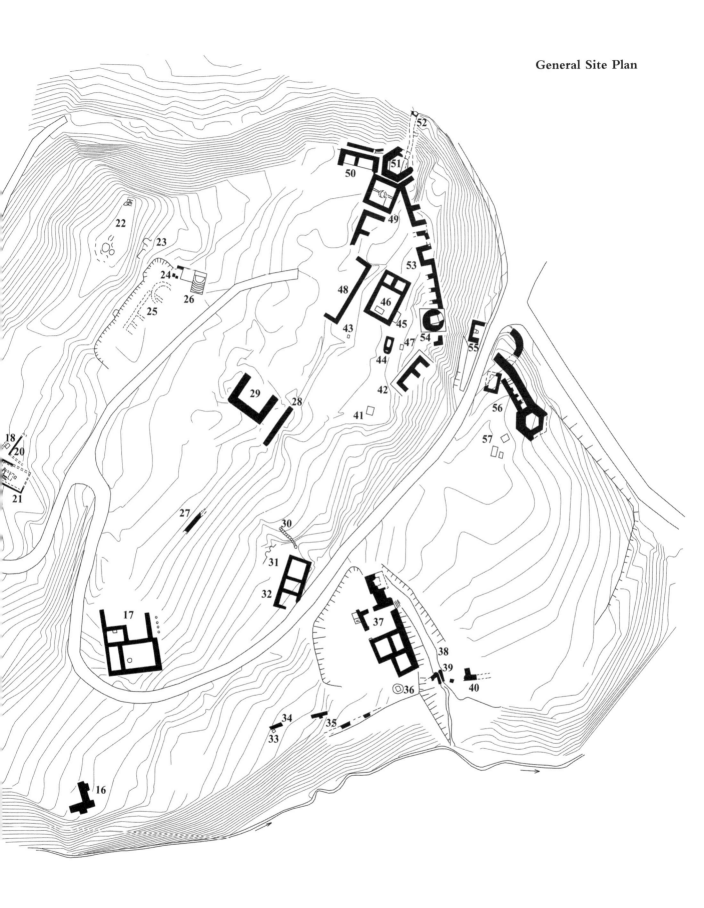

## Phase 1

The first phase dates from the eighth to the seventh century B.C., a period during which Vani may have functioned as a major cult center for the region.[4] The dearth of architectural and archaeological evidence from this period, however, requires cautious rather than conclusive statements. Nevertheless, at this early stage, the upper and lower terraces were both part of the settlement, as finds of pottery sherds and bronze arrowheads demonstrate.[5] A complex occupying an area of about 90 square meters on the northeast slope of the central terrace belongs to this first phase and has been interpreted as having been used for ritual purposes. Of this complex, fragments of plaster, most probably meant to decorate wooden walls, and an *eschara* containing pottery sherds and animal bones (mostly cattle and pigs) have been found. Terracotta figurines of animals and fantastic creatures made according to a ritual-votive design and fragments of small-sized clay altars were found in an ash-pile layer. Together with numerous animal bones, they attest to the presence of cult rituals performed in the area.

In addition, a structure interpreted as an altar, built of roughly hewn sandstone ashlars, was found on the northeast slope of the central terrace. The pottery associated with it dates mainly to the pre-Classical period, but it does not provide conclusive evidence for the date of the altar itself, which is still rather problematic.[6]

The pottery characteristic of this first phase was wheel-made, well-baked, black-fired, and polished on the surface. The vessels with fluted bodies and flat bases, and the tapered drinking cups, so common in Vani, find close comparisons in the pottery production of other contemporary Colchian sites (fig. 3).[7] The handles of these vessels are generally decorated with horn-like appliqués, while geometric patterns (concentric circles, spirals, wavy lines, conic knobs, hatched chevrons, and notches) cover the polished surfaces of their bodies.

Four-footed figurines of fantastic creatures with multiple heads on both sides of the body and kantharos-like vessels with arched handles stand out as atypical of the contemporary Colchian pottery production (fig. 4). They have been identified as the results of pre-colonial Greek contacts, local products inspired by Greek

3. Pottery shapes from Phase 1 at Vani (after O. Lordkipanidze, "Über zwei Funde aus Wani," *Achäologischer Anzeiger*, 1995, fig. 3).

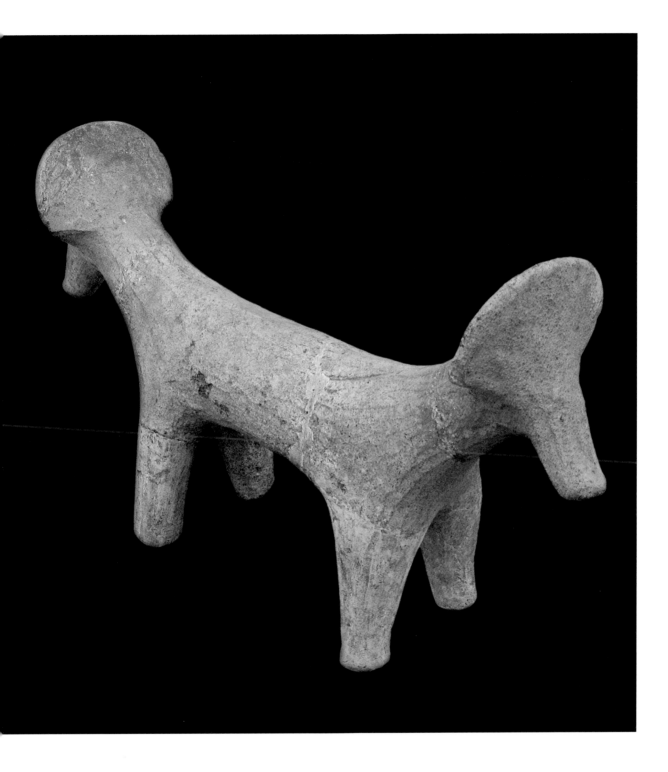

4. Figurine representing a fantastic two-headed creature.
Terracotta, H. 14.8 cm, L. 26.6 cm. Phase 1, 8th–7th century B.C.
Georgian National Museum.

prototypes;[8] no Greek vessel has yet been found in Vani or elsewhere in Colchis in a Phase 1 context.

## Phase 2

The second phase starts at the end of the seventh or beginning of the sixth century and lasts until the first half of the fourth century B.C. (fig. 5). All three terraces on the hillside show traces of settlement: wooden structures, sacrificial altars cut into bedrock, and rich burials attest to the importance of Vani in Colchian history of this period. In particular, the burials, notable for the splendor of their goods, differ sharply from those revealed in other parts of Colchis. They show close parallels only with the rich graves excavated in Sairkhe, a site in northeastern Colchis.[9] The drastically different funerary rites adopted in Vani, both in terms of burial practices and in the repertoire of grave goods, indicate the presence on the site of a group of individuals socially distinct from the rest of Colchian society. The deceased who rest in the rich graves of Vani and Sairkhe may have belonged to a local elite that ruled over an administrative district of the Colchian kingdom.[10] If we accept this hypothesis, we can then infer that Vani functioned in this period as the "capital" of one of the key political-administrative units in the kingdom of Colchis.

The architectural remains of this phase are rather scanty. This absence of monumental architecture can be explained by the prevalence of wooden structures in Vani, as well as in the rest of Colchis, that left almost no traces on the ground. The best-preserved complex of this period occupies an area of 600 square meters on the upper terrace (fig. 5, no. 2). It includes a wooden construction with a large courtyard, thought to be for ritual

1. Ritual channels and pits, Classical period.
2. Remains of wooden temple, 5th–beginning of the 4th century B.C.
3. Grave 11, mid–5th century B.C.
4. Graves 6–8, second quarter of the 5th–first half of the 4th century B.C.
5. Structure, built of white stone, 5th–4th century B.C.

N

5. General plan of the Vani site. Phase 2.

3 □

4 ◇
□ ˑ

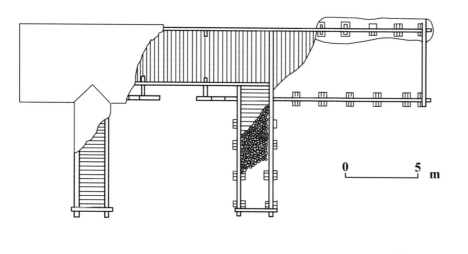

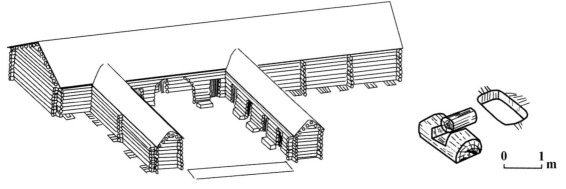

6. Wooden temple complex. 5th–beginning of the 4th century B.C.
(after O. Lordkipanidze, "Vani–ein antikes religiöses Zentrum im
Lande des Goldenen Vlieses [Kolchis]," *Jahrbuch des Römisch-
Germanischen Zentralmuseums, Mainz* 42, Jahrgang 1995 [1996],
fig. 4).

activities, and an associated structure in which to store the offerings (fig. 6). Interpreted as a temple to an unknown divinity because of its ritual courtyard, the structure was destroyed by fire sometime at the end of the fifth or beginning of the fourth century B.C. The main building of the complex rested directly on bedrock and was encircled on its southeast, south, and southwest sides by an earlier channel. On these sides, a pebble fill, strengthened by transverse timbers and overlaid with an earth-beaten clay pavement, was laid as a substructure for leveling the area. The building's foundations were cut directly on the rock and filled in with timbers. Wall beams overlaid the foundation cuttings, and clay plastering covered the whole structure. Many fragments of this plastering, most of them still bearing impressions of wooden beams, have been found on site. The north and south walls, 2.5 meters thick and preserved for a length of 8 meters, were both built using a timber frame-work filled in by a series of transverse and longitudinal beams. The space between the beams was filled by clay over a pebble-stone layer, while the intersections of beams were fastened with mortises. The presence of iron nails at the southeastern area of the excavation may be evidence for the use, at this corner of the build-ing, of a different technique for the substructure. The west wall was 5 meters thick; however, between the two series of parallel rock cuts defining its foundations, there is no fill, which suggests that the wall had an empty space between its two faces. In this area, traces of a floor beam, apparently supporting a wooden platform, have been found. Since there are no visible traces on the ground of an eastern wall, it has been supposed that the building was open

to the east, with a U-shaped plan. Yellowish beaten clay constituted its flooring, and an underlying gray layer remains from an earlier, pre-Classical occupation of the area.[11]

In addition to the complex with the wooden structure, traces of two badly damaged stone structures were found on the upper terraces of the hill (fig. 5, no. 5). This is the first phase in the history of Vani in which stone structures appear. Both were built of white limestone and sandstone, of which only two to three courses of two walls remain up to a length of 2.10 meters. Stratigraphic data allows us to date one of the structures to the beginning of the fourth century B.C.[12] The other rectangular construction, built of white stone with pebble foundations and a rammed-clay floor, dates to the fifth and fourth centuries.[13]

To the north of the wooden temple, on the upper terrace, sits a rock-cut complex, possibly used for cult activities.[14] It consists of two intersecting channels, two pits, and a cave (fig. 5, no. 1). One of the channels has a northeast–southwest orientation (L. 26 m), while the other runs northwest–south-east (13 m); their maximum depth is 2.70 meters. The two pits connecting the channels are rather shallow (0.30 m deep), and the cave, which narrows drastically toward the southeast, has not yet been fully cleaned.

Graves 6, 7, 8, and 11 (fig. 5, nos. 3 and 4), dated to this second phase, are remarkable for the richness of their grave goods: numerous gold, silver, bronze, and clay wares demonstrate their high artistic value. No necropolis has been identified: there-fore it seems plausible that the deceased were buried near their dwellings.

During this phase, local pottery continued earlier traditions of shape and ornament, as well as technology. But new shapes were also developed, such as pithoi, jugs with a tubular handle, and various types of drinking cups and bowls, all attesting to the extensive development of viticulture and wine-making (fig. 7).[15] All these shapes find close comparisons in contemporary sites throughout western Georgia. Noteworthy are the large bronze situlae with decorated handles characteristic of Colchian culture.[16]

The gold jewelry found in the graves is remarkable for both its quantity and quality, as well as for the originality of its artistic forms.[17] Almost all these ornaments display stylistic and technological unity, with an abundant use of granulation as one of their most notable features.[18] The production of silver ornaments was also important. It is interesting to note that comparable silver jewelry has been found only within western Georgia.[19] Jewelry in Vani reflects what Greek and Roman literary sources said about Colchis being rich in gold. Moreover, the rather abundant silver jewelry found in the graves show that the country was rich in silver, too, as was also noted by Classical authors (e.g., Strabo, *Geog.* 1.2.38).

The second phase in Vani is marked by the appearance of Greek imports: painted, black-glazed, and plain pottery; bronze, silver, and glass vessels; signet rings and beads. Among the amphorae found at the site, products of Chios, Lesbos, and Thasos have been identified.[20] A sherd of a Chian chalice and a few fragments of Athenian Little Master cups are among the earliest imports of fine pottery found at Vani.[21] Black-glazed earthenware of Attic origin considerably outnumbers

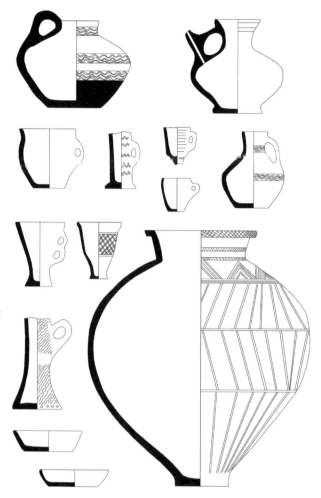

painted pottery.[22] Included in this group of imports are polychrome glass vessels. The provenance of two unique vases from Grave 11 (mid-fifth century B.C.) is so far unknown, though the brown color and the style of decoration may point to western Iran or Mesopotamia. Core-formed vessels—three amphoriskoi and an oinochoe—from Grave 6 (first half of the fourth century B.C.) are thought to be from Rhodes. A rod-formed kohl-tube from the same grave has been connected to a west Iranian

7. Pottery shapes and decoration from Phase 2 at Vani (after O. Lordkipanidze, "Über zwei Funde aus Wani," *Achäologischer Anzeiger*, 1995, fig. 5).

workshop (fig. 8).[23] Some bronzes, probably produced in the workshops of Athens, increase the number of imports from Greece,[24] as do several gems. Among the glyptic materials found at the site are late Archaic gems of Ionian manufacture, as well as Attic and West Greek signet rings, and an amber intaglio of orientalizing style.[25] Finally, a gold pectoral with inlaid decoration, from Grave 6, is rendered in a style reminiscent of the Egyptianizing art of the Achaemenid period.

**Phase 3**

The third phase in the history of Vani spans approximately from the second half of the fourth to the first half of the third century B.C. (fig. 9). By the mid-fourth century, both the wooden constructions and the ritual channels of the upper terrace had stopped functioning and the area next to them was occupied by graves. The same happened on the central terrace, where graves obliterated earlier cult constructions and, in turn, were themselves covered by constructions of later

8. Glass kohl-tube found in Grave 6. Phase 2, first half of the 4th century B.C. Georgian National Museum.

1. Graves 12–14, 4th–3rd century B.C.
2. Graves 1–4, 3rd century B.C.
3. Sanctuary I, 3rd century B.C.
4. Sanctuary II with a pithos burial (Grave 18), 3rd century B.C.
5. Grave 17, second half of the 4th–beginning of the 3rd century B.C.
6. Grave 16, second half of the 4th–beginning of the 3rd century B.C.
7. Sanctuary III, 3rd century B.C.
8. Sanctuary IV with four metal figurines, 3rd century B.C.
9. Grave 20, second half of the 4th century B.C.
10. Grave 21, second half of the 4th century B.C.
11. Grave 22, second half of the 4th century B.C.
12. Grave 23, second half of the 4th century B.C.
13. Grave 24, second half of the 4th century B.C.
14. Grave 26, second half of the 4th century B.C.
15. Grave 28, second half of the 4th century B.C.
16. Grave 25, first half of the 3rd century B.C.
17. Remains of buildings, 4th–3rd century B.C.
18. Remains of buildings, 4th–3rd century B.C.
19. Remains of cult building with Grave 27, 3rd century B.C.
20. Sanctuary paved with cobblestones, 4th–3rd century B.C.
21. Defensive wall, 4th–3rd century B.C.
22. Grave 19, second half of the 4th century B.C.
23. Grave 15, first half of the 3rd century B.C.
24. Grave 9, third quarter of the 4th century B.C.
25. Grave 10, second half of the 4th century B.C.

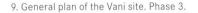

9. General plan of the Vani site. Phase 3.

N

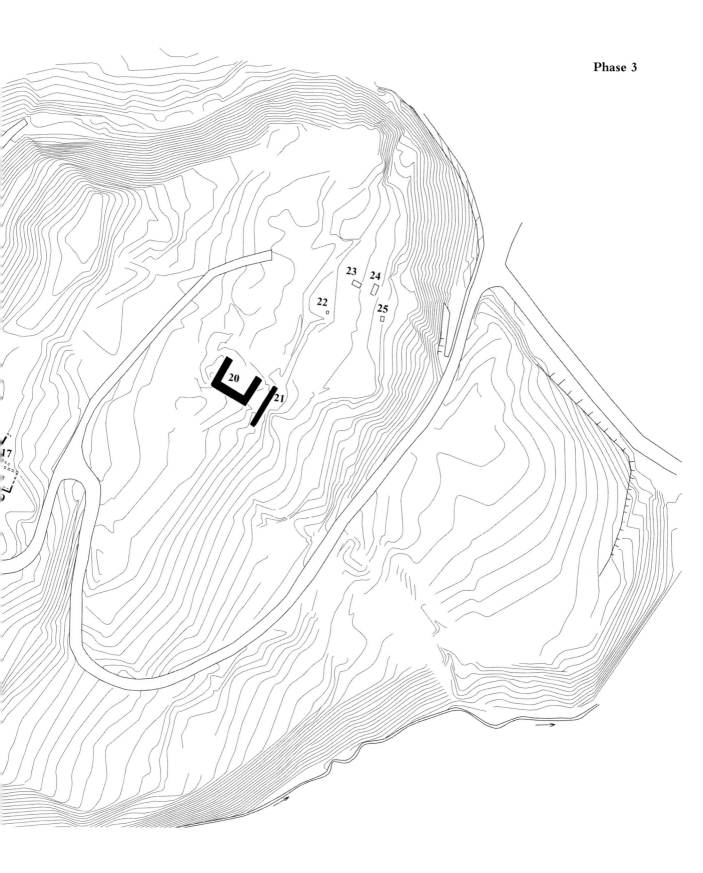

10. Sanctuary paved with cobblestones. 4th–3rd century B.C.

periods. The spread of a new burial rite, interment in pithoi, in Vani and its vicinity might be explained as a result of changes in the ethnic character of the population, related to the activities of eastern tribes of Colchis. It may be that in this period Vani rulers gained a new measure of independence because of the progressive weakening of the Colchian kingdom.[26]

It was precisely at this time that stone architecture eclipsed the use of timber as a main building material. Several structures are connected with this phase: a monumental wall, a cobblestone complex, a U-shaped construction on the central terrace, U-shaped sanctuaries on the hilltop, and a clay mound (13 x 17 m) on the upper terrace originally encircled with sandstone slabs. According to the stratigraphic data, this last feature was built as early as the first half of the third century B.C.[27]

The cobblestone complex probably had religious connections (fig. 9, no. 20). It was composed of a pavement and walls surrounding it on three sides, leaving the northern side open (fig. 10). The latter feature was quite unusual in Vani's architectural complexes, where the eastern side was the one usually left open.[28] The floor, with its four shallow pits possibly designed for libations, occupied an area of 40 square meters.

A monumental wall (W. 3.5 m; L. 22 m; preserved H. 6 m) was excavated southeast of the cobblestone complex. The core of the wall, consisting of rubble, was strengthened with timber lacing. Several holes are visible in the rubble, possibly post-holes for protruding transverse beams. In its lower portion the wall was built of sandstone slabs; rubble and timbers were erected

on top of these.[29] Since the most likely function of a wall this size would have been defense (fig. 9, no. 21), it seems reasonable that at least this part of the city was fortified.

Traces of another U-shaped construction are visible on the easternmost edge of the central terrace. The preserved parts of the west and north walls, together with cuttings in the bedrock for the foundations, suggest that the building was open to the east. It was completely obliterated in the late Hellenistic period by the so-called Round Temple (fig. 2, no. 54).[30]

Four cult structures, with similar U-shaped plans facing east, came to light on the upper terrace of the site (fig. 9, nos. 3, 4, 7, 8). All four were built on platforms, cut into the bedrock and surrounded by rock-cut walls on three sides. Shallow ditches, apparently for draining rainwater, surround these complexes on the three sides. The structures are built of adobe walls erected on a single-course stone socle.[31] Given the frequent use of U-shaped buildings at Vani, it seems possible to establish a relationship between this peculiar plan type and a possible religious function that makes the U-shaped east-facing building type a specific feature for sacral architecture. It is worth remembering that the wooden temple dating from Phase 2 had the same kind of plan.

Among the large number of graves belonging to this phase, traditional and new elements coexist in the funerary rites documented on the site. Most of the graves are pit burials cut into the bedrock, typical of the earlier phase of the settlement. In the first half of the third century B.C., interment in clay vessels and stone cists came into practice.

Data collected in recent years may argue for the presence of another burial practice at Vani. Dated around the middle to second half of the fourth century B.C., this is characterized by the presence of a raised platform along the south wall of the grave-pit specifically built to host the bodies of servants and pet animals interred with the deceased. Among the new elements appearing during this phase, the custom of placing coins—sometimes as Charon's obol—and the presence of amphorae and of silver belts in the burials are the most notable.[32] Interestingly, all the U-shaped buildings discovered on the upper terrace and discussed above seem to be connected with either a group of graves or a single burial, thus proving the existence of a funerary practice in Vani that finds no parallels elsewhere in Colchis.

In this phase, some innovations equate to variants in the production of local pottery, otherwise solidly rooted in tradition. Indeed, together with more traditional shapes, ornamentation, and techniques typical of Early Classical Colchian production, vessels of new types, decorated with new morphologic features and ornamental motifs, appear on the site.[33] Yet the greatest innovations were the emergence of a Greek pottery shape, the amphora (fig. 11), and the beginning of tile production.[34]

Variation in the shape and decoration of jewelry produced during this phase also demonstrates increasingly close relations between Vani and the rest of the Greek world.[35] While traditional trade and economic contacts with the Greek world (Athens, Chios) continued to flourish, new contacts were opened with centers such as Mende, Sinope, Thasos, and Heraclea. Persian goods appear among the finds in Vani, mostly metal and glass vessels,

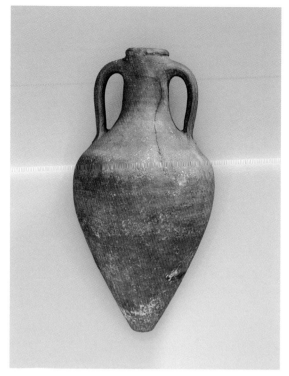

and the discovery of a double-bull column capital of Achaemenid type is also notable.

The data collected at Vani for this third phase shows a definite influence of Greek culture on building techniques, artisanship, and burial practices. In this connection, a Greek inscription on a bronze plaque, dated by its letter forms to the end of the fourth or beginning of the third century B.C., assumes particular relevance. The technique used to carve the lettering and the flawless Greek in the text suggest that the inscription itself is of Greek workmanship.[36] The use of Greek language and lettering in a local document of official character is particularly interesting, and suggests, as do contemporary royal stamps (*basilike* in Greek letters) on Colchian tiles, that

11. Colchian Amphora from Grave 9, locally produced. Phase 3, third quarter of the 4th century B.C. Georgian National Museum.

Greek influence affected mostly the upper levels of the society; its impact on the rest of the population seems to have been considerably less.[37]

## Phase 4

Phase four begins with drastic changes in the city, in the mid-third century B.C., when the practice of burying individuals of the upper strata of the society inside the town ceased, and the settlement seems to have changed its function altogether. Excavations have thus far unearthed only buildings with probable religious functions (temples, altars, sanctuaries, shrines, sacrificial grounds); no dwelling has yet been found (fig. 12). Considering this data, Otar Lordkipanidze has argued that in this fourth phase Vani should be interpreted as a temple city, possibly to be identified with the sanctuary of Leukothea mentioned by Strabo (*Geog.* 11.2.17).[38] The recent discovery of a hoard of objects usually associated with a temple inventory (candelabra, lamps, a basin, an incense burner, legs of a couch, and three stands), deposited in a rock-cut pit, seems to reinforce the theory that the city had a prominent cult character (fig. 12, no. 17; fig. 13). Further study of these extraordinary finds is forthcoming.

During this last phase, dated from the second half of the third to the middle of the first century B.C., defensive walls, towers, a small gate with an adjacent shrine, and a large temple complex were built on the lower terrace (fig. 14, I). On the central terrace, an architectural complex arose in the south, a Round Temple with a sacred barn in the east, and a twelve-stepped altar with a treasury in the west (fig. 12, nos. 3, 4, 7, 12 and fig. 14, II–IV). On the hilltop, a ceremonial altar and numerous sacrificial platforms cut into the bedrock have been excavated (fig. 12, no. 1 and 14, V).

A defensive system, parts of which remain visible on all three terraces, protected the city in this period. On the upper terrace, defensive walls of adobe bricks erected on stone socles, which sometimes obliterated earlier burials, appear to belong to the casemate type.[39] The defensive line, well preserved in the southern part of the lower terrace, consists of a gate, two towers, and a curtain wall (fig. 12, nos. 36–39 and fig. 15). The gate is of dipylon type, with a portcullis and a two-leaved door that extend for a total width of 2.40 meters. A stepped threshold indicates that the gate was intended for pedestrians only. A pedestal for a statue (fig. 15, no. 1) stands outside the gate at the eastern part of the wall. A protector-goddess statue might have been erected there, as suggested by an inscription scratched vertically on the wall, which reads: "I pray thee, ruler-goddess."

Beyond the gate a rectangular courtyard (7 x 3.20 m) opened on its south end. Its western half, adjacent to the gate, had a U-shaped plan and was built of rusticated ashlars, arranged according to a pseudo-isodomic technique (masonry with courses of different heights).[40] Excavations inside the structure revealed collapsed mud-brick walls and remains of charred wooden beams. In all probability, the latter belonged to the ceiling, which served as floor for a second story, presupposed by the existence of the portcullis. Underneath the debris, twenty-three clay vessels (two-handled jugs, bowls, and amphorae) were found, surrounding an altar adjacent to the western wall. These findings suggest a possible use of the structure for religious purposes. A causeway paved with small cobblestones (W. 2 m; L. 18 m) is attached to the inner court from the south. A stone basin found at one end of the cobble-way and probably used for

1. Ceremonial altar, 3rd–1st century B.C.
2. Remains of cult building, 2nd–1st century B.C.
3. Defensive walls, 2nd–1st century B.C.
4. Defensive walls, 2nd–1st century B.C.
5. "Smithery," late Hellenistic period.
6. Building with counterforts, 2nd–1st century B.C.
7. Temple complex, 2nd–1st century B.C.
8. Rock-cut pits of undefined function, 2nd–1st century B.C.
9. Sacrificial pits, 3rd–2nd century B.C.
10. Sacrificial pits, 2nd–1st century B.C.
11. Remains of buildings, 3rd–2nd century B.C.
12. Ceremonial altar, 2nd–1st century B.C.
13. Remains of wall, 3rd–1st century B.C.
14. Remains of paved road, 2nd–1st century B.C.
15. Ritual niches, 3rd–2nd century B.C.
16. Remains of building, 2nd–1st century B.C.
17. Pit with composed of temple-inventory hoard, mid–1st century B.C.
18. Remains of defensive walls, 2nd–1st century B.C.
19. Remains of defensive walls, 2nd–1st century B.C.
20. Shaft, 2nd–1st century B.C.
21. Temple complex, 2nd–1st century B.C.
22. Channel, 2nd–1st century B.C.
23. Water-gate, 2nd–1st century B.C.
24. Remains of defensive walls, 2nd–1st century B.C.
25. Sacred barn, 2nd–1st century B.C.
26. Building with an apse, 2nd–1st century B.C.
27. Remains of building, 3rd–2nd century B.C.
28. Monumental stone-block platform, 2nd–1st century B.C.
29. Remains of buildings, 3rd–2nd century B.C.
30. Defensive walls, 2nd–1st century B.C.
31. Tower, 2nd–1st century B.C.
32. Tunnel cut in the bedrock, late Hellenistic period.
33. Defensive wall, mid–1st century B.C.
34. Round Temple, 2nd–1st century B.C.
35. Architectural complex of the gate, 2nd–1st century B.C.
36. Tower, 2nd–1st century B.C.
37. Barracks, 2nd–1st century B.C.
38. Curtain wall, 2nd–1st century B.C.
39. Polygonal tower, 2nd–1st century B.C.

12. General plan of the Vani site. Phase 4.

N

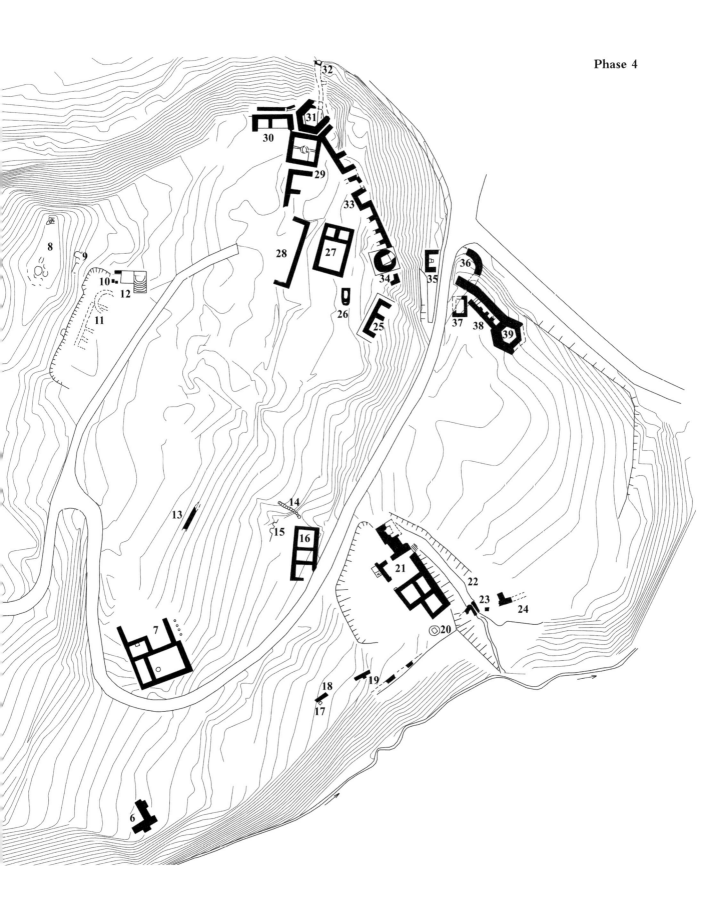

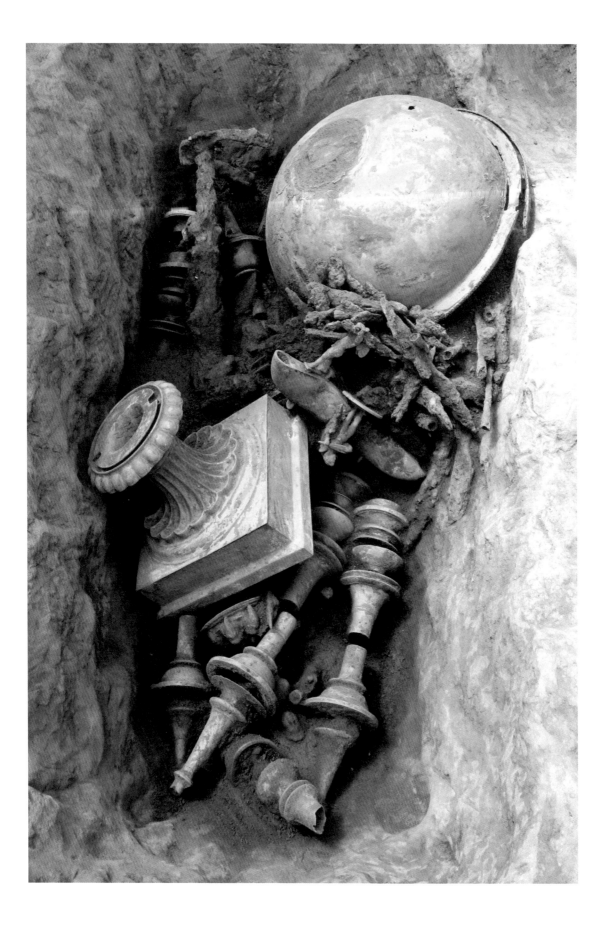

13. Hoard of objects, mostly of bronze, deposited in a rock-cut pit from the 2007 excavation season. Phase 4.

14. Plan of main cult structures. Phase 4 (after O. Lordkipanidze, "Vani: An Ancient City of Colchis," *Greek, Roman and Byzantine Studies* 32, no. 2 [1991]: fig. 7.I):
I. Temple complex on the lower terrace: (1) tower-like building; (2) sacrificial ground; (3) stepped altar; (4) colonnaded hall; (5) hall of offerings; (6) shaft; (7) water-gate; (8) ritual channel. II. Round Temple. III. Temple complex on the central terrace: (1) chamber with an altar, bronze vessels, and amphorae; (2) partially destroyed chamber; (3) chamber with

an altar; (4) ritual channel; (5) ritual pits; (6) colonnaded altar with steps. IV. Ceremonial altar on the central terrace.
V. Ceremonial altar on the hilltop.

15. Plan of the city gate and fortification system. Phase 4 (after O. Lordkipanidze, "Vani-ein antikes religiöses Zentrum im Lande des Goldenen Vlieses (Kolchis)," *Jahrbuch des Römisch-Germanischen Zentralmuseums Mainz* 42, no. 2 [1995]: fig. 8):
(1) postament for a statue of the protecting goddess;
(2) portcullis; (3) door; (4) altar and inner court; (5) stone basin; (6) causeway; (7) tower; (8) curtain wall; (9) polygonal tower; (10) barracks; (11) casemates.

containing the blood of sacrificed animals, reinforces the argument for a sacral character of the gate complex. The placement of a sanctuary next to the gate and the divine protector statue outside it, the erection of an altar against the sanctuary wall, and the unusually short distance between the portcullis and the two-leaved door stand out as local variations on the otherwise common prototype for Hellenistic gate complexes.

The east side of the gate is flanked by a semicircular tower which connects to a second, polygonal tower by means of a long curtain wall (L. 15 m) of the casemate type (fig. 15). Both towers were filled with a mixture of clay and crushed sandstone, designed to add to the towers' resistance to battering rams. The finding of a limestone pilaster capital and bronze plates for window shutters suggest that the polygonal tower may have been a three-storied structure since these elements are typically found on the third floor.[41]

On the hilltop, the main structure is a monumental ceremonial altar, built as early as the end of the third century or the beginning of the second century B.C. (fig. 14, V). Its rectangular platform and the eight-stepped staircase arranged at the center of its eastern wall make it a rarity in Hellenistic architecture (fig. 16).[42]

The central terrace is characterized by a large number of monumental buildings. An altar,

16. Monumental ceremonial altar on the upper terrace. Phase 4.

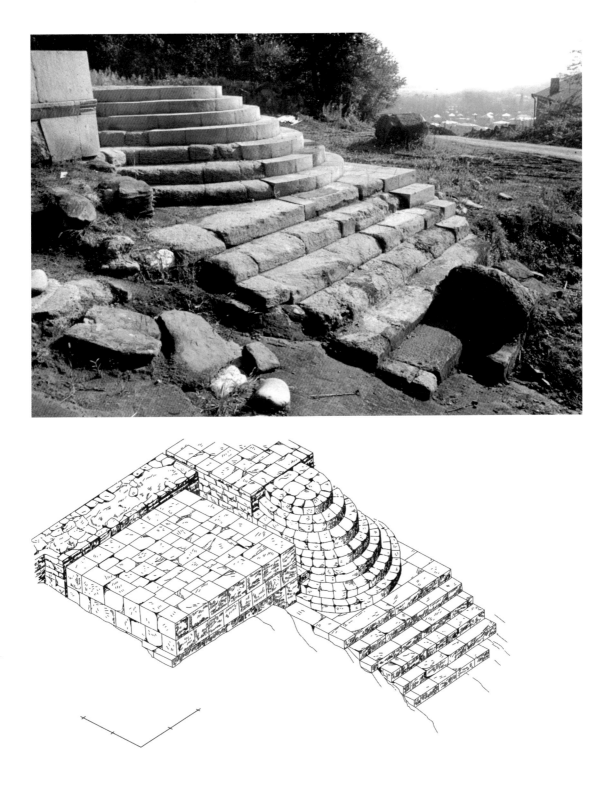

17a, b. Ceremonial twelve-stepped altar. Phase 4 (b. after
M. Pirtskhalava and G. Kipiani, "The Results of Fieldwork
Carried Out in the Western Part of the Central Terrace in
1978–1981 [Twelve-stepped Altar Area]," in *Vani VIII* [Tibilisi,
1986], fig. 38).

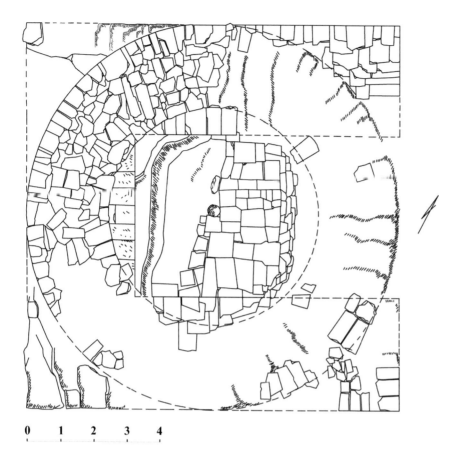

0    1    2    3    4

located at the west, is composed of a platform and an adjoining staircase made of six rectangular and six rounded steps (figs. 14, IV and 17a, b). Its north–south orientation deviates both from Hellenistic architectural norms, where the east–west orientation of monumental altars is obligatory, and the architectural practice common in Vani, where an east–west orientation seems to have been preferable.[43] The other buildings of the central terrace seem to share the same religious function.[44]

In the northern part of the central terrace, the so-called Round Temple (outer Diam. 10 m, inner Diam. 5.4 m), built of sandstone, was erected over the above-discussed U-shaped building of Phase 3 (fig. 2, no. 54; fig. 12, no. 34; and fig. 18). Its cult character is established by the discovery of a grooved sacrificial table. In all probability, the dozen trapezoid plaques (measuring 0.90 x 0.95 m) that were excavated nearby represent parts of a coffer-type roof structure. Round cult buildings were common in Greece, the Near East, and Central Asia in the Hellenistic period. Limestone architectural details in the shape of a hydria-like vessel and three lion's heads, discovered in the area, might belong either to this very temple or to another nearby monumental construction. A sacred barn, excavated a few meters from the Round

18. Plan of the Round Temple. Phase 4.

Temple and containing amphorae with wheat and millet inside the vessels, is thought to be connected with it.[45]

Another large architectural complex, measuring about 800 square meters, occupies the lower terrace. It consists of a tower, a central hall, a sacred barn, a sacrificial ground, a stepped altar, a ritual channel, a "water-gate," and a shaft (investigated up to a depth of 20 meters) (fig. 14, I). The central hall has three doors; the northwestern one opens up to the sacrificial ground. The other two doors seem to function as main entrances: the area in front of the western doorway is paved with sandstone slabs, while a staircase leads up to the eastern one. Various altars and two column bases of the so-called Attic type were found in the hall. A compartment divided from the hall by means of a massive blind wall has been interpreted as a sacred barn because of the clay vessels, some of which were filled with cereals, found inside. A ceremonial stepped altar adjoined the northwestern part of the columned hall from outside, a solution not typical for Hellenistic buildings, where the altar is usually freestanding. The function of the shaft (well, cistern, or sacrificial pit) is not yet defined. The presence in it of ashlars and mud bricks demonstrate that it functioned contemporaneously with the entire complex. The cult practiced in this temple is still a matter of dispute.[46]

A pathway of sandstone slabs was found on the slope of the central terrace, apparently connecting the lower terrace with the central one (fig. 1).

The material of this period is fairly diverse: architectural details and fragments of friezes with relief ornaments, earthenware of both local and Greek production, and fragments of bronze statues stand side by side with graffiti and signs on walls and pottery, arms, and coins. Noteworthy is a rather large collection of bronze sculpture found at the site. It seems that in the second and first centuries B.C. the city was embellished with statues of different sizes, from smaller than life-size to monumental. A torso of a youth in a classicizing style, however, is the real gem of this collection.[47] The numerous finds of patches, cuttings of sheet bronze and bars, and bronze slag attest to the casting of at least some of the bronze statues on the spot. Moreover, remains of a foundry for casting bronze statues, dated to the end of the second or beginning of the first century B.C., were discovered on the central terrace of the site.

The process of Hellenization is also evident in the pottery production: fish-plates and kantharoi, typically Greek shapes, were introduced into the local repertoire. The technique of rustication flourished in stone-cutting, and Greek technology penetrated also in weaving, as attested by the numerous finds of loom-weights for vertical looms. Hellenistic influence is evident in the graffiti on the pottery and on stone walls, as well as in the spread of the late Attic weight system.

According to the archaeological data, Vani was destroyed in the mid-first century B.C. Two destruction levels within a rather short period are visible. If Vani were indeed the sanctuary of Leucothea, then these destructions could be traced back respectively to Pharnaces, king of Bosphorus, and Mithridates VII, ruler of Pergamon, both of whom attacked the city, the one ca. 49 B.C. and the other ca. 47 B.C. (Strabo, Geog. 11.2.17).

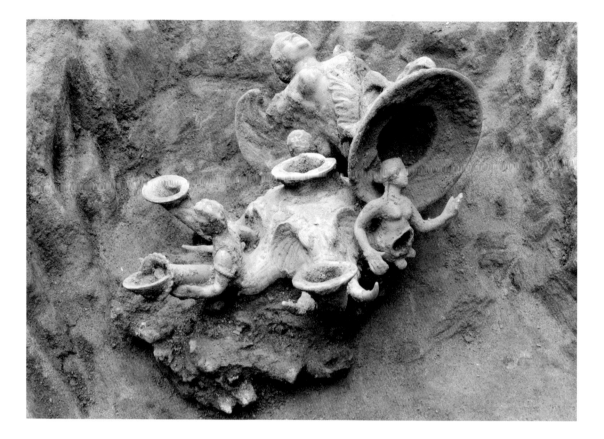

The site, however, was not completely abandoned after these destructions. Archaeological remains from Roman times are, thus far, small in number but present: a robbed burial was excavated in the northwestern part of the hilltop. The deceased was buried in a bronze sarcophagus with four ring-shaped handles suspended from lion's heads. On the basis of a gold finger ring found near the sarcophagus, and of some coins, the grave was dated to the third century A.D. Excavations on the hilltop also revealed the remains of a warrior's grave dated to the ninth or tenth century. A church and burials without finds related to them, and the remains of a pottery kiln, date from the medieval period.

Together with the excavations of the city, a planned study of the territory adjoining Vani is underway, mainly to create a complete archaeological map of the area. Most of the settlements identified in the surrounding area date to the Early Iron Age (eighth–seventh centuries B.C.). This is a period of a "demographic explosion" in Colchis and of large-scale, economic development of the Rioni valley area. These settlements continued to exist and developed concurrently with Vani. Of these sites, the best-studied are Dapnari, Dablagomi, Mtisdziri, Tsikhe-Sulori, and Saqanchia.[48] Excavations in Vani continue (fig. 19).

19. Unearthing of a bronze lamp during the 2007 excavation season.

## Notes

**1.**

The inclusion of at least one more place name in this inscription also precludes us from identifying the name of ancient Vani with certainty. See T. Qaukhchishvili, "A Greek Inscription on a Bronze Plaque from Vani," in *Local Ethno-political Entities of the Black Sea Area in the 7th-4th Centuries B.C.* (Tbilisi, 1988), 248–63 [in Russian]; J. Vinogradov, *Pontische Studien* (Mainz, 1997), 577–601.

**2.**

On the excavations since 1947, see: N. V. Khoshtaria: "Archaeological Excavations at Vani," in *Caucasian and Near Eastern Studies* 2 (Tbilisi, 1962): 65–79 [in Russian, with an English summary]; "History of Archaeological Study of Vani," in *Vani I* (Tbilisi, 1972), 81–95 [in Georgian, with a Russian summary]; and "Excavations on the Upper Terrace of the Hill in 1947–1959," in *Vani IV* (Tbilisi, 1979), 115–34 [in Russian]; O. Lordkipanidze and T. Mikeladze, "Results of Field Work Carried Out on Plot IV of the Vani Archaeological Expedition in 1960–1961," in *Vani I,* 96–110; R. Puturidze, N. Khoshtaria, and A. Chqonia, "Results of Archaeological Excavations in the North-eastern Part of the Site in 1961–1963," in *Vani I,* 111–36; N. Khoshtaria, O. Lordkipanidze, R. Puturidze, and G. Lezhava, "Archaeological Excavations in Vani in 1966," in *Vani I,* 147–74; N. Khoshtaria, O. Lordkipanidze, and R. Puturidze, "Archaeological Excavations in Vani in 1967," in *Vani I,* 175–85; O. Lordkipanidze and R. Puturidze, "Archaeological Excavations at the Vani Site in 1968," in *Vani I,* 186–97; O. Lordkipanidze, R. Puturidze, V. Tolordava, and A. Chqonia, "Archaeological Excavations at Vani in 1969, in *Vani I,* 198–215; O. Lordkipanidze, R. Puturidze, V. Tolordava, G. Lezhava, G. Lordkipanidze, N. Matiashvili, A. Chqonia, and B. Mchedlishvili, "Results of Field Archaeological Investigations Carried Out in Vani in 1970–1971," in *Vani II* (Tbilisi, 1976), 7–31, figs. 1–52 [in Georgian, with a Russian summary]; D. Kacharava, O. Lordkipanidze, R. Puturidze, and G. Kipiani, "Archaeological Excavations on the Upper Terrace of the Vani Site (1970–1977)," in *Vani IV,* 7–37; D. Kacharava and Z. Mzhavanadze, "Report of Works Carried Out on the Upper Terrace in 1980," in *Vani VIII* (Tbilisi, 1986), 9–33 [in Georgian, with a Russian summary]; R. Puturidze, "Archaeological Excavations in the South-western Part of the Central Terrace of the Vani Site," in *Vani VIII,* 34–41; M. Pirtskhalava and G. Kipiani, "Results of Excavations Carried Out in the Western Part of the Central Terrace in 1978–1981," in *Vani VIII,* 52–78; V. Tolordava, "North-eastern Slope of the Central Terrace (Results of Excavations in 1975–1979)," in *Vani VIII,* 79–92; A. Chqonia, "Archaeological Excavations on the Central Terrace of the Vani Site (Plots 102–103, 117–119)," in *Vani VIII,* 93–115; D. Kacharava, "Recent Finds at Vani," in *Dialogues d'histoire ancienne,* Supplement 1 (2005), 291–307.

**3.**

O. Lordkipanidze, "Vani: An Ancient City of Colchis," *Greek, Roman and Byzantine Studies* 32, no. 2 (Summer 1991): 155–95; O. Lordkipanidze, "Vani–ein antikes religiöses Zentrum im Lande des Goldenen Vlieses (Kolchis)," *Jahrbuch des Römisch-Germanischen Zentralmuseums Mainz* 42, Jahrgang 1995 (1996): 359–401.

**4.**

O. Lordkipanidze, "Vani–ein antikes religiöses Zentrum," 359–62; V. Tolordava, "Vani Cult-ritual Complex of the 8th-7th Centuries B.C. (Chronological Issues)," in *Essays on the Archaeology of Colchis in the Classical Period, Dedicated to the 70th Birth Anniversary of Prof. Otar Lordkipanidze* (Tbilisi, 2001), 37–47 [in Georgian, with an English summary].

**5.**

Kacharava, Lordkipanidze, Puturidze, and Kipiani, "Archaeological Excavations on the Upper Terrace of the Vani Site (1970–1977)," in *Vani IV,* 37, fig. 123; Lordkipanidze and Mikeladze, "Results of Field Work Carried Out on Plot IV of the Vani Archaeological Expedition in 1960–1961," in *Vani I,* 104–7.

**6.**

Tolordava, "North-eastern Slope of the Central Terrace," in *Vani VIII,* 80–81, fig. 60. Also, stray finds of the pre-Classical period were revealed in the western part of the same terrace; see Pirtskhalava and Kipiani, "Results of Excavations Carried Out in the Western Part of the Central Terrace," in *Vani VIII,* 52–53, figs. 31–32.

**7.**

Tolordava, "Vani Cult-ritual Complex of the 8th-7th Centuries B.C.," 37–47.

**8.**

O. Lordkipanidze, "Über zwei Funde aus Wani," *Achäologischer Anzeiger,* 1995, 41–49.

**9.**

J. Nadiradze, *Sairkhe: An Ancient Town of Georgia* (Tbilisi, 1990), 22–97 [in Georgian, with Russian and English summaries].

**10.**

Lordkipanidze, "Vani: An Ancient City of Colchis," 172–73.

**11.**

Kacharava, Lordkipanidze, Puturidze, and Kipiani, "Archaeological Excavations on the Upper Terrace," in *Vani IV,* 30–33, figs. 133–50; G. Kipiani, *Pagan Temples of Colchis and Iberia and Problems of the Origin of Christian Architecture* (Tbilisi, 2000), 5–8 [in Georgian, with a Russian summary]. To the northwest of this building another wooden construction was excavated. It was so poorly preserved that it has not been possible to reconstruct its plan; however, the associated materials suggest an early date. Although this building and the temple complex seem to have been destroyed at the same time, their relationship remains unclear.

See Kacharava, Lordkipanidze, Puturidze, and Kipiani, "Archaeological Excavations on the Upper Terrace," 33–34.

**12.**
Kacharava, Lordkipanidze, Puturidze, and Kipiani, "Archaeological Excavations on the Upper Terrace," in *Vani IV,* 34–35, figs. 166–68.

**13.**
O. Lordkipanidze, Puturidze, Tolordava, Lezhava, G. Lordkipanidze, Matiashvili, Chqonia, and Mchedlishvili, "Results of Field Archaeological Investigations Carried Out in Vani in 1970–1971," in *Vani II,* 26–27, figs. 41–44.

**14.**
Kacharava, Lordkipanidze, Puturidze, and Kipiani, "Archaeological Excavations on the Upper Terrace," in *Vani IV,* 36–37.

**15.**
O. Lordkipanidze, E. Gigolashvili, D. Kacharava, V. Licheli, M. Pirtskhalava, and A. Chqonia, *Colchian Pottery of the 5th–4th Centuries B.C. from Vani = Vani V* (Tbilisi, 1981) [in Georgian, with a Russian summary].

**16.**
Lordkipanidze, "Vani–ein antikes religiöses Zentrum," 368, fig. 6; Lordkipanidze, "Vani: An Ancient City of Colchis," 164, fig. 4.

**17.**
A. Chqonia, *Gold Ornaments from the Vani City Site = Vani VI* (Tbilisi, 1981), 11–53, cat. nos. 1–71 [in Georgian, with Russian and English summaries].

**18.**
See A. M. Chqonia, "Colchian Goldwork," in this volume.

**19.**
A. Chqonia, "Les diadèmes en argent. Traditions et emprunts dans l'orfèvrerie colchidienne," in *La mer Noire zone de contacts, Actes du 7e Symposium de Vani (Colchide)* (Paris, 1999), 159–64.

**20.**
R. Puturidze, "Clay Containers," *in Vani VII* (Tbilisi, 1983), 9–10 [in Georgian, with a Russian summary].

**21.**
Fragments of skyphoi of the Haimon group and a sherd of a white-ground lekythos confirm the presence of later imports from Greece. Attic red-figure finds are rather well attested at Vani: vases of the St.-Valentin and Fat Boy groups are quite numerous.

**22.**
D. Kacharava, "Painted, Black glazed and Plain pottery," in *Vani VII,* 26–51.

**23.**
M. Pirtskhalava, "Glass Vessels," in *Vani VII,* 79–86.

**24.**
O. Lordkipanidze, "Toreutics," in *Vani VII,* 89–91.

**25.**
M. Lordkipanidze, "Gems," in *Vani VII,* 92–96.

**26.**
Lordkipanidze, "*Vani–ein antikes religiöses Zentrum,*" 383–85 and "Vani: An Ancient City of Colchis, 182–84.

**27.**
Although the function is difficult to determine, it may have served as a sacrificial area or sanctuary. See Kacharava, Lordkipanidze, Puturidze, and Kipiani, "Archaeological Excavations on the Upper Terrace," in *Vani IV,* 24–25, figs. 166–68.

**28.**
Chqonia, "Archaeological Excavations on the Central Terrace," in *Vani VIII,* 97–99, fig. 82; Kipiani, *Pagan Temples of Colchis and Iberia*, 8–9.

**29.**
Chqonia, "Archaeological Excavations on the Central Terrace," in *Vani VIII,* 94, pls. 80–81.

**30.**
Lordkipanidze, Puturidze, Tolordava, and Chqonia, "Archaeological Excavations at Vani in 1969," in *Vani I,* 200–201, pls. 153–58.

**31.**
D. Kacharava, D. Akhvlediani, and G. Kvirkvelia, "Vani in the Fourth and the First Half of the Third Century B.C.," *Iberia-Colchis: Research on the Archaeology and History of Georgia in the Classical and Early Medieval Period* 3 (Tbilisi, 2007): 57, fig. 4 [in Georgian, with an English summary].

**32.**
Kacharava, Akhvlediani, and Kvirkvelia, "Vani in the Fourth and the First Half of the Third Century B.C.," 57–59.

**33.**
Chqonia, "Archaeological Excavations on the Central Terrace," in *Vani VIII,* 100–106, figs. 84–91.

**34.**
D. Akhvlediani, *Tiles from the Vani Site* (Tbilisi, 1999) [in Georgian with an English summary].

**35.**
A. Chqonia, "Colchian Goldsmithery: Local Tradition and Influence of Hellenistic Culture," in *Black Sea Area in the Hellenistic World System* (Tbilisi, 2005), 47–48, 73 [parallel texts in Georgian and English].

**36.**
Vinogradov, *Pontische Studien*, 580–81. See also M. Vickers, "Vani, Rich in Gold," fig. 9a, b in this volume.

**37.**
For the stamped tiles, see Akhvlediani, *Tiles from the Vani Site*, 4–11; see also Vickers, "Vani, Rich in Gold," fig. 8.

**38.**
O. Lordkipanidze, "On the Location of τὸ τῆς λευχθέας ἱερὸν," *Vestnik Drevnei Istorii* 2 (1972): 106–25 [in Russian, with an English summary].

**39.**
On the burials: Kacharava, Lordkipanidze, Puturidze, and Kipiani, "Archaeological Excavations on the Upper Terrace," in *Vani IV,* 25. On the defensive walls: ibid., 13–14, figs. 39–56.

**40.**
See R. Ginouvès and R. Martin, *L'architecture grecque et romaine*, vol. 1 (Rome, 1985), 99.

**41.**

O. Lordkipanidze, "The Fortification of Ancient Colchis (Eastern Black Sea Littoral)," in *La fortification dans l'histoire du monde grec, Actes du Colloque International* (Paris, 1986), 179–84, figs. 222–26.

**42.**

Kacharava, Lordkipanidze, Puturidze, and Kipiani, "Archaeological Excavations on the Upper Terrace," in *Vani IV,* 21–23, figs. 69–96.

**43.**

Pirtskhalava and Kipiani, "Results of Excavations Carried Out in the Western Part of the Central Terrace," in *Vani VIII,* 55–57.

**44.**

An architectural complex consisting of a sanctuary dedicated to the god of viticulture and wine-making, a colonnaded altar, and ritual ditches and pits in the southern part of the central terrace are discussed in our essay "Viticulture and Dionysos in Hellenistic Vani" in this volume.

**45.**

Lordkipanidze and Puturidze, "Archaeological Excavations at the Vani Site in 1968," in *Vani I,* 189; Lordkipanidze, Puturidze, Tolordava, and Chqonia, "Archaeological Excavations at Vani in 1969," in *Vani I,* 199–201; O. Lordkipanidze, "The Ancient City of Vani," in *Vani I,* 36–37; O. Lordkipanidze, Ancient Colchis (Tbilisi, 1979), 206–7 [in Russian, with an English summary]; O. Lordkipanidze, *At the Dawn of Georgia's Ancient Civilization* (Tbilisi, 2002), 227–28 [in Georgian].

**46.**

Kipiani, *Pagan Temples of Colchis and Iberia*, 10–25; Lordkipanidze, *At the Dawn of Georgia's Ancient Civilization*, 221–23; N. Matiashvili, *Questions of Colchian History of the Hellenistic Period* (Tbilisi, 2005), 43–62 [in Georgian, with English and Russian summaries].

**47.**

Illustrated on p. 45 in this volume. See also Lordkipanidze, "Vani: An Ancient City of Colchis," 189–93, fig. 10. pl. 15.

**48.**

Dapnari: N. Kighuradze, *Dapnari Necropolis* (Tbilisi, 1976) [in Russian]. Mtisdziri: *Ancient Settlement of Central Colchis (Village of Mtisdziri)* (Tbilisi, 1982) [in Georgian, with Russian and English summaries]. Saqanchia: V. Licheli, *Ancient Vani. Industrial district* (Tbilisi, 1991) [in Georgian, with Russian and English summaries]. Dablagomi: V. Tolordava, "Excavations in Dablagomi in 1970–1971," in *Vani II,* 48–67; V. Tolordava, "A Rich Grave from Dablagomi," in *Vani II,* 68–78. Tsikhe-Sulori: M. Mitsishvili, "Results of Archaeological Excavations Carried Out at Tsikhe-Sulori," in *Vani II,* 32–47.

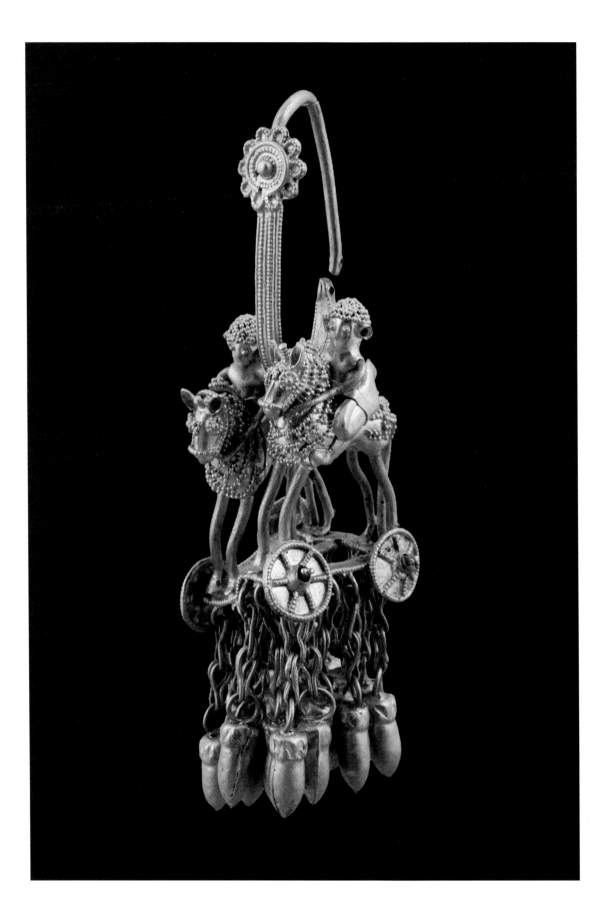

# Colchian Goldwork Anna Chqonia

The fame of Colchis, an area known far and wide in antiquity as "rich in gold" (πολύχρυσος) and in modern times as "the classical land of gold," was traditionally attributed to gold mining. The current notion of Colchian gold implies both the existence of the precious metal in ancient Colchis and the beautifully wrought examples of the gold-smith's art brought to light in large numbers during the ongoing excavations of ancient Colchian cities, especially Vani (fig. 1).

Greek and Roman writers relate tales about the richness of Colchis in precious metals gold and silver (Strabo, 1.2.39; Pliny, *HN* 33.4) — or describe a method of obtaining gold from the river sand using sheep fleece (Strabo 11.2.19; Appian, *Mith.* 103). The popular myth of the Golden Fleece is linked with procuring gold in Colchis.[1] Some-times Greek writers emphasize Colchis's gold wealth through indirect references and various poetic means. For example, Mimnermus (ca. 625 B.C.) describes the city of Aeëtes, "where the rays of swift Helios lie in a golden storeroom at the edge of Okeanos, where god-like Jason went."[2] Colchian Medea, daughter of Aeëtes, makes her magic potions in pots of gold, sends the golden wreath to Glauke, daughter of Creon (hypothesis, Euripides *Medea*), and offers a golden vessel to Triton (Lycophron, *Alexandra*, 886–890). King

Aeëtes of the Colchians, rich in gold, is men-tioned in one epitaph, erroneously attributed to Aristotle (*Peplos*, epitaph 43).[3] These literary sources regarding the existence of gold in Colchis, the method of obtaining it, and the explanation of the Golden Fleece myth are supported by geological, ethnographic, and linguistic-toponymic data.[4]

Many scientists and travelers in relatively modern times have noted the same richness in precious metals. These include, among others, the well-known sixteenth-century scientist Georgius Agricola, the seventeenth-century Italian mis-sionary Arcangelo Lamberti, the eighteenth-century German scientist Jacob Reineggs, the French Consul in Tbilisi Jacques-François Gamba, and the Swiss scientist Frédéric Dubois de Monpéreux (first half of the nineteenth century).[5] In their works Colchis is identified with the country rich in gold.

The local presence of raw material — the precious metals of gold and silver — was one of the driving forces in the development of Colchian goldworking. Other factors include a long-standing tradition of artistic metalworking (bronze), as well as cultural and economic contacts with the Hellenic and Near Eastern worlds. Three chronological stages of

1. Temple ornament/earring with two horsemen, from Grave 6. First half of the 4th century B.C. Georgian National Museum.

development have been identified as a result of the numerous and varied gold ornaments found at Vani: (1) fifth century B.C. to the first half of the fourth; (2) second half of the fourth century to the beginning of the third; (3) third to the first century B.C. Distinctive styles and unique features characterize each of these phases, all within a single artistic vision.

The graves at Vani have yielded plentiful amounts of ornaments that typify the earliest chronological phase. For example, stunning diadems have been found in Grave 11 (mid–fifth century B.C.) and Grave 6 (first half of the fourth century B.C.). They are of twisted gold, ending in distinctive lozenge-shaped (rhomboid) finials, or plaques, with characteristic three-figure, fighting-animal compositions hammered in low relief—for example, two lions attacking a wild boar (figs. 2a, b). The twisted rod terminated in rhomboid plaques that were worn at the front of the head, fastened by a central hook. One possible reconstruction is that delicate chains suspending gold hoops with ornaments (pendant balls attached to rods, or radials) fell onto the individual's temples or sides of the forehead. The formal elements of the silver diadems resemble those made of gold. The main difference is that their lozenge-shaped plaques are usually ornamented with geometric patterns and a rosette in the center.[6] The distribution of this type of diadem is mainly confined to the territory of Colchis, and the component parts are related to Colchian Late Bronze and Early Iron Age examples.[7] The fighting-animal compositions clearly demonstrate the influence of Near Eastern (Assyrian, Mannean–Median, Achaemenid) as well as Greek art.[8] Nevertheless, certain deviations from canonical norms (e.g., the representation

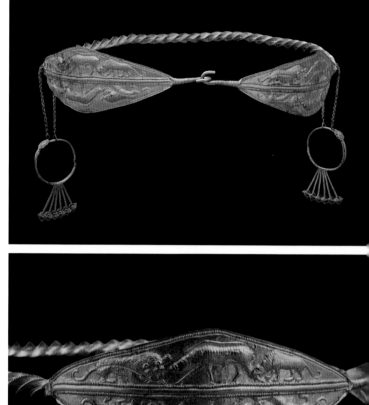

2a. Diadem with temple rings, from Grave 6. First half of the 4th century B.C. Georgian National Museum.

2b. Detail of left lozenge-shaped plaque with animal combat scenes.

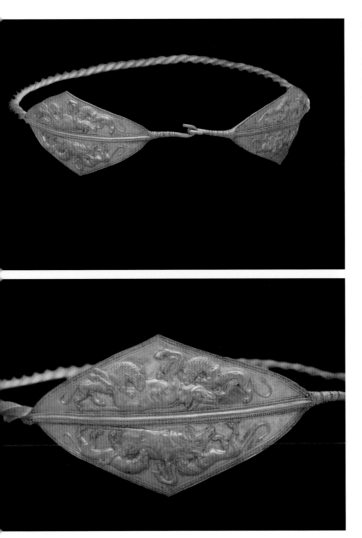

of the hair on the back of an Achaemenid-type ibex, the non-observance of the principle of frontal design) and the combination of different artistic styles indicate the distinctive character of these luxury objects (figs. 3a, b). Their limited distribution area, original forms, and link with earlier examples of the goldsmith's art recovered on Georgian soil strongly suggest that they belong to the culture of Colchis.

Sometimes it is difficult to determine whether or not a gold hanging element functioned as a temple ornament or earring (for the sake of clarity, this type of jewelry will hereafter be referred to as a temple ornament). Among the various forms of temple ornaments uncovered at Vani in burials that date from the fifth to the first half of the fourth century B.C., there are two distinct types: radial (fig. 4) and globular. The latter ornaments use more than one decorative principle: openwork (fig. 5), fluted, bands of granulation, and bipyramidal structure (fig. 6). Of special interest are the figural pendants (fig. 1). Despite their differences in typology and shape, these temple ornaments are characterized by artistic and stylistic unity: a penannular (open on one side) hoop, circular or oval, is decorated with a rosette and an ornamental band, elements specific to Colchian earrings.[9] The same decorative elements also appear on a pair of crescent-shaped earrings (fig. 7), a form foreign to Colchis.[10] Nevertheless, this type is quite widespread here, especially in Vani in the fourth century B.C. It is most likely that this type of temple ornament was made locally, using a shape borrowed from outside the region combined with technical elements and ornamental features characteristic of Colchian goldwork.

3a. Diadem, from Grave 11. Mid–5th century B.C. Georgian National Museum.

3b. Detail of left lozenge-shaped plaque with animal combat scenes.

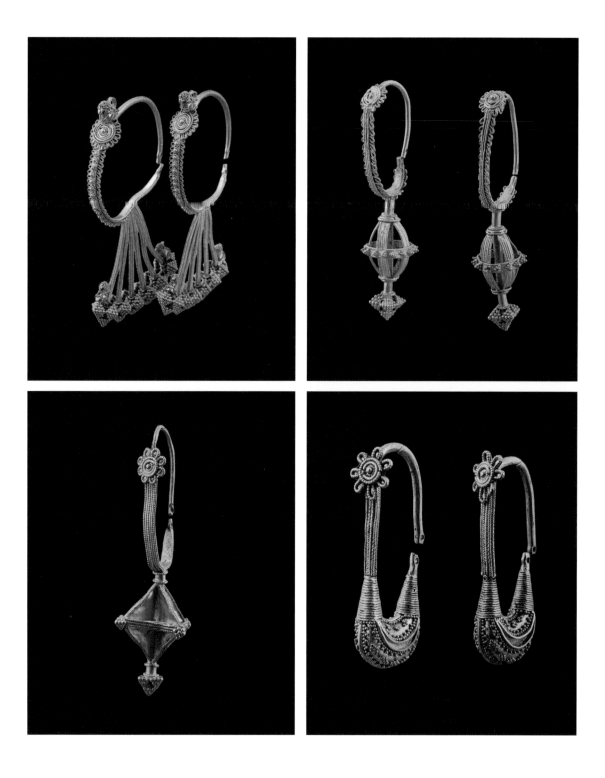

4. Radial temple ornaments/earrings with birds, from Grave 11. Mid–5th century B.C. Georgian National Museum.

5. Openwork temple ornaments/earrings, from Grave 11. Mid–5th century B.C. Georgian National Museum.

6. Bipyramidal temple ornaments/earrings, from Grave 6. First half of the 4th century B.C. Georgian National Museum.

7. Crescent-shaped temple ornaments/earrings, from Grave 6. First half of the 4th century B.C. Georgian National Museum.

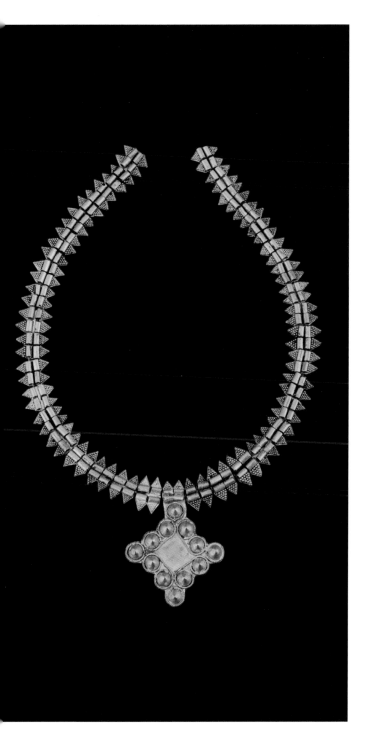

In the fifth century B.C. some examples from this class of ornament display miniature representations of birds, as on the radial earrings from Grave 11 (fig. 4). These birds seem to have had not only a decorative function, but also a definite role in the religion of the ancient Colchians.[11] Such birds, which appear more frequently on temple ornaments/earrings dating from the second half of the fourth century B.C. (Vani Graves 19, 22, 24), exemplify both the traditional character and the continuing development of Colchian goldwork.

A typical structural feature of Colchian temple ornaments/earrings from this earliest phase is a fixed, stable pendant attached to a hoop. Radial or globule-shaped pendants are soldered to a hoop. The earrings with figural pendants discovered in Vani Grave 6 are an exception; that is, they are structurally loose rather than fixed. Here, figures of two horsemen on a four-wheeled frame are suspended loosely from a hoop (fig. 1), and acorn-shaped ornaments hang from short loop-on-loop chains. The freely moving elements are the first instances of a dynamism that becomes more evident in the next phase of Colchian goldwork.

Necklaces from Vani of this period (5th–first half of the 4th century B.C.) are notable for their diversity. Pendants are shaped like miniature birds and animals, for example, ibexes, turtles, wild boars, and ram's heads. Some are geometric in form (fig. 8); others remind us of maize but we are unsure what they actually represent (fig. 9). The techniques employed in the decoration of the necklaces are typical of those used for other Colchian gold objects. Wide use is made of filigree and granulation. The latter is applied to a variety of shapes: triangle, pyramid, rhombus,

8. Necklace with central rhomboid pendant, from Grave 6. First half of the 4th century B.C. Georgian National Museum.

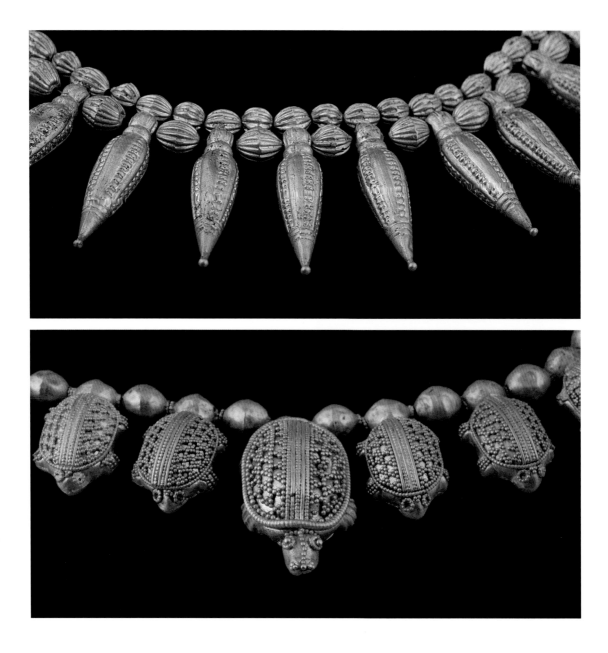

9. Detail of necklace with maize-like pendants, from Grave 11.
Mid–5th century B.c. Georgian National Museum.

10. Detail of necklace with turtle pendants, from Grave 11.
Mid–5th century B.c. Georgian National Museum.

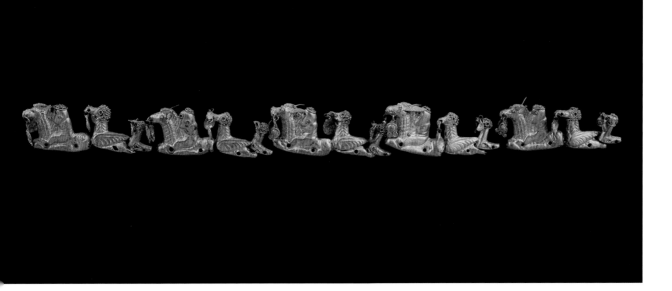

meander, and swastika. Similar forms and decorative elements occur on silver objects as well. The influence of Greek and Near Eastern jewelers' arts are apparent, too: in the paste inlay of the turtles' and birds' eyes and in the design emphasis on a central ornament, as in the necklace with turtle pendants (fig. 10).[12] The symbolism of the necklace pendants—images of animals and birds—is connected to religious beliefs in ancient Colchis, probably with the widespread cult of the Great Mother.[13] Gold ornaments and other archaeological examples, in which the existence of the cult of the Great Mother is reflected, have been found throughout the territory of Colchis. This cult must have had official status and importance in Colchis, where a special place was assigned in goldwork to one of the attributes of the Great Mother, namely, the bird.

The character of Colchian goldwork changed during the second half of the fourth century B.C.

Innovations that had already been discernable in articles from the first half of the century became more noticeable. This was primarily evident in the ornamental repertoire: diadems with rhomboid plaques disappeared in the second half of the century and were replaced by new forms of sophisticated head ornaments. Only two instances of the latter have been recorded so far, and each is unique. One, from the burial of Colchian warrior Dedatos (Grave 9), is made up of pendants in the form of horsemen and birds, beads and tubes (fig. 11). The other, from Grave 24, is the very richly decorated and carefully wrought piece whose openwork center contains images of a stag, deer, birds, and lions (fig. 12). These head ornaments find no analogies elsewhere. However, artistic devices and techniques, as well as themes represented, point to a continuing tradition in the Colchian goldsmiths' art: in their style and meaning, the images on openwork jewelry bear a strong resemblance to engraved representations on eighth to seventh-century B.C. Colchian axes,

11. Head ornament with horsemen and birds, from Grave 9. Third quarter of the 4th century B.C. Georgian National Museum.

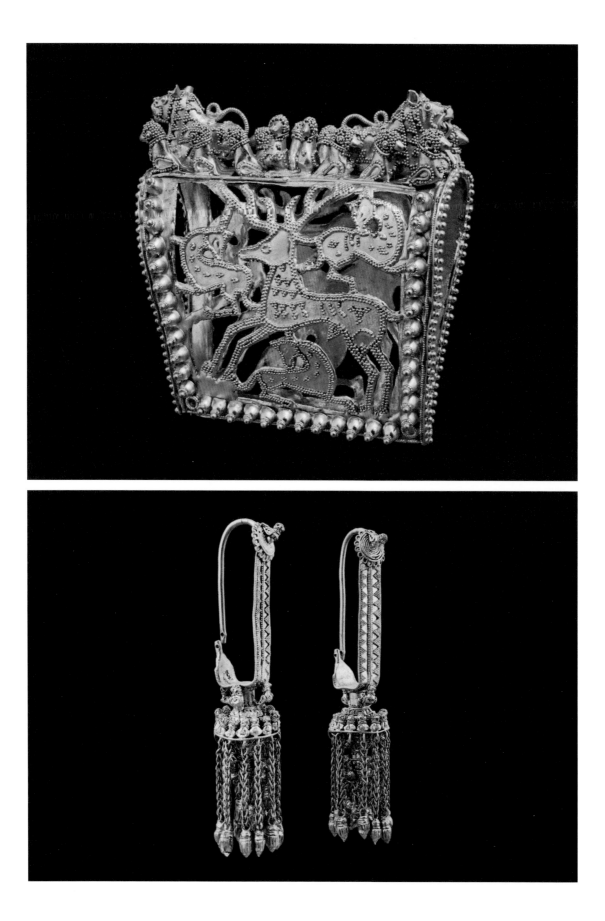

on the one hand, and to bronze openwork buckles dated to the first century A.D., on the other.[14] These connections are another indication of the long continuity of Colchian art.

Traditional forms of Colchian earrings/temple ornaments—with fixed globular or bipyramidal pendants (openwork, ribbed, and/or granulated) and characteristic ornaments (decorated band, rosettes, birds, granulated pyramids, banded globules, hoops with holes at the thickened ends)— continued to be produced into the second half of the fourth century B.C. and the beginning of

thc third. These elements were modified, and new, mostly loose, details were added: hoop finials became flatter, the ornamental band became simpler, as on the earrings from Grave 16, and, in addition, grain-like ornaments were suspended from the globule, as on the earrings from Graves 22 (fig. 13) and 24.

The most dramatic changes in the goldsmith's art occurred from the third through the first century B.C. The foundation for these changes was laid by the long-flourishing local school of goldsmiths and by new artistic trends introduced from through-

12. Headdress ornament with openwork decoration, from Grave 24. Second half of the 4th century B.C. Georgian National Museum.

13. Temple ornaments/earrings, from Grave 22. End of the 4th century B.C. Georgian National Museum.

14. Necklace with carnelian and onyx beads, from Grave 13. 3rd century B.C. Georgian National Museum.

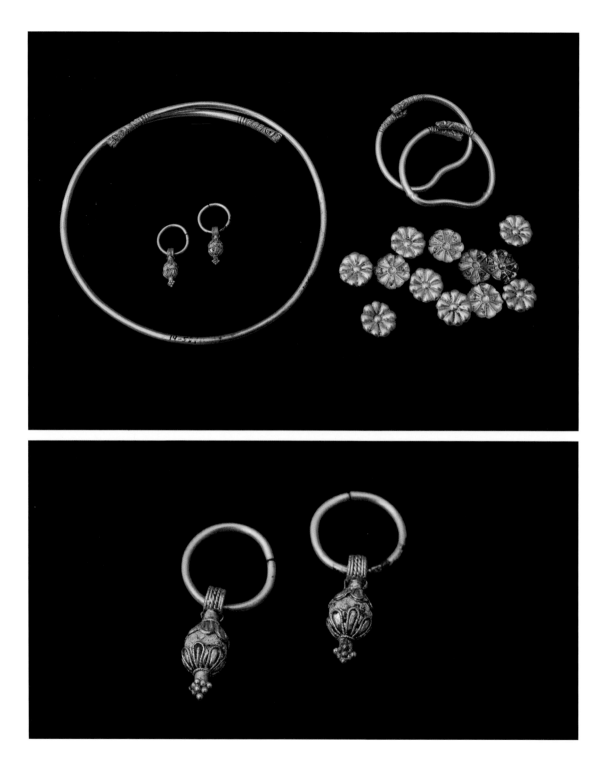

15a. Jewelry, from Grave 4. First half of the 3rd century B.C.
Georgian National Museum.

15b. Detail showing earrings with steatite and gold pendants.

out the Hellenistic world. The defining features of the jeweler's art of this period—polychromy, dynamism, decorativeness, new forms and motifs—were reflected to a certain extent on Colchian jewelry and facilitated the formation of a new developmental stage in Colchian goldwork.[15] Some ornaments from Vani are typical examples of the Hellenistic jeweler's art: fragments of wreaths; necklaces made of stone, glass, gold beads, and pendants (fig. 14); the pendant decorated with garnet and a part of the necklace fastener; the so-called trifoliate leaf pendants; barrel-shaped beads; plaques to be sewn onto fabric with vegetable motifs; rosettes decorated with granulation and wire. These articles are among the works made in the style of the Hellenistic *koine*. Evidently, Colchis, with its sophisticated local goldwork, did not remain outside the development process of the Hellenistic jeweler's art; its artisans appear to have had no difficulty making ornaments that were, to a certain extent, imitative or influenced by a foreign culture. In some cases, typical Hellenistic types were reinterpreted by Colchian goldsmiths. It is, nevertheless, noteworthy that the complete repertoire of ornaments of this period has not been found in Colchis, nor have complete sets of jewelry been discovered to date.

Colchian traditions and Hellenistic artistic innovations found a clear reflection in one of the most popular types of jewelry, namely earrings. In the third century B.C. a new type of earring appeared in Colchis: one with loose (suspended) globular pendants. The same type of earring was also widespread in eastern Georgia—Iberia (Samadlo, Tsikhiagora, Uplistsikhe, Mtskheta).[16] Its main elements are a plain penannular hoop and loosely suspended globular pendants of various kinds: in

one pair of earrings from Grave 4, a steatite globule is placed between gold hemispherical rosettes (figs. 15a, b). Plain globular pendants or those decorated with wire-encircled granulation are also recorded. Earrings with a grain-like ornament instead of a globule occur on a bronze statuette found in 2002 at Vani.[17]

The earrings with loose globular pendants nevertheless emerge as unusual examples against the background of varied earrings typical of the Hellenistic *koine*. In spite of new features characteristic of the Hellenistic jeweler's art, some earring types known elsewhere in the Hellenistic world have not yet been found in Colchis. Apparently, this variety of jewelry developed mostly on the basis of local traditions. In this regard, it is interesting to compare earrings having loose globular pendants and wire-encircled granulation with fixed-ball (Colchian-type) earrings in which granulation is placed in horizontal bands at regular intervals.[18] It becomes clear that Hellenistic fashions (including polychromy) in common ornaments such as earrings are represented in a limited manner. Hence, special interest attaches to buckles in the form of a Herakles knot, as well as to a necklace chain with horned lion's-head finials (fig. 16), and to glass beads—all ornament types recovered at Vani that are typical of the Hellenistic period.[19] These are imported examples, possibly indicative of the societal position of their respective owners—and emblematic of the demand for the repertoire of the Hellenistic-Macedonian world. Sometimes, the Hellenistic model is deliberately reinterpreted, as on a gold buckle showing in low relief the fight between a youth and a lion (fig. 17).[20] Although this may at first appear to represent Herakles

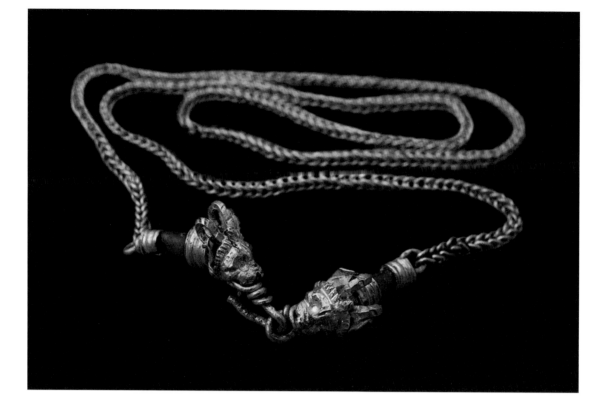

battling the Nemean lion, the local goldsmith seems to have charged this story with a different meaning: here the youth (Herakles) is a victim attacked by the lion.

The gold ornaments from Vani that date from the third to the first century B.C. attest to the existence of a local goldsmithing school—"a regional center" even during the turmoil of this period—against the background of the Hellenistic *koine*.[21] The activity of professional goldsmiths at Vani is obvious not only from the high quality of the jewelry they produced but also from gold products—ingots (fig. 18), "drops," blanks, cuttings from plaques and wire—that indicate the functioning of a goldsmith's workshop or workshops.

The existence of local workshops is also confirmed by repaired or altered ornaments, as well as damaged, out-of-use pieces (fragmented or deformed), which must have been intended for recycling. One group of such ornaments (deformed hoop, parts of pendants, tubes, fragments of ornamental plaques) has been discovered on the central terrace of Vani, to the west of the complex built of cobblestones, where they were scattered over a small area (1.5 x 0.8 meters). In some cases, it has been possible to connect remains of artistic working of gold with certain complexes in Vani though without being able to specify the goldsmith's work site.[22] With one exception, the conditions of discovery have prevented exact localization of the work place.

16. Necklace with horned lion's-head finials. 3rd century B.C. Georgian National Museum.

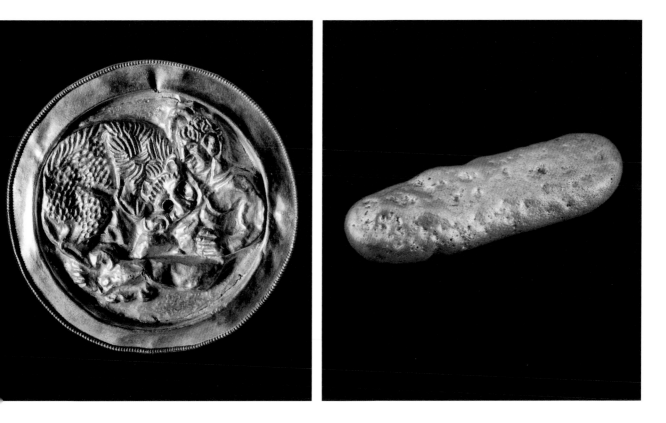

This exception is on the central terrace, where archaeological excavations have revealed the remains of a goldsmith's workshop. A fragment of a limestone-block wall remains of the workshop building itself and traces of manufacture are also present: a mass of burned clay, slag, ashes, fragments of charred wood; a blank in the form of a gold bar; a gold "drop"; tools made of bone.[23] A cult place has been discovered near the building, probably functioning at the workshop: in situ were two clay pots, a big pot (*dergi*) and a Colchian amphora, as well as bones of bulls' or cows' jaws placed in several rows on top of one another, which, on the basis of ethnographic parallels, were linked with the religious ritual performed at the goldsmith's workshop. Taking stratigraphic data into account, we may date the Vani workshop to the end of the fourth century B.C.[24]

The available archaeological material does not allow us to trace the organization of artisanal production or its role in the general development of the city. One thing is certain, however: the superb examples of Colchian goldsmithery brought to light at Vani, together with the remnants of an actual workshop, attest to the existence of a highly developed professional school. Thus, Vani emerges as one of the major centers of artistic craftsmanship—the Colchian goldsmiths' art. The names and social status of the Colchian goldsmiths are unknown, but their works live on, charming the viewer with their refinement and originality.

17. Buckle with youth attacked by a lion. 3rd century B.C. Georgian National Museum.

18. Ingot, from Grave 6. First half of the 4th century B.C. Georgian National Museum.

## Notes

**1.**

O. Lordkipanidze, *Drevnyaya Kolkhida: Mif i Arkheologia* [Ancient Colchis: Myth and Archaeology] (Tbilisi, 1979), 98–100 [in Russian]; A. M. Chqonia, "K Izucheniyu Kolkhidskogo Zlatokuznechestva" [Towards the Study of Colchian Goldsmithery], *Brief Reports of the Institute of Archaeology* 151 (Moscow, 1977): 75–76 [in Russian].

**2.**

Mimnermus, Fragment 11: *Greek Elegiac Poetry: From the Seventh to the Fifth Centuries B.C.*, ed. and trans. D. E. Gerber (Cambridge, Mass., 1999). For more detailed discussion, see A. M. Chkonia, "Gold Artistic Craftsmanship in Vani during Antiquity," in *Vani II* (Tbilisi, 1976), 209 [in Georgian, with a Russian summary].

**3.**

For the Greek texts, see A. Urushadze, *Ancient Colchis in the Argonaut Legend. Research* [Greek texts with Georgian translation and notes] (Tbilisi, 1964), 202, 237, 294, 301 [in Georgian].

**4.**

A. A. Iessen and T. S. Passek, "Zoloto Kavkaza" [Gold of the Caucasus], in *Proceedings of the State Academy of History of Material Culture* 110 (Moscow and Leningrad, 1935), 162 ff. [in Russian].

**5.**

A. M. Chkonia, "À propos de l'exportation de l'or colchidien," in *Pont-Euxin et commerce. Actes du 9e Symposium de Van*i (Paris, 2002), 264–66; with references.

**6.**

O. Lordkipanidze, "Vani–ein antikes religiöses Zentrum im Lande des Goldenen Vlieses (Kolchis)," *Jahrbuch des Römisch-Germanische n Zentral-museum, Mainz* 42 (1996): 370; A. M. Chkonia, "Gold Ornaments from the Ancient City Site of Vani," in *Vani VI* (Tbilisi, 1981), 11–16 [in Georgian, with an English summary]; A. M. Chkonia, "Les diadèmes en argent. Traditions et emprunts dans l'orfèvrerie colchidienne," in *La mer Noire, zone de contacts. Actes du 7e Symposium de Vani (Colchide), 26–30* septembre 1994, ed. O. Lordkipanidze and P. Lévêque (Paris, 1999), 159–64.

**7.**

For parallels of twisted hoops and hooked diadems, see E. I. Krupnov, *Drevnyaya Istoriya Severnogo Kavkaza* "The Ancient History of the Northern Caucasus" (Moscow, 1960), 289–90 [in Russian]; I. M. Gagoshidze, *Samadlo* (Tbilisi, 1979), 72 [in Russian]. Widening of the ends of the hoop is characteristic as well (not only in the form of rhomboid plaques). The shape of the rhomboid plaques resembles that of plaques for covering the eyes of the deceased discovered in burials at Tsintsqaro and Qanchaeti; see B. A. Kuftin, "Archaeo-logical Excavations at Trialeti," *Arkheologicheskie Raskopki v Trialeri* 1 (Tbilisi, 1941): 30 [in Russian]; I. Gagoshidze, "Remains of the Early Classical Period from the Ksani Valley," in *Adreantikuri khanis dzeglebi ksnis kheobidan* 15 [in Georgian]."

**8.**

The Achaemenid influence is visible not only in the adaptation of iconographic motifs, but also in the adoption of the metrological standard set by the Persian Empire, as demonstrated by the analysis of some of the Colchian silverware. See M. Vickers, "Metrological Reflections: The Georgian Dimension," in *La mer Noire, zone de contacts*, 117–28, esp. 122 ff.

**9.**

A. Chqonia, "Early Classical Gold Earrings from the Ancient City Site of Vani," in *Vani III* (Tbilisi, 1977), 81–100, 188–89 [in Georgian, with a Russian summary].

**10.**

K. Hadaczek, *Der Ohrschmuck der Griechen und Etrusker* (Vienna, 1903), 21 ff.; K. R. Maxwell-Hyslop, *Western Asiatic Jewelry, c. 3000–612 B.C.* (London, 1971), 203, 208, 264. These earrings are also known as "boat"-type earrings: *The Search for Alexander: An Exhibition* (Boston, 1980), cat. no. 61.

**11.**

A. M. Chkonia, "Le culte de la Grande Déesse dans l'orfèvrerie colchidienne," in *Religions du Pont-Euxin. Actes du 8e Symposium de Vani (Colchide), 1997*, ed. O. Lordkipanidze and P. Lévêque (Paris, 1999), 119–21.

**12.**

B. Deppert-Lippitz, "Interrelations between Greek Jewellery of the 6th and 5th Centuries B.C. and Gold Finds from the Black Sea Region," in *Actes du 6e symposium de Vani (Colchide), 22–29 septembre 1990* (Paris, 1996), 119.

**13.**

Chkonia, "Le culte de la Grande Déesse," 115–28.

**14.**

L. Pantskhava, "Remains of Artistic Craftsmanship of Colchian Culture," in *Kolkhuri kulturis mkhatvruli khelosnobis dzeglebi* (Tbilisi, 1988), pls. VII.1, XIII.2–3, XIV.1, XIX [in Georgian, with a Russian summary]; M. Khidasheli, "On the History of Artistic Working of Bronze in Classical Georgia," in *Brnijaos mkhatvruli damushavebis istoriisatvis antikur sakartveloshi* (Tbilisi, 1972), cat. nos. 157–171 (in Georgian, with a Russian summary).

**15.**

A. M. Chqonia, "The Jeweller's Art in Colchis of the 4th-2nd Century B.C. (Problems of Innovation)," in *The Black Sea Littoral in Hellenistic Times. Materials of the 3rd All-Union Symposium on the Ancient History of the Black Sea Littoral* (Tbilisi, 1985), 519–27 [in Russian, with an English summary]; A. Chqonia, "Kolchis und die hellenistische Koine im Entwicklungskontext der Goldschmiedenkunst," *Phasis: Greek and Roman Studies* 2–3 (Tbilisi, 2000): 68–72.

**16.**

A. Chqonia, "A Gold Earring from Dzegvi (Mtskheta District)," *Iberia-Colchis. Researches on the Archaeology of Georgia in the Classical Period* 1 (Tbilisi, 2003): 159–60; with references (p.163) [in Georgian].

**17.**

D. Kacharava, "A Bronze Figurine from Vani," *Journal of Georgian Archaeology* 1 (Tbilisi, 2004): 226–27.

**18.**

A. Chqonia, *Colchian Jewelry from the Vani City Site, Ancient Jewelry and Archaeology* (Bloomington and Indianapolis, 1995), 49, fig. 8.

**19.**

B. Deppert-Lippitz, *Griechischer Goldschmuck* (Mainz, 1985), 201–2; H. Hoffman and P. Davidson, *Greek Gold: Jewelry from the Age of Alexander* (Mainz, 1965), 6; R. A. Higgins, *Greek and Roman Jewellery* (London, 1962), 155 ff.

**20.**

B. A. Kuftin, *Materialyi k Arkheologii Kolkhidyi* [Materials on the Archaeology of Colchis], vol. 2 (Tbilisi, 1950), 4–6 [in Russian].

**21.**

Study of much of the excavated material, together with comparative technical and stylistic analyses, has made it possible to identify the local style and regional differences. See M. Pfrommer, *Untersuchungen zur Chronologie Früh- und Hochhellenistischen Goldschmucks, Istanbuler Forschungen* 37 (Tübingen, 1990), 2 ff.

**22.**

For example, cuttings of plaques and blanks in the form of small balls and a thick round plaque are linked to the temple complex of the lower terrace.

**23.**

The fangs of a wild boar, apparently used in the process of working, must have been used for polishing the surface of a gold plaque; see A. Chqonia, "Arkeologiuri gatkhrebi vanis nakalakaris tsentralur terasaze" [Archaeological Excavations at the Central Terrace of the Vani City Site]," in *Vani VIII* (Tbilisi, 1986), 114, fig. 97 [in Georgian, with a Russian summary].

**24.**

A. M. Chkonia, "L'artisanat d'art dans le développement des villes colchidiennes," in *Pont-Euxin et Polis: Polis Hellenis et Polis Barbaron. Actes du 10e Symposium de Vani (Colchide), 23–26 septembre 2002* (Paris, 2005), 265–70.

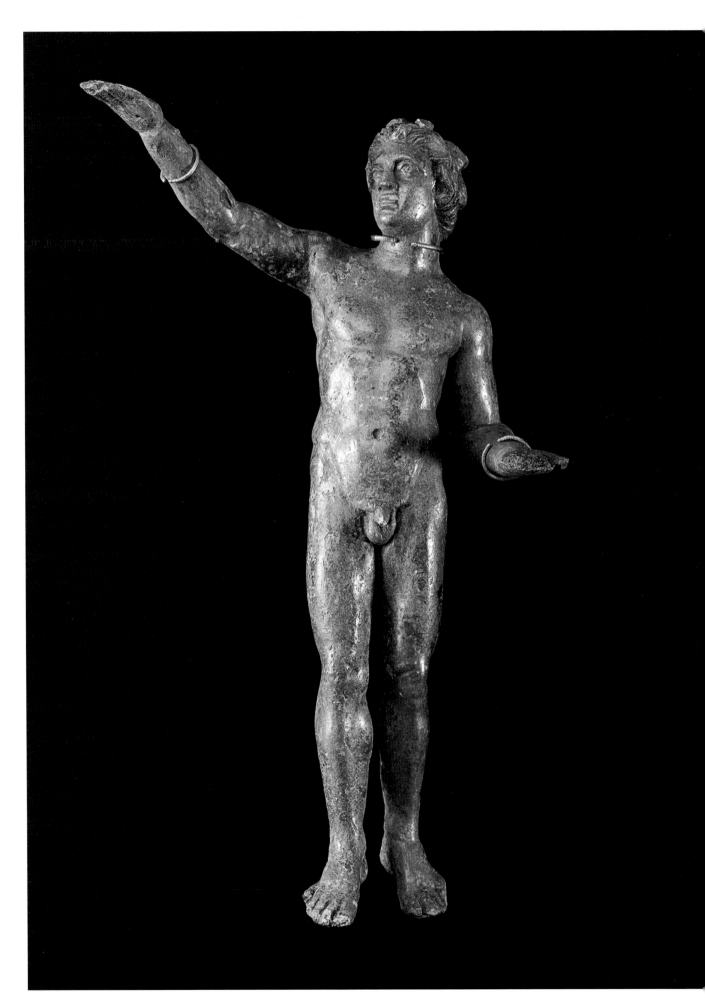

# Religious Ritual: Bronze and Iron Figurines from Vani Darejan Kacharava and Guram Kvirkvelia

Recognizably human, but elongated, simplified, and abstracted far from Classical Greek form are most of the metal figurines brought to light in the sanctuaries on the upper terrace of Vani (fig. 2). The six odd-looking, jewelry-bedecked figures, together with one standard Hellenistic type, are intriguing not only because of how they look, but also because of how and where they were buried. Four are displayed in this exhibition Their discovery in or near what were likely sacred building spaces, together with the particularly careful manner of their burial, highlights the special attention paid to these figurines by those who laid them to rest and may suggest unusual ritual functions for them.

The first figurine (no. 1) made its appearance in 1947 and was excavated on the northernmost part of the hilltop (fig. 3). The small rectangular pit (0.50 x 0.30 x 0.25 m) in which it was found was oriented north-south and was located in between two graves (Graves 2 and 3) and close to a third (Grave 4). When it was discovered, the figurine, made of iron, lay with its head to the north between two cover-tiles that seem to imitate wooden constructions used in some burials. The man is standing, naked, hands stretched forward. He is ithyphallic and adorned with gold jewelry—a torque and earrings. Gold appliqués with eyelets on the back were found near the figurine and probably constituted additional ornaments for him.[1]

Roughly five meters to the east of the just-mentioned group of graves, a structure on top of a level, rock-cut platform was uncovered (fig. 2. I).[2] On three sides the platform is surrounded by walls cut into the same rocky ground, while the fourth side, the southeast, was left open. The structure itself is U-shaped and measures 5 by 4 meters; built of rusticated sandstone ashlar blocks, it, too, is open to the southeast. Above two courses of masonry, occasional layers of clay were revealed, suggesting that either clay walls were erected on top of the stone foundations or the upper surface of the uppermost masonry course was coated with clay plaster. Inside the structure is evidence of an altar or sacrificial table, which attests to the building's cult function (Sanctuary I).

On the platform, outside the sanctuary proper, a small rectangular pit (0.60 x 0.30 m) was uncovered; it had been cut into the rocky ground and filled with crushed sandstone. At a depth of 0.85 meters, a bronze figurine (no. 2) was placed in between two cover-tiles, the head pointing to the east (figs. 4a, b). Thus, the cover-tiles served as a receptacle for the buried figurine.

1. Figurine no. 7, Statuette of a Satyr. Bronze, H. 21 cm. 3rd century B.C. Georgian National Museum.

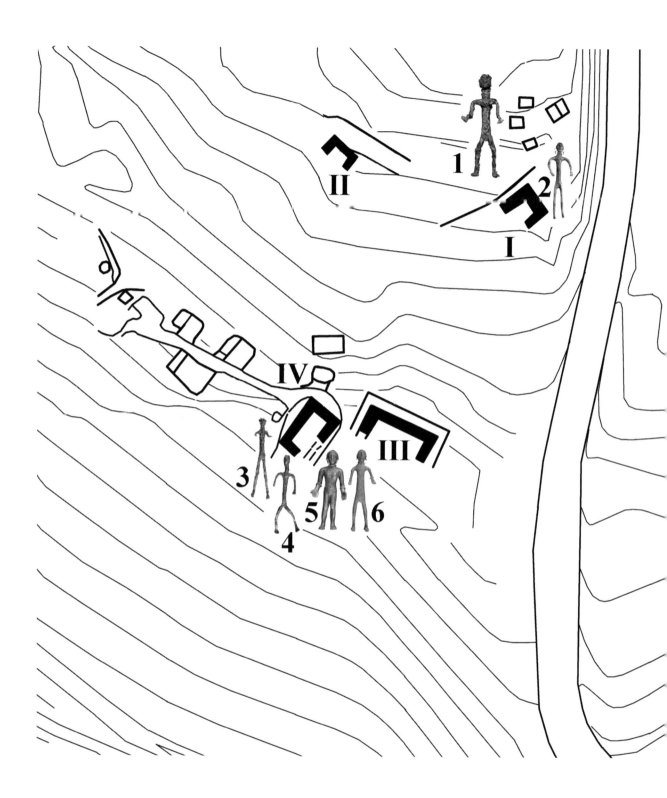

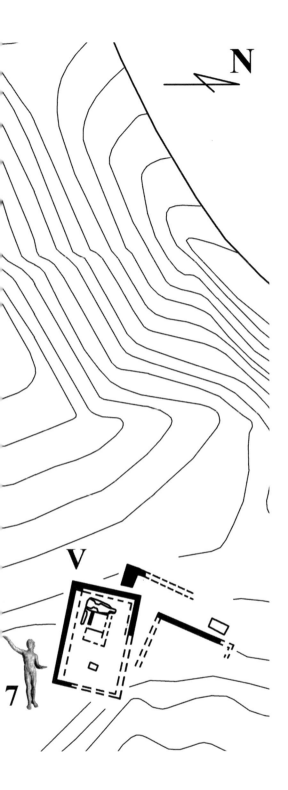

2. Main cult structures (I–V) showing location of
figurine burials (1–7).

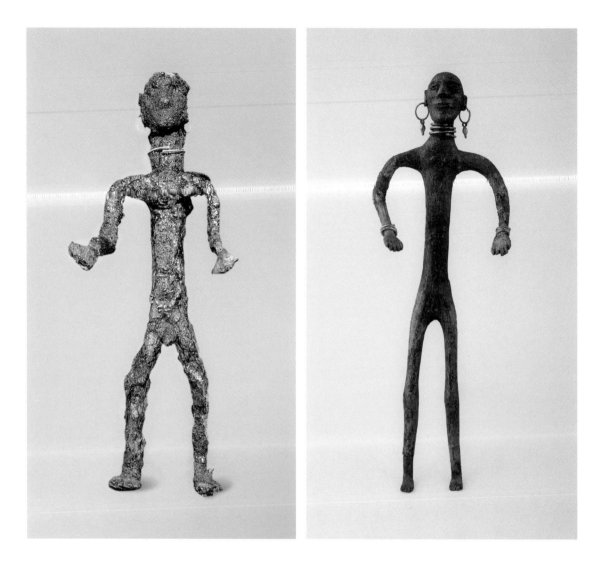

Figurine no. 2 was adorned with a variety of gold ornaments, some still attached, others discovered nearby. A headdress comprised of rosettes once adorned the head; in addition, the figurine wears a torque, bracelets, and earrings. Pendants as well as two glass beads were discovered along with it. The headdress consists of five rosettes, each with an attachment loop in the rear to string them on thread, thus allowing them to rest on the head.

It is worth noting that a headdress composed of rosettes came to light in a child's grave (Grave 4) at Vani,[3] dated to the third century B.C. This provides clear evidence that humans, too, wore the same type of headdress. The hoop-and-pendant earrings type is well known at Vani from the end of the fourth century to the first century B.C.[4] The spiral torque is made of wire, round in section (Diam. 0.15 cm). It has three coils and thickened

3. Figurine no. 1. Iron, H. 30 cm. 3rd century B.C. Georgian National Museum.

4a, b. Figurine no. 2. Bronze, H. 25 cm. 3rd century B.C. Georgian National Museum.

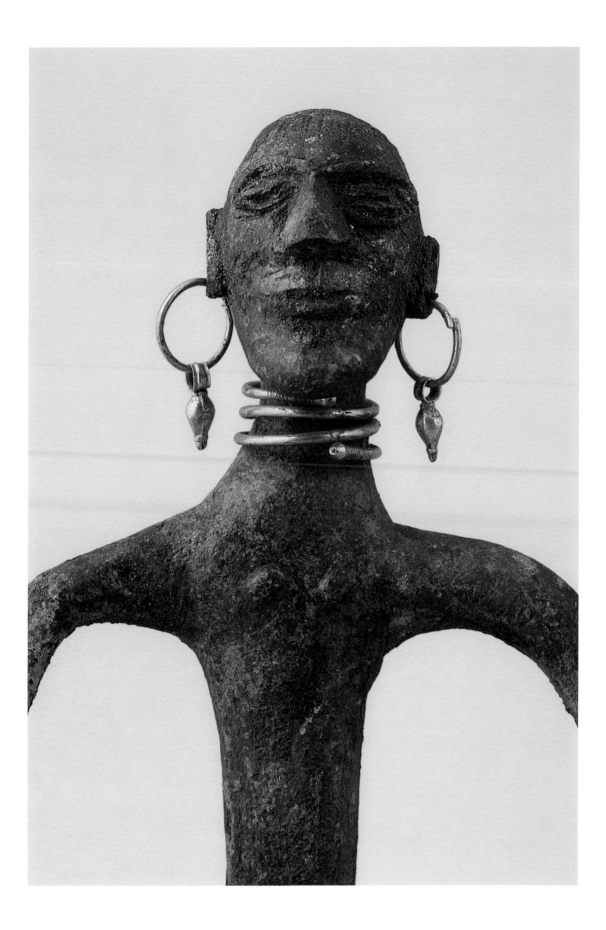

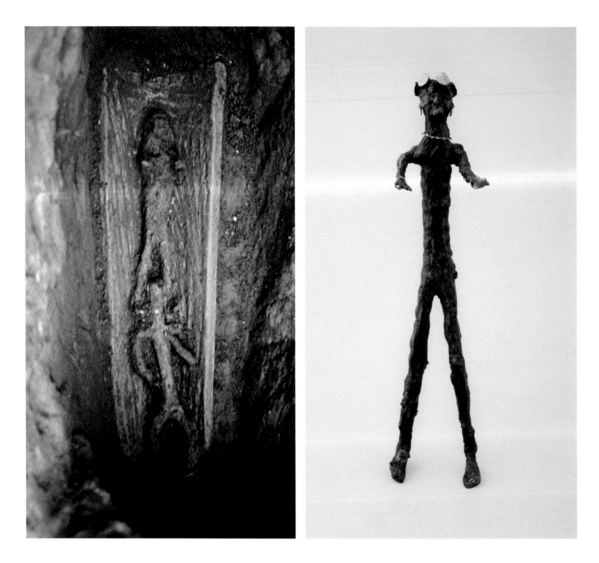

terminals with grooves at the point of thickening. The torque finds its closest parallel with that of figurine no. 1. The figurine's bracelets resemble the torque in both shape and decoration: all are round in section, spiral-shaped, and have thickened terminals.

Ten pendants, each fashioned from a boss and a disk, were found in the area of the neck and chest of figurine no. 2. An attachment loop is soldered onto the edge of the boss from which hangs a twisted wire. Its ends are soldered onto the disk. Similar fragmentary bosses and disk-shaped pendants have been found not only in Vani but also elsewhere in Colchis. For example, figurine no. 1 was decorated with similar bosses. Some stray finds are also known;[5] and there have been casual finds of disk-shaped pendants hanging

5. Figurines nos. 3 and 4, in situ on cover-tile.

6a, b. Figurine no. 3. Iron, H. 24.5 cm. 3rd century B.C. Georgian National Museum.

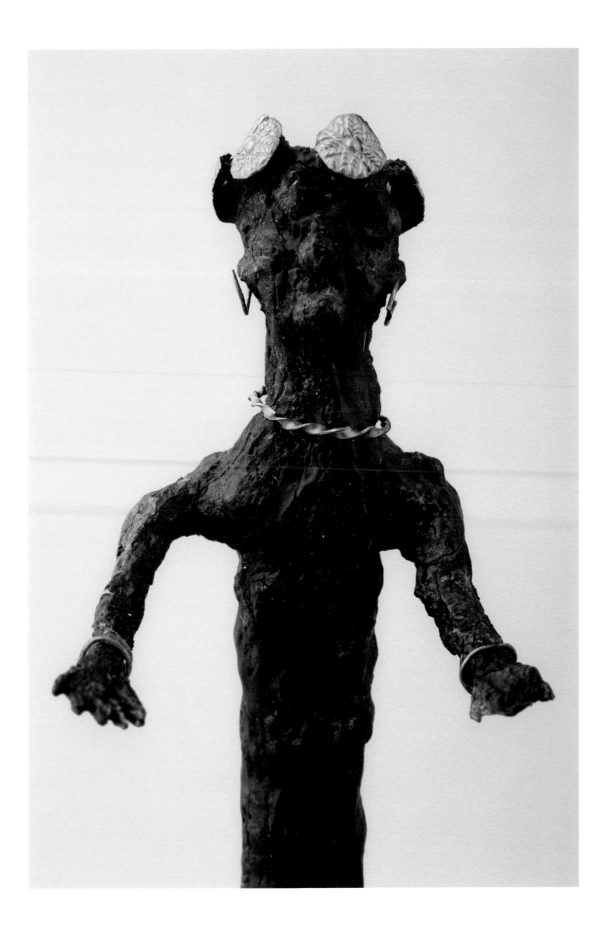

from tubular elements.[6] Parallels are known from the grave goods of the tile-roofed burial from Dablagomi (17 km from Vani), dated to the beginning of the third century B.C.[7] Thus, on the grounds of jewelry parallels, figurine no. 2 should be dated to the third century B.C.[8]

Four additional figurines were found in a structure excavated near the southeastern edge of the upper terrace (fig. 2. IV). This structure (6.454 m) is similar to Sanctuary I, discussed above. Open to one side, it was erected on a rock-cut platform without a roof; its rusticated sandstone wall, built of ashlar-block masonry and covered with plaster, stands 1.04 meters high and measures 0.65 meters wide.[9] A bronze *thymiaterion* and a silver *phiale* were found here, again suggesting a cult site (Sanctuary IV). Two of the figurines were made of iron and two of bronze. The iron figurines (nos. 3 and 4) were placed together in a rectangular pit (0.45 x 0.30 m) cut into the bedrock in the southwestern corner of the structure (fig. 5). Just as figurines nos. 1 and 2, both wear gold jewelry: one is adorned with a twisted torque, bracelets, and a headdress of rosettes, while the other once wore a beaded necklace (figs. 6a, b and 7).[10]

The two bronze figurines (nos. 5 and 6) were not unearthed together. One was discovered inside Sanctuary IV, in a shallow depression roughly cut into the bedrock (fig. 9); an earlier channel outside the sanctuary was used for the other (figs. 8 and 12). Both were discovered face downward and wore gold ornaments (torques, bracelets, and earrings), similar to the jewelry of figurines nos. 1–4. Moreover, no. 6 wore an ivy-wreath head-dress made of golden thread that unfortunately disintegrated soon after its discovery (fig. 10).

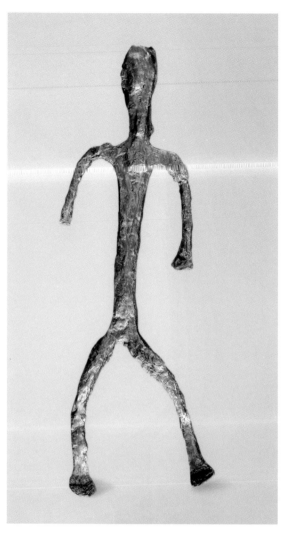

These two figurines seem to have been either wrapped or dressed in a textile, as further fragments of golden thread found around their bodies demonstrate.

Another anthropomorphic figurine (no. 7) was found in 2005, inside a cult structure in the north-western part of the upper terrace (figs. 1 and 11). This building (9.85 x 6.90 m), oriented east–west,

7. Figurine no. 4. Iron, H. 19 cm. 3rd century B.C. Georgian National Museum.

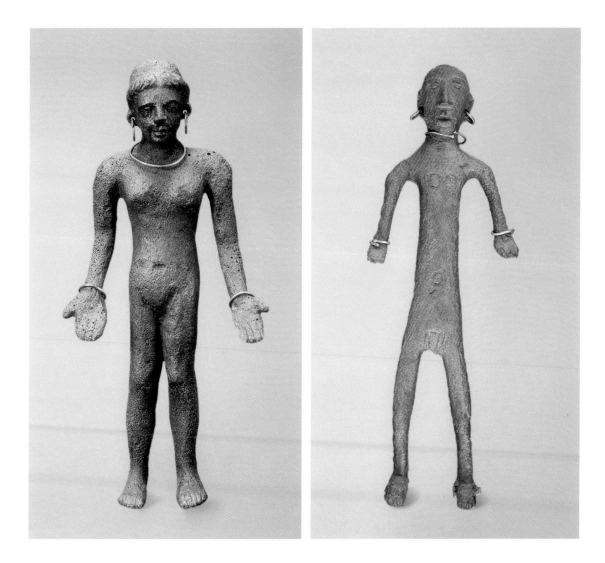

was also erected on a specially cut platform (fig. 2. V). Though the building was completely destroyed in the late Hellenistic period, cuttings for ashlars preserved on the bedrock allow for a reconstruction of its original plan. Its overall layout proved to be a novelty for the site, with its stepped socle on which walls decorated with half-columns had been erected. In the western part of the building, outlines of an altar came to light, with a sacrificial pit, attesting to the cult character of the building. In a rectangular hollow (0.30 x 0.26 m) located between this altar and the southern wall of the sanctuary, a bronze figurine was placed, facing upward, with its head to the east. This figurine (no. 7) is a standing nude youth, wearing a torque and bracelets. Appliqués to be sewn on cloth were also found with the figurine, suggesting that it was perhaps wrapped

8. Figurine no. 5. Bronze, H. 16 cm. 3rd century B.C. Georgian National Museum.

9. Figurine no. 6. Bronze, H. 18 cm. 3rd century B.C. Georgian National Museum.

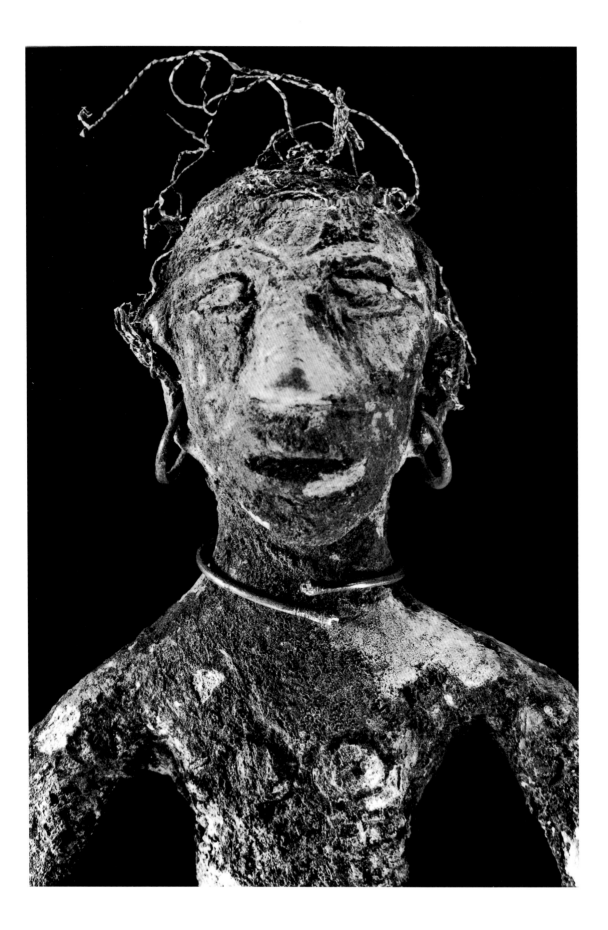

with decorated material like some of the others. Pointed ears and an ivy wreath identify him as a satyr, a member of the Dionysiac circle. The protuberances on the underside of the feet were apparently designed for attachment to another object. Thus, the original design of this very figurine seems to have been of a decorative character.[11] All the jewelry adornments are gold and have parallels among Colchian personal ornaments of the third century B.C.[12] The satyr's tail as well as the attributes once held in its hands were intentionally removed before burial, apparently in an attempt to divorce the satyr from its original meaning.[13] This kind of alteration, together with the iconography of the figure, suggests that the figurine, imported from the Hellenistic Greek world, was reused at a later time, when the locally produced gold accessories would have been added.

In summary: of the figurines, three are made of iron and four of bronze. The sculptures are small in size, ranging from 16 to 30 centimeters in height. All figurines are depicted in standing posture, naked, with hands stretched forward (one bronze figurine no. 7 has its right arm raised), and all are adorned with gold ornaments. Abnormally elongated body proportions, short hands, and a triangular nose characterizes figurine nos. 1–4, and 6, giving them an awkward appearance. Details are more delicately rendered on no. 5; no. 7 is a typical piece of Hellenistic Greek bronze work. Interestingly enough, none of the figures is stable (except no. 7), since they were not designed to be used as decorative statuary. Presumably, all the figures were clothed: imprints of fabric—garments or shrouds—are noticeable on the ithyphallic iron figurine (no. 1); fragments of gold thread were found on two bronze figurines (nos. 5 and 6); imprints of cloth are also noticeable on bronze figurine no. 2. The latter and figurine no. 7 were accompanied by ornaments to be sewn onto fabric.[14]

All seven figurines proved to be connected with cult buildings, although the conditions of their discovery were somewhat different in details. Four of the group—the three iron figurines and one bronze (nos. 1–4)—lay on a cover-tile placed in a pit specially hewn in the bedrock and covered with another cover-tile (fig. 5). These are clearly an imitation of contemporary burials but with simple cover-tiles used instead of wooden constructions as in the pit-graves. In one case, the pit was cut inside the sanctuary; in two others, pits were hewn outside the sanctuary, either on the platform or beyond it. Neither special pits nor coffins were made for the two bronze figurines found in Sanctuary IV (nos. 5 and 6). One of the figurines was placed in a shallow hollow, cut inside the structure, while for the other an earlier ditch outside the sanctuary was used (fig. 12). Both were placed face downward. The conditions of discovery for bronze figurine no. 7 had affinities with both groups. This one was placed in a pit deliberately cut inside the cult structure and without a special receptacle; however, it lay face upward.

Opinions differ about the function of these figurines. Guram Lordkipanidze connected the ithyphallic iron figurine with the mysteries of mourning chthonic deities, such as Persephone, who spent part of her life in the underworld.[15] While not specifically ruling out such a function

10. Figurine no. 6, detail showing gold threads of the headdress.

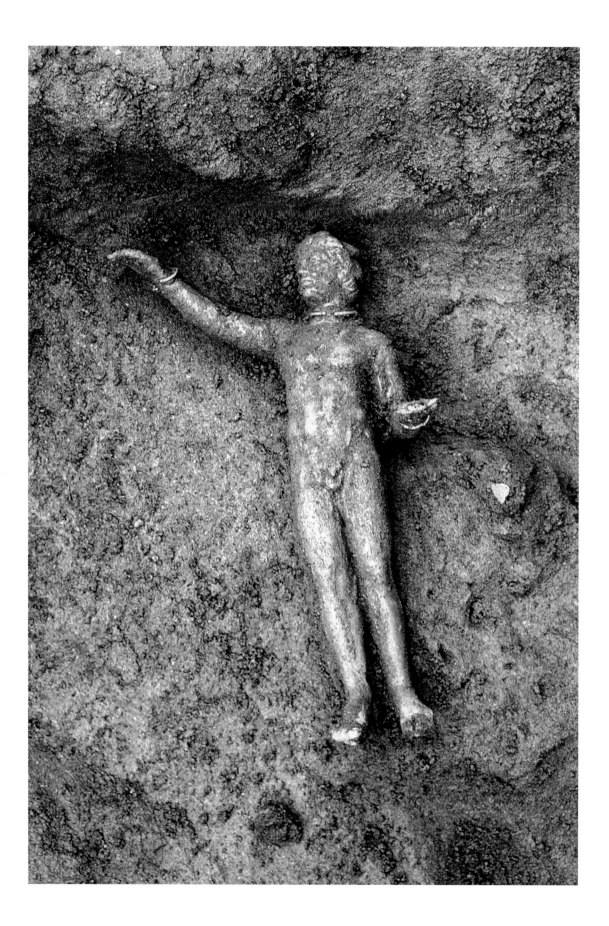

11. Figurine no. 7, Statuette of a Satyr, in situ.

12. Figurine no. 5, face down, in situ.

for some of the figurines, Otar Lordkipanidze identified figurines nos. 5 and 6 as priests praying for fertility.[16] Since they were deliberately buried face down, that is, with their outstretched arms toward the earth, Lordkipanidze interpreted them as priests asking the Mother Goddess to bless the land of Vani (fig. 12). In addition, because they were not found in coffins or between cover-tiles like the other figurines but were simply buried in the ground, a non-funerary explanation seems possible.

Recently, Nana Matiashvili has argued that in earlier periods priests could have been sacrificed in an unknown religious ritual. By the third century B.C., however, she goes on to suggest that this practice may have been replaced by the use of small figurines substituted for the actual priests.[17]

While the authors agree with Otar Lordkipanidze's argument for figurines nos. 5 and 6, we would like to present a new interpretation for the others. All were buried within or close to a sanctuary. The sanctuaries in turn had several graves associated with them.[18] The figurines were also placed in pits that mimicked these graves. Such deliberate placement as well as the burial context suggests that the function of these figurines was different from that of nos. 5 and 6. Clearly, there was a connection between their placement and burial rites in Vani. The proximity to a sanctuary also suggests that the ritual practice may be related to a cult of the dead at Vani. Although there are no written sources from Vani itself or in Greek literature that discuss the cult of the dead here, the undeniable burial circumstances of these figurines and their connection with what have been identified as sanctuaries suggest that a cult

of the dead did exist in the Hellenistic period. The particular ritual practice described above appears to be unique to Vani, without analogy in Colchis or elsewhere in the Black Sea region, suggesting individualized ritual practice in this sanctuary city.

Notes

1.
N. V. Khoshtaria, "On the Excavation on the Top of the Hill," in *Vani IV* (Tbilisi, 1979), 115–34 [in Russian].
2.
D. Kacharava, "A Bronze Figurine from Vani," *Journal of Georgian Archaeology* 1 (Tbilisi, 2004): 225–26, fig. 10
3.
Khoshtaria, "On the Excavation on the Top of the Hill," 128–29; A. Chqonia, *Gold Ornaments from the Vani Site=Vani VI* (Tbilisi, 1981), 57–58, cat. no. 73 [in Georgian, with Russian and English summaries].
4.
Chqonia, *Gold Ornaments from the Vani Site*, 67–68, cat. nos. 79–81.
5.
Chqonia, *Gold Ornaments from the Vani Site*, 86, 128, cat. nos. 220–41.
6.
Chqonia, *Gold Ornaments from the Vani Site*, 118, cat. nos. 1100–1113.
7.
V. Tolordava, "A Rich Grave from Dablagomi," in *Vani II* (Tbilisi, 1976), 69, fig. 96 [in Georgian, with a Russian summary].
8.
D. Kacharava, "A Bronze Figurine from Vani," *Journal of Georgian Archaeology 1* (Tbilisi, 2004): 225–26, fig, 1.
9.
D. Kacharava, "Bronze Figurines from Vani," *Dzeglis megobari* 63 (Tbilisi, 1983): 33–34 [in Georgian, with summaries in Russian and English].
10.
The beads were found near the figure during the excavations.
11.
G. Kvirkvelia, "A New Bronze Statuette from Vani," in *Iberia-Colchis: Collected Papers on the Archaeological Studies of Georgia of the Classical Period 2* (Tbilisi, 2005), 187–88 [in Georgian, with an English summary].
12.
Chqonia, *Gold Ornaments from the Vani Site*, 74, 86.
13.
This is the unpublished opinion of Nino Lordkipanidze.
14.
Khoshtaria, "On the Excavation on the Top of the Hill," 115–16; Kacharava, "A Bronze Figurine from Vani," 225–26; Kacharava, "Bronze Figurines from Vani," 33–34; Kvirkvelia, "A New Bronze Statuette from Vani," 187–88.
15.
G. Lordkipanidze, *Towards the History of Ancient Colchis* (Tbilisi, 1970), 123 [in Russian].
16.
O. Lordkipanidze, *At the Sources of Georgia's Ancient Civilization* (Tbilisi, 2002), 212 [in Georgian].
17.
N. Matiashvili, *Questions of the History of Colchis in the Hellenistic Period* (Tbilisi, 2005), 39 [in Georgian].
18.
Specifically, Graves 1–4 are associated with Sanctuary I; Graves 20–24 and 26 form a group together with Sanctuary IV; Grave 16 is located next to Sanctuary III, while Grave 18 is located on the very platform of Sanctuary II (p. 52, fig. 2, nos. 7, 14, 11, and 9). See also the essay in this volume that deals with the contents of the graves, "The Golden Graves of Ancient Vani."

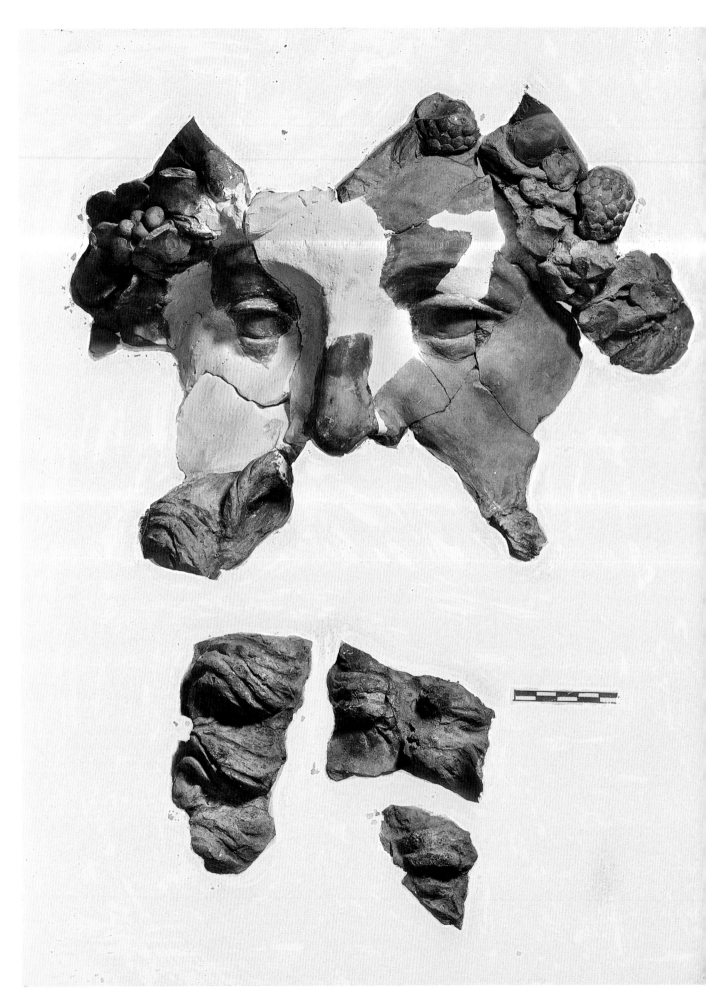

# Viticulture and Dionysos in Hellenistic Vani
## Darejan Kacharava and Guram Kvirkvelia

That wine played a central role in ancient Vani's social and religious life is demonstrated not only by the many objects in this exhibition associated with banqueting and wine-making, but also by the partially preserved architectural complex discovered on the southwestern part of the central terrace (p. 52, fig. 2, no. 17). Excavated periocally during the 1960s and 1970s, the precinct contained numerous objects that are clearly related to Dionysos and his circle. These finds, together with the organization and details of the complex itself, have led excavators to believe that this was an area dedicated to viticulture and wine-making and, thus, to Dionysos, the Greek god of wine.[1]

The production and consumption of wine and the cultivation of varieties of grapes were important aspects of Colchian life.[2] Although no literary sources specifically mention a cult dedicated to viticulture and wine-making in Colchis, it seems likely that such a cult would have existed in Vani and would have been associated with Dionysos at least by the Hellenistic period.

Archaeologically, the importance of wine in Colchis is most eloquently suggested by the composition of pottery finds: ceramic shapes that are definitely connected with the wine industry predominate as early as the sixth century B.C. and continue through the fourth. Large pithoi for storage or transportation of grains, oil, and honey, but mostly for the fermentation and storage of wine, as well as different kinds of jugs, bowls, *phialai*, and drinking cups, have been identified.[3] Metal drinking cups and wine jars, mostly bronze and silver, must also be mentioned. Local production of sizable clay amphorae began in the early Hellenistic period;[4] since their primary function was transportation of wine, their fabrication attests to the large scale of wine production in the region. The discovery of Colchian amphorae from this period in the northern Black Sea region provides additional evidence of wine production and its export.[5]

The importance of wine-making in the social and economic life of early Hellenistic Colchis is reflected in the widespread use of a specific burial rite—interment in pithoi during the Hellenistic period.[6] Although we do not have a full picture of burial customs in previous periods, it seems that pit-graves were often used. The use of pithoi during the Hellenistic period could be interpreted as evidence of the importance, or increased importance, of wine in burial practices (figs. 2a, b).

Of interest in this regard is a small bronze figurine representing a man drinking wine (fig. 3). Found in the vicinity of Vani, it can be dated to the seventh or sixth century B.C.[7] The figure has a

1. Mask of bearded Dionysos, from city-gate area. Terracotta, H. 32 cm. 2nd–1st century B.C., imported from Asia Minor. Georgian National Museum.

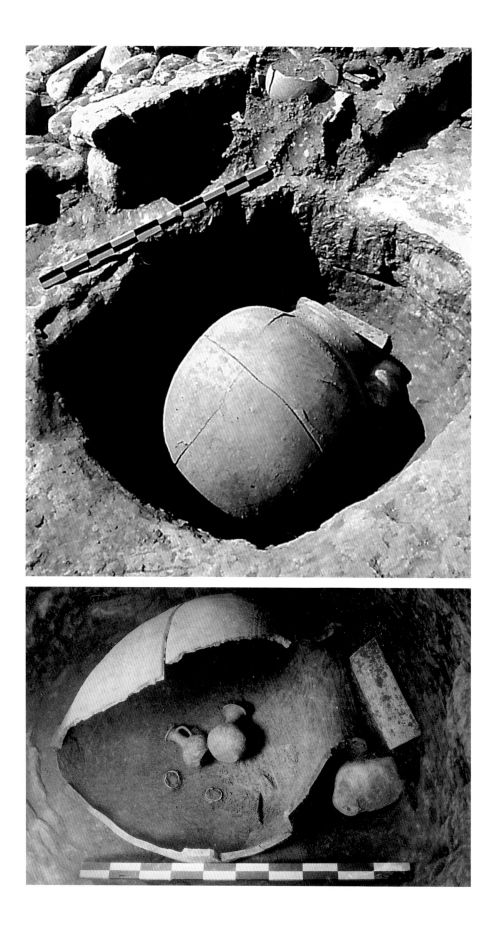

simplified anatomy—round head, elongated arms, particularly in comparison to his short legs—and is seated on an armchair with a short back. He holds his rhyton in front of him, perhaps offering a toast. This figure and the many storage, holding, pouring, and drinking vessels (as well as other representative pieces to be discussed below) point to the extensive development of viticulture and wine-making in ancient Colchis.

The overall plan of the architectural complex associated with viticulture and Dionysos is difficult to determine. Modern building activity destroyed the southwest corner of the three known rooms. Nevertheless, the general character of the complex can be ascertained from the excavated area (figs. 4a, b).[8] It had a complicated layout that incorporated local and Greek architectural elements, the latter indicating a certain amount of Hellenistic influence during the third to first centuries B.C. Built mainly of sandstone, the structure as excavated today has three adjoining chambers that are relatively small in scale, and what appears to be a colonnaded two-stepped altar on its northeast side. In addition, a narrow channel surrounded with holes at the top and to one side formed part of the complex. Hellenistic aspects of the building include rusticated ashlar masonry found in all three chambers and the use of clamps to hold the blocks together.[9]

One accessed the complex through a small, off-set opening at its northeast corner, entering its best-preserved chamber. This was the largest room, measuring 11 x 7 meters. An altar comprised of a base and a column measuring 70 centimeters in height stood toward the west wall. Its placement there forms part of the argument that the complex

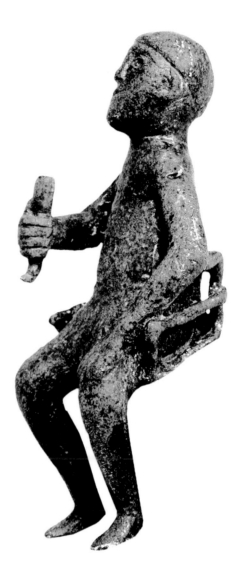

2a, b. Pithos before opening; pithos after opening, with various drinking and pouring vessels inside, from Grave 18. First half of the 3rd century B.C.

3. Seated figurine holding a *rhyton* for wine. Bronze, H. 7.5 cm. 7th or 6th century B.C. Georgian National Museum.

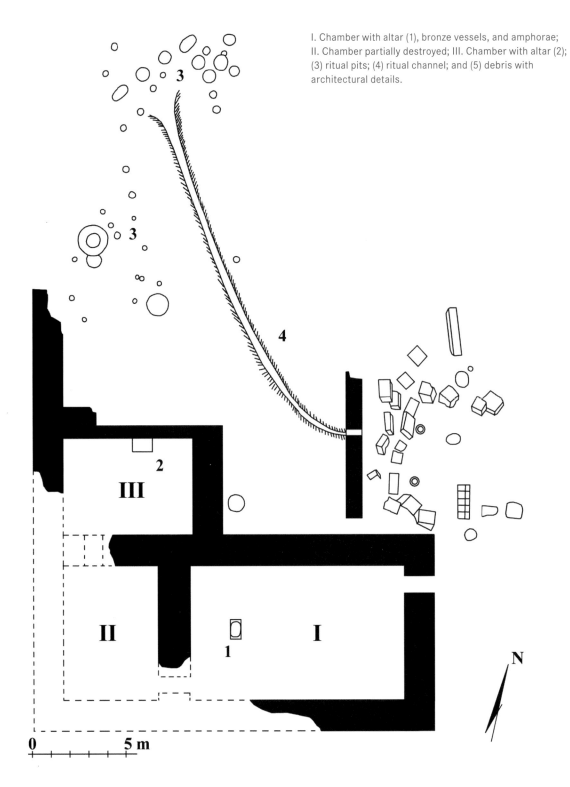

I. Chamber with altar (1), bronze vessels, and amphorae;
II. Chamber partially destroyed; III. Chamber with altar (2);
(3) ritual pits; (4) ritual channel; and (5) debris with
architectural details.

**3**

**3**

**4**

**2**

**III**

**II**

**I**

**1**

**N**

0        5 m

4a. Plan of temple complex on the central terrace
(after G. Kipiani, *Pagan Temples of Colchis and Iberia and
Problems of Origin of Georgian Christian Architecture*
[Tbilisi, 2000], pl. V).

functioned as a cult area, as this would have been the site for ritual sacrifices. Two more chambers are known to have existed, one of which extended from the first chamber to the west; the hypothetical reconstruction suggests that it measured 5 x 7 meters, but this is uncertain on account of the modern destruction. Along the north wall of the third chamber measuring 7 x 5 m, another altar was uncovered. Each of the three rooms is thought to have had an off-set entrance. This architectural feature also occurs in the temple complex on the lower terrace, which suggests that such entrances were characteristic of Vani's religious architecture.[10]

Excavated architectural fragments—large slabs of sandstone, three limestone column capitals (one with figural decoration), two column bases, and a fully preserved architrave block—suggest the existence of a portico adjacent to the complex (fig. 4b). This portico covered two steps that led to a rocky platform. A man-made channel, 18 meters long, ran from the top of the complex to the center of the portico's wall of hewn stone; surrounding the upper area of the channel are a series of pits. The bedrock-cut channel and the pits are elements that bring to mind a ritual act: perhaps blood was poured down the channel as a sacrifice. But since the excavators have not discovered anything in the channel or in the pits, we can only speculate on their precise function.

Two coins of the more than one hundred found in the first chamber are crucial in dating the complex. The first is a tetrachalkos minted in Amisos in 111–105 B.C.[11] The second, found in a Colchian pithos, was a tetrachalkos of the last group of Pontic copper coinage dated to 80–70 B.C.[12] Based on these two coins, it appears that the complex was in all likelihood functioning from at least the second half of the second century B.C. until the city's destruction. Architectural fragments in stone and terracotta, as well as pottery finds, confirm this time period for activity in the complex.

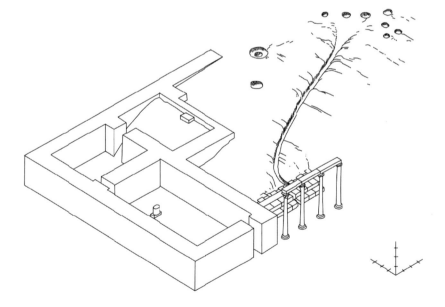

4b. Axonometric reconstruction of temple complex on the central terrace (after G. Kipiani, *Pagan Temples of Colchis and Iberia and Problems of Origin of Georgian Christian Architecture* [Tbilisi, 2000], pl. VIII).

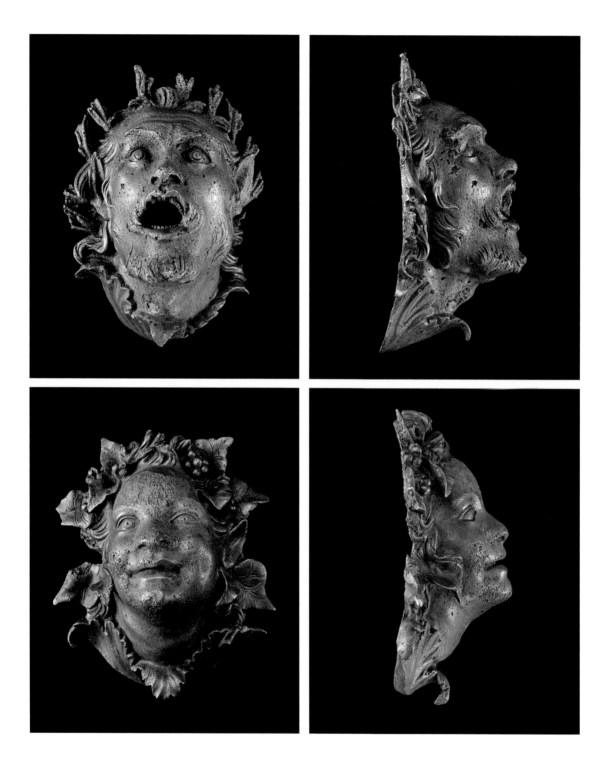

5a, b. Appliqué of a Pan. Bronze, H. 13 cm, W. 9.8 cm.
Second half of the 2nd century B.C., probably imported from
Asia Minor. Georgian National Museum.

6a, b. Appliqué of a Satyr. Bronze, H. 12.4 cm, W. 10.5 cm.
Second half of the 2nd century B.C., probably imported from
Asia Minor. Georgian National Museum.

The abundant finds aid in identifying the complex as a possible sanctuary dedicated to viticulture and, by the Hellenistic period, perhaps also to Dionysos. In support of this hypothesis are the forty Colchian amphorae that were found along the east side of the first chamber, presumably placed there as cult offerings. Even more important, however, are the many figural appliqués found in the same room, most of which show connections to Dionysos. In his book *Vani, une Pompéi géorgienne*, Otar Lordkipanidze discussed six bronze appliqués that represent members of the Dionysiac *thiasos* in conjunction with three pairs of griffin claws, positing that they could have formed one or more large vessels, perhaps for holding wine. On stylistic grounds, Lordkipanidze noted that they were clearly imported, perhaps from Asia Minor, and most likely dated to the second half of the second century B.C.[13] No pieces of the vessels' bodies were found, but the claws and three of the appliqués are included in this exhibition, and their iconography and function are worth exploring here.

The six exquisitely rendered appliqués, ranging from 10 to 13 centimeters in height, depict companions of Dionysos—namely, Pan, a satyr, Ariadne, and two maenads. The sixth is missing its face, but its grapevine wreath is preserved, thus connecting it to Dionysos. A highly expressive Pan is perhaps the most impressive of the group (figs. 5a, b). His large, intense eyes stare upward and his wide-open mouth reveals his teeth. His strongly creased brow adds to his energetic, if not frightening, expression. The beard and hair are not thick, but the latter is formed into clumps of various sizes that move in many different

directions, endowing it with a baroque quality. An ivy wreath frames his neck, adding to the figure's decorativeness. When viewed in profile, the almost aggressive three-dimensionality of the figure becomes apparent. The strongly rounded contour line suggests that it would have had to have come from a large rounded vessel, perhaps a cauldron.

Stylistically different from the Pan is a satyr whose expression and overall appearance is much more inviting (figs. 6a, b). Slightly inebriated, as his smiling face and vacant stare suggest, he looks blankly off to the side. His chubby face, almost cherubic in appearance, is characterized by round cheeks, small eyes, and full lips; rolls of plump flesh cover his thick neck. His lush wreath, which covers the front and sides of his head and extends around his neck, has a soft, luxuriant quality. This is clearly a satyr who has indulged in the pleasures of wine and its relaxing effects.

His partner, a similarly plump maenad, has an almost wild-eyed stare (figs. 7a, b). Her head, more oval in shape, turns sharply to the left. She gazes upward and to the left, her mouth slightly open. Like the satyr's, her hair is covered by a large, lush grapevine wreath, while two pin curls sit on top of her forehead. The strong three-dimensionality of these two appliqués suggests that they, too, came from large rounded vessels. The distinct stylistic differences between the Pan and the satyr and his companion maenad make it likely that more than one large vessel of extremely high quality was found in chamber one.

Also included in this exhibition are three pairs of griffin claws discovered along with the appliqués

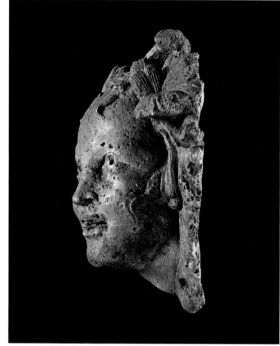

(fig. 8). Although they could have functioned as the feet for two tripods, comparative examples indicate that, alternatively, they can be interpreted as the feet of small furniture used for the preparation of food and drink.[14] The sharp claws of the griffin aggressively move forward; they terminate above the first joint, extending from a square plaque decorated by three evenly spaced arches. The flat back and apparent lack of any grooves for rod attachments provide strong evidence that they could have indeed functioned as attachments for wood legs. Comparative examples can be found in Greek furniture from the Hellenistic period: griffin claws similar to those found in Vani were commonly used for large chests with slatted sides and for rectangular or round tables with three legs.[15] The chests would be set near a *kline* (banqueting couch) with the tables in front of it;

both sets of furniture played a primary role in wine consumption during banquets.

Three eagles, one of which is included in this exhibition (fig. 9), were also discovered in chamber one. All had their wings fully spread in an active and temporary posture, as if caught at the moment they are ready to take flight. Solid-cast and thus extremely heavy, it is difficult to view the eagles as appliqués for a vessel. The flat bottom under their claws suggests that they would have been attached to another element— perhaps functioning as a decorative attachment for a piece of furniture. Without written sources, it is difficult to determine the precise meaning of the eagles at Vani. Although Zeus is frequently represented as an eagle in Western iconography, it is uncertain whether the head of the Greek

7a, b. Appliqué of a Maenad. Bronze, H. 12 cm, W. 12 cm. Second half of the 2nd century B.C., probably imported from Asia Minor. Georgian National Museum.

8. Three pairs of griffin claws. Bronze, H. 7.3–8.4 cm,
W. 7.3–8.1 cm. Second half of the 2nd century B.C., probably
imported from Asia Minor. Georgian National Museum.

9. Eagle. Bronze, H. 18.6 cm. Second half of the 2nd century B.C.,
probably imported from Asia Minor. Georgian National Museum.

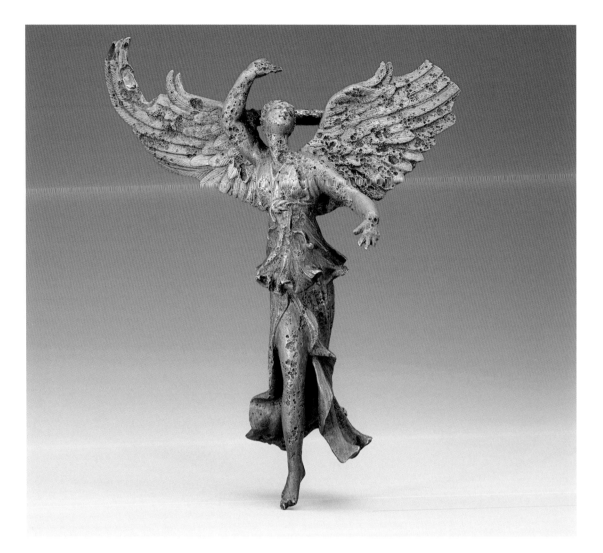

pantheon was worshipped at Vani or in Colchis during this period.

Finally, a figure of Nike, previously thought to have formed an appliqué for a large vessel, is solid-cast and at the same scale as the eagle (figs. 10a, b). She raises her right arm and extends her left. With sinuous drapery fluttering around her, she epitomizes the Hellenistic baroque style, recalling particularly the Nike of Samothrace.[16] The lower edge of her belted peplos is represented in a manner that suggests she is alighting in a windblown environment. The powerful expanse of her wings and the thin rod connecting them indicate that she could have held another element on her shoulders, but her exact function remains unknown. Perhaps she referred to the militaristic environment of the Hellenistic world with which Vani was engaged.

10a, b. Nike. Bronze, H. 22 cm. Second half of the 2nd century B.C., probably imported from Asia Minor. Georgian National Museum.

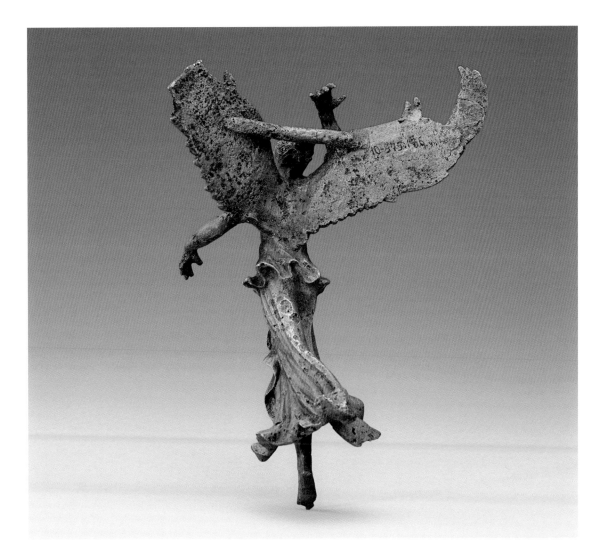

From the appliqués and the longstanding importance of viticulture in Colchis, one can assume that the people of ancient Vani were familiar with mythological images connected with Dionysos. The discovery of other Dionysiac objects supports this notion. Noteworthy among them are the fine fragments of a mask of Dionysos himself, discovered in chamber three.[17] Its glazed red color and strongly modeled face give it a fierce appearance.

Interestingly enough, the majority of the terracotta finds from this period at Vani are also directly related to the Dionysiac circle. One terracotta mask of Dionysos, in particular, stands out for its superb quality (fig. 1). It was found outside the gate of the town, together with some forty small clay pots and remains of charred beams. The mask represents an older Dionysos, his long beard comprised of two thickly twisted

The cumulative evidence of the wine amphorae, the other ceramic shapes connected with consumption of wine, the bronze vessels with Dionysiac ornament, the many Dionysiac objects including masks of the deity himself, and the terracotta mold of Silenos leads us to believe that the architectural complex here may have been dedicated to viticulture and thus directly connected with Dionysos. It lends strong support to the idea that Dionysos was worshipped in late Hellenistic Vani, though the scale and idiosyncrasies involved in the cult practice remain difficult to define, given the present state of our knowledge. The existence of the cult of viticulture and/or of Dionysos in Colchis is, however, quite understandable and could be easily explained, keeping in mind the widespread practice of Dionysiac cults in the Hellenistic East, on the one hand, and on the other hand, the centuries-old traditions of viticulture in ancient Georgia.[21]

sections. The face has a strongly realistic quality with the features rendered in fine details. Based on the pottery finds, the mask can be dated to the second to first century and ascribed to a production center in Asia Minor.[18]

And, finally, the discovery of a mold for casting a Silenos is extremely important (fig. 11). Excavated in a context dated to the second to first century B.C.,[19] the mold proves irrefutably that figures representing the Dionysiac thiasos were manufactured locally. Moreover, a representation of Dionysos and his companions made of local clay has been found at the Saqanchia settlement, about one kilometer from Vani and considered its industrial district: a fragment of a terracotta plaque from a wall of an altar, dated to the second half of the second century B.C., shows Ariadne embracing Dionysos, who is supported by his young favorite, the satyr Ampelos.[19]

11. Mold for casting a Silenos. Terracotta, H. 5.7 cm. 2nd–1st century B.C., produced locally. Georgian National Museum.

## Notes

**1.**

N. Khoshtaria, O. Lordkipanidze, and R. Puturidze, "Archaeological Excavations at Vani in 1967," in *Vani I* (Tbilisi, 1972), 176–79; O. Lordkipanidze, R. Puturidze, V. Tolordava, G. Lezhava, G. Lordkipanidze, N. Matiashvili, A. Chqonia, and B. Mchedlishvili, "Results of Field Archaeological Excavations Carried Out in Vani in 1970–1971," in *Vani II* (Tbilisi, 1976), 7–31 [in Georgian, with a Russian summary]; R. Puturidze, "Archaeological Excavations in the Southwestern Part of the Central Terrace of the Vani Site," in *Vani VIII* (Tbilisi, 1986), 34–41 [in Georgian, with a Russian summary].

**2.**

A. Bokhochadze, *Viticulture and Wine-making in Ancient Georgia according to Archaeological Remains* (Tbilisi, 1963) [in Georgian]; G. Lordkipanidze, *Colchis in the Sixth to Second Centuries B.C.* (Tbilisi, 1978), 97 [in Russian, with an English summary].

**3.**

O. Lordkipanidze, Gigolashvili, D. Kacharava, V. Licheli, M. Pirtskhalava, and A. Chqonia, *Colchian Pottery of the 6th–4th Centuries from Vani = Vani V* (Tbilisi, 1981), 14–25, 33–43 [in Georgian, with a Russian summary].

**4.**

R. Puturidze, "Colchian Amphorae from Vani," *Kratkie soobshchenia Instituta arjheologii* 151 (1977): 69–71 [in Russian].

**5.**

G. Kvirkvelia, "Colchis–North Black Sea Area–Sinope: The System of Interregional Trade," in *Production and Trade of Amphorae in the Black Sea, International Round-table Conference, Batumi-Trabzon, 27–29 April 2006*, List of Abstracts, 27–28.

**6.**

V. Tolordava, *Burial Rites in Georgia of the Hellenistic Period* (Tbilisi, 1980) [in Georgian, with a Russian summary].

**7.**

S. Kharabadze, "Wine Drinker from Inashauri Village (Vani district)," *Dziebani* 17–18 (2006): 145–50 [in Georgian, with an English summary].

**8.**

There may also be more of the building to the east, but modern building at present does not allow the team to excavate in this area.

**9.**

G. Kipiani, *Pagan Temples of Colchis and Iberia and Problems of the Origin of Georgian Christian Architecture* (Tbilisi, 2000), 10–25 [in Georgian].

**10.**

Kipiani, *Pagan Temples of Colchis and Iberia*, 9–10.

**11.**

G. Dundua, "Were coins minted in Vani?" *Herald of the Georgian Academy of Sciences* 2 (1974): 152; G. Dundua and G. Lordkipanidze, "Coins from Vani," in *Vani III* (Tbilisi, 1977), 141, cat. no. 91.

**12.**

Dundua and Lordkipanidze, "Coins from Vani," 125, 140, cat. no. 79.

**13.**

O. Lordkipanidze, *Vani, une Pompéi géorgienne* (Besançon, 1995), 37–41.

**14.**

For an introduction to ancient furniture, see H. S. Baker, *Furniture in the Ancient World: Origins and Evolution, 3100–475 B.C.* (New York, 1966), in particular, Greek furniture: 255–83.

**15.**

G. M. A. Richter, *Ancient Furniture: A History of Greek, Etruscan, and Roman Furniture* (Oxford, 1926): rectangular tables 80–81; round tables 87; chests 91.

**16.**

For description of the Nike of Samothrace, its chronology, and its setting in the context of the sanctuary of the Great Gods, see R. R. R. Smith, *Hellenistic Sculpture: A Handbook* (London, 1991), 77–79; H. Knell, *Die Nike von Samothrake: Typus, Form, Bedeutung und Wirkungsgeschichte eines rhodischen Sieges Anathems im Kabirenheiligtum von Samothrake* (Darmstadt, 1995).

**17.**

R. Puturidze, Archeological Excavations of the South-western part of the Central Terrace of the Vani site, in *Vani VIII*, Tibilisi, 1987, pl 25.8.

**18.**

K. Ramishvili, "Terracottas from Vani," in *Vani II*, 191–204 [in Georgian, with a Russian summary].

**19.**

N. Matiashvili, "Metal Vessels," in *Vani III*, 113–14, 11 [in Georgian, with a Russian summary].

**20.**

For Saqanchia, see V. Licheli, *Ancient Vani: The Industrial District* (Tbilisi, 1991), 82–88 [in Georgian, with summaries in Russian and English]. For the fragmentary terracotta plaque, see ibid., 81, fig. XXXVII; and P. Guldager Bilde, "Roadmap to Salvation? Reflections on a Group of Hellenistic Terracotta Altars," in *The Black Sea in the Hellenistic World System* (Tbilisi, 2005), 78–81.

**21.**

In Georgia, pips of cultivated grapes are found at the sites of the early farming culture, dated to 7000–5000 B.C. See T. Chubinishvili, L. Nebieridze, and G. Pkhakadze, "Sites of Early Farming Culture (VI–IV Millennia) in the Zone of the Arukhlo Hydrosystem," in *Archaeological Investigations on the Construction Sites of Georgia* (Tbilisi, 1976) [in Russian]; see also P. McGovern, *Ancient Wine: The Search for the Origins of Viniculture* (Princeton, 2003), 23–24; D. Cavalieri, P. E. McGovern, et al., "Evidence for S. cervisiae Fermentations in Ancient Wine," *Journal of Molecular Evolution* 57 (2003): 226.

# The Golden Graves of Ancient Vani
## Darejan Kacharava and Guram Kvirkvelia

Perhaps the most compelling evidence for cultural interaction and exchange at Vani comes from the city's "golden graves." Although archaeological evidence indicates that the city was in existence from at least the eighth century B.C., the twenty-eight graves uncovered thus far are from a later period, ca. 450–250 B.C., when Vani seems to have been at the height of its prosperity.[1] In the richest of these graves, a vast array of objects was interred with the deceased—from large quantities of locally produced gold jewelry to exotic imports from both western and eastern neighbors.

A brief discussion of grave construction and burial practices during this period is provided below. Treatment of the five graves included in the exhibition follows, together with a listing of objects found in each grave. Only some of the grave goods are on display, their selection based primarily on their state of preservation. Since the graves are the subject of the 2010 Vani Symposium, only very tentative conclusions about their ritual significance can be proposed here. It is our hope, however, that the outlines provided will stimulate further discussion of the material.

Of the twenty-eight graves excavated to date, only four—Graves **6**, 7, 8, and **11,**[2] located on the central and lower terraces—date to the earliest period (450–350 B.C.). All four were surrounded by habitation layers, and it is therefore assumed that, unlike in the Greek world where the deceased were buried outside the city limits, no separate necropolis existed at Vani. Rather, the dead were buried not far from, or in the immediate vicinity of, their dwellings.[3]

The graves themselves were cut into the bedrock and were normally covered with pebble mounds. In addition, the discovery of nails within some graves indicates that wooden constructions were set into the pits and most likely served as containers for the remains of the deceased. No strict burial rites seem to have been followed. Both group and individual burials, for example, have been unearthed. It appears, however, that inhumation was the common practice.

Grave **11**, the earliest grave excavated thus far at Vani, provides evidence that the practice of ritual sacrifice of both human and animals already existed in the fifth century B.C. Although the origin of this funerary rite has not yet been fully explored,[4] archaeological evidence indicates that ritual sacrifice continued into later periods and, thus, must have been of some significance at Vani and, indeed, in other Colchian cities.[5]

Later graves, from about 350 B.C. onward, were located on the central and upper terraces. While the majority of burials continued to be pits cut into the bedrock, and the practice of inhumation continued, some new customs made their appearance. One was the arrangement of a special platform along the south wall of the pit where servants and animals (horses, dogs) were laid to rest.[6] In some graves there is evidence of the continued use of a wooden construction.[7] Other new practices were the placement of death-coins in the mouth of the deceased,[8] as well as throughout the grave, and the inclusion as grave goods of amphorae or storage vessels and silver belts decorated with both geometric and figural motifs. The large number of gold and silver coins found in some graves might be interpreted as simple offerings for their intrinsic worth, paralleling other kinds of valuables for grave gifts.

Interment in clay vessels and stone cists came into common practice ca. 300–250 B.C. The prevalence of utilizing clay vessels as grave containers was not limited to Vani, but was also widespread throughout early Hellenistic Colchis, including the immediate vicinity of the city.[9] The cist-graves, however, seem to have been limited to Vani itself.

Another development is the placement of graves in the proximity of sacred buildings on the upper terrace. This practice occurred in the later fourth and third centuries. Sanctuary I and Graves 1–4 formed one group.[10] Sanctuary II and Grave 18 occupied the same rock-cut platform. In addition, a pithos-burial was arranged in an oval pit-grave located between the northeast walls of the platform and the sanctuary.[11] Sanctuary III and Grave 16, which was covered with a stone mound, formed a third group.[12] Finally, close to Sanctuary IV were Graves 20–24 and 26.[13]

Grave goods included in this exhibition are outstanding for their quality and quantity and clearly belong to the upper stratum of Colchian society.[14] The following sections present the graves included in this exhibition in chronological order: Graves **11**, **6**, **9**, **24**, and **4**.

---

Grave 11: Mid–5th century B.C.

---

Grave 6: First half of the 4th century B.C.

---

Grave 9: Third quarter of the 4th century B.C.

---

Grave 24: Second half of the 4th century B.C.

---

Grave 4: First half of the 3rd century B.C.

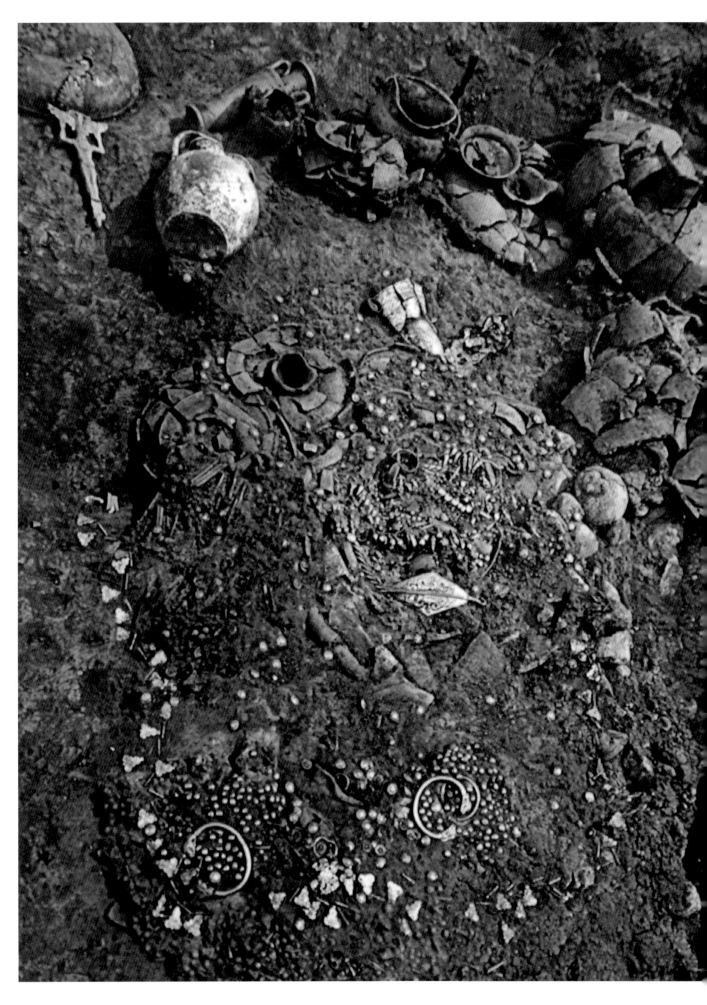

# Grave 11

The richest burial at Vani, Grave **11** was excavated in 1969 on the central terrace (figs. 1, 2). Its rectangular pit (3 × 3.70 m), cut into the bedrock, was covered with a pebble mound (p. 52, fig. 2, no. 41). The disposition of a series of iron nails suggests the existence of a wooden construction (L. 3.10 m; W. 2. 25 m; H. 1.50 m). Placed within the construction in an east–west orientation were four skeletons laid out in a supine posture: the principal deceased, a woman, was distinguished by the richness of her personal ornaments and her central location within the construction. In addition, three servants or slaves were buried south of her, and a horse's skeleton and iron horse-bits were discovered outside the structure.

The woman's body was richly adorned with gold and silver jewelry, indicating her elite status. Gold ornaments included: a diadem and a headdress decoration with pear-shaped pendants; two pairs of temple ornaments; five necklaces; two pairs of bracelets; and five finger rings.[15] Gold and carnelian spherical beads were also found in the wrist area, suggesting that they functioned as a distinct type of wrist decoration. Her garment was decorated with a fibula and two appliqués shaped like eagles. Also of interest is a clip-like ornament that perhaps functioned as part of the headdress.

An abundant amount of silver jewelry was found to the right side of the principal deceased. Although the silver objects outnumber the gold by almost three to one, there is less typological variety among them. Tubular and spherical beads have been identified, as well as a variety of multilateral, semispherical, fluted, bipyramidal, and boar-shaped pendants. A shroud adorned with gold bosses, its edges marked with tubular beads and ornamented plaques, appears to have covered her body.

The three servants laid to rest in the grave were far less richly adorned although it is interesting to note that they, too, wore gold jewelry. One servant wore a pair of gold earrings and a necklace of fluted gold beads; another, a combination of gold and silver that included a pair of gold earrings, two gold necklaces, three silver diadems, and five silver bracelets. A single gold earring was the only ornament connected with the third servant.[16]

The principal deceased was also distinguished from the rest of the interred by the grave gifts that were found surrounding her head area and placed along the pit walls. Many of these objects provide crucial evidence in dating the grave and, at the same time, are valuable indicators of Vani's active trade relations with both the West and the East.[17]

1. Detail of Grave 11, showing gold ornaments decorating the principal deceased and surrounding grave goods. Photographed during the 1969 excavation.

Along the east wall, near the woman's head, two glass vases, a clay jug, and an amphoriskos were set among valuable metal vessels: a bronze patera with an anthropomorphic handle from the so-called Acropolis Group (ca. 500–480 B.C.), an Attic bronze oinochoe (ca. 475–450 B.C.), and a bronze situla were side by side with two Attic silver kylikes, a silver situla, and a silver aryballos.[18] The silver situla found in the grave is another example of this commixture of different influences: its shape conforms to that of local bronze situlae, while its ornamentation seems to be influenced by Achaemenid art.[19]

The aryballos, magnificently decorated with a row of sphinxes, is also indicative of cultural exchange in the combination of exotic motifs, shape, and style. It has been interpreted as a product of Attic artisans by Otar Lordkipanidze and as an example of Lydian "Graeco-Persian" craftsmanship by John Boardman. More recently, Elene Gigolashvili interpreted it as the result of a combination of an Attic shape, an Ionian "orientalizing" style, and Achaemenid decorative elements.[20]

Other artifacts were set at the south end of the grave. At the southeast corner, an Athenian black-glazed cup (ca. 475–450 B.C.)[21] was placed among four Colchian bowls containing animal bones (geese, pig, goat, and cow),[22] while the southwest corner was occupied by two bronze situlae of Colchian production. On the pit floor, three large two-handled pots, three jugs, and two vases, now all in fragments, had originally been placed under the coffin, while a silver spoon was found between two servants. Finally, along the right side of the principal deceased, four rows of carefully arranged silver spherical beads alternated with three rows of tubular beads,[23] showing how precious jewelry was placed in the tomb.[24]

The inclusion of material that was clearly imported from Attica suggests an established familiarity with impressive Greek objects of the highest quality. In contrast, the influence of Achaemenid art is largely noticeable in decorative ornamentation on locally produced objects, as in the silver situla mentioned above.

2. Archival drawing of Grave 11, showing gold ornaments decorating the principal deceased and some of the surrounding grave goods.

סתיו 1969

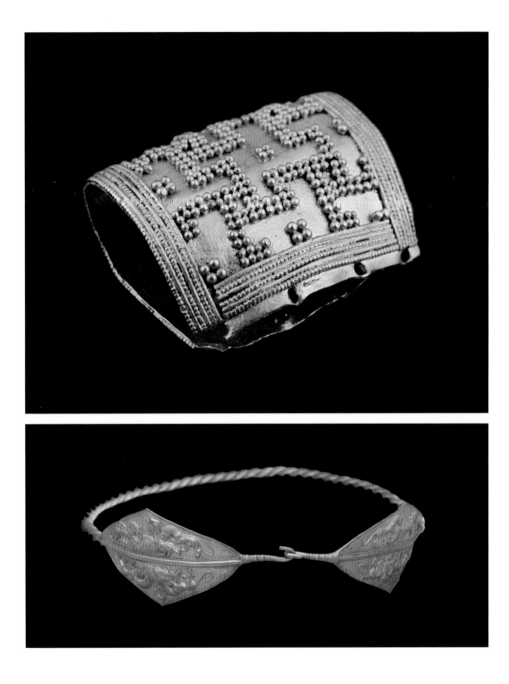

Plate 1

a. Gold Head Ornament with Swastika Decoration
Vani, mid-5th century B.C.
L. 1.9 cm, H. 1.4 cm
GNM:10-975:67

b. Gold Diadem with Twisted Rod and Lozenge-Shaped
Plaques with Animal Combat Scenes
Vani, mid-5th century B.C.
D. 23.5 cm, H. of Plaques 5.7 cm, L. of Plaques 10.6 cm
GNM:10-975:52

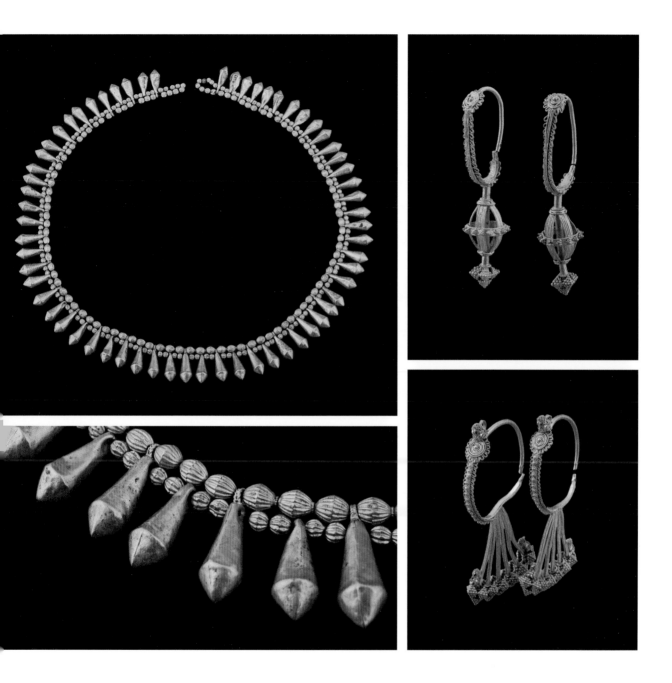

Plate 2

a. Gold Headdress with Stylized Pear Pendants
Vani, mid-5th century B.C.
L. of Chain 71 cm, H. of Beads 2.5 cm, D. of Beads 0.7 cm
GNM: 10-975:53

b. Detail of Gold Headdress with Stylized Pear Pendants

c. Pair of Gold Temple Ornaments/Earrings
with Open-Work Pendants
Vani, mid-5th century B.C.
Ring A: H. 6.6 cm, D. 1.6 cm
Ring B: H. 6.7 cm, D. 1.6 cm
GNM: 10-975:55a-b

d. Pair of Gold Temple Ornaments with Birds
Vani, mid-5th century B.C.
Ring A: H. 8.9 cm, D. of Ring 4.2 cm
Ring B: H. 8.3 cm, D. of Ring 4.2 cm
GNM: 10-975:54a-b

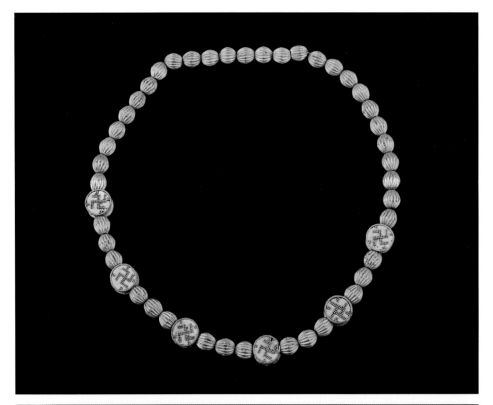

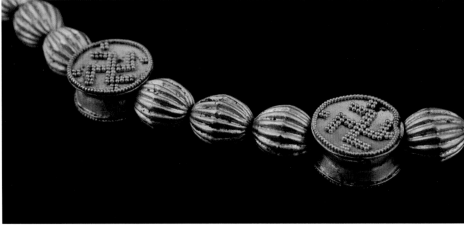

Plate 3

a. Gold Necklace with Swastika Decoration
Vani, mid-5th century B.C.
L. of Chain 39 cm, H. of Beads 0.6 cm
D. of Beads 1.1 cm, D. of Fluted Beads 0.8 cm
GNM: 10-975:60

b. Detail of Gold Necklace with Swastika Decoration

Plate 4

a. Gold Necklace with Ram Head Pendants
Vani, mid-5th century B.C.
L. of Chain 49 cm, H. of Pendants 1.5 cm
D. of Pendants 0.7 cm, D. of Beads 0.5 cm
GNM: 10-975:57

b. Detail of Gold Necklace with Ram Head Pendants

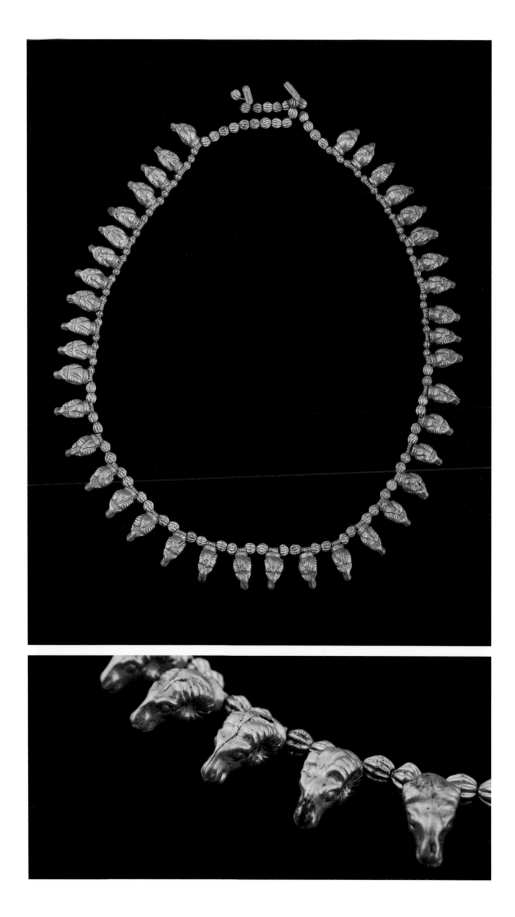

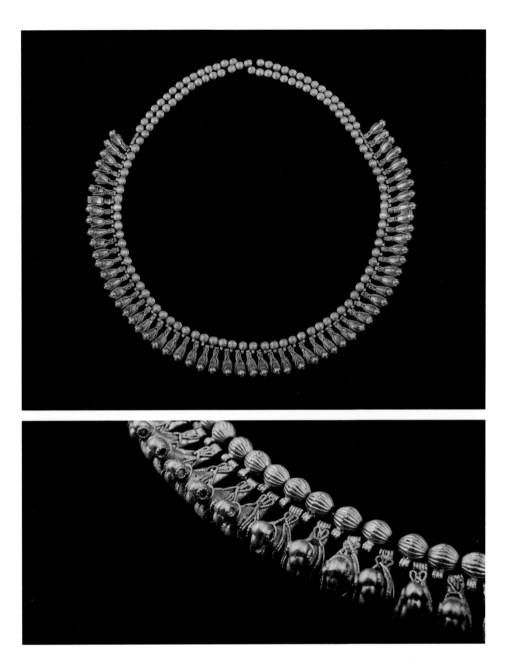

Plate 5

a. Gold Necklace with Bird Pendants
Vani, mid-5th century B.C.
L. of Chain 44 cm, H. of Pendants 1.8 cm
H. of Birds (max) 1.5 cm, D. of Birds (max) 0.8 cm
D. of Beads 0.5 cm
GNM: 10-975:58

b. Detail of Gold Necklace with Bird Pendants

Plate 6

a. Gold Necklace with Maize-Like Pendants
Vani, mid-5th century B.C.
L. of Chain 49 cm, H. of Pendants 3.0 cm, D. of Beads 0.6 cm,
GNM: 10-975:59

b. Gold Necklace with Turtle Pendants
Vani, mid-5th century B.C.
L. of Chain 66 cm, H. of Pendants 3.0 cm
GNM: 10-975:56

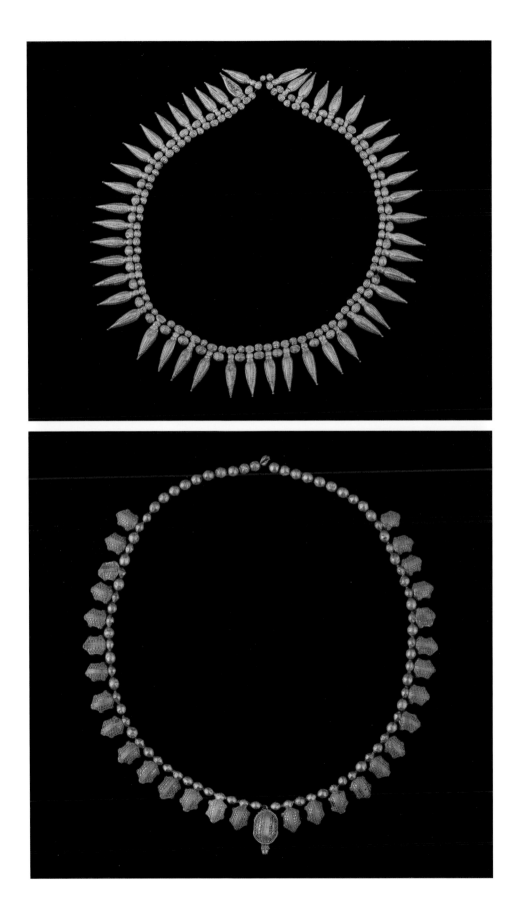

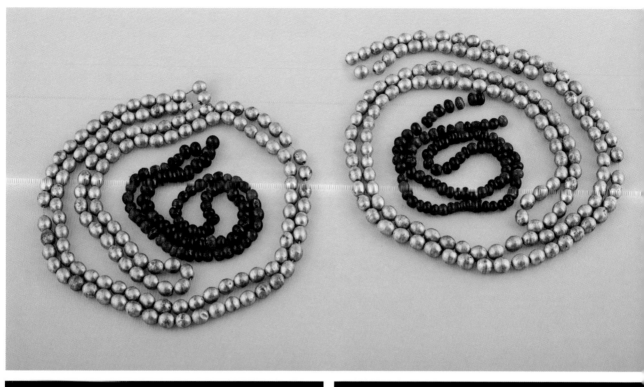

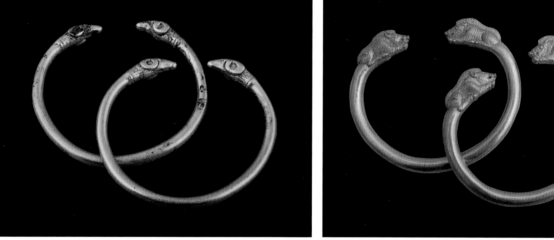

Plate 7

a. Two Sets of Gold and Carnelian Beads
Vani, mid-5th century B.C.
Set no. 63: L. of Gold String 62 cm, D. of Beads (max.) 1.0 cm
L. of Carnelian String 21 cm, D. of Beads (max.) 0.7 cm
Set no. 64: L. of Gold String 59 cm, D. of Beads (max.) 1.0 cm
L. of Carnelian String 21.5 cm, D. of Beads (max.) 0.8 cm,
GNM:10-975:63-64

b. Pair of Gold Bracelets with Ram Head Finials
Achaemenid, mid-5th century B.C.
Bracelet A: D. 5.3 cm, D. of Terminals 0.4 cm

Bracelet B: D. 5.3 cm, D. of Terminals 0.4 cm
GNM: 10-975:62a-b

c. Pair of Gold Bracelets with Boar Finials
Achaemenid, mid-5th century B.C.
Bracelet A: D. 7.8 cm, D. of Terminals 0.6 cm
Bracelet B: D. 7.6 cm, D. of Terminals 0.7 cm
GNM: 10-975:61a-b

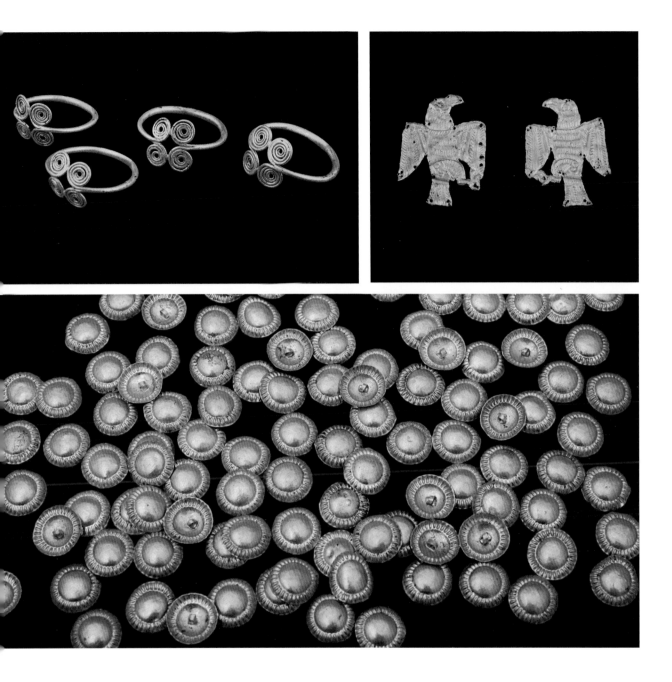

Plate 8

a. Four Gold Rings with Central Spiral Elements
Vani, mid-5th century B.C.
Ring A: D. 2.0 cm, H. of Spiral 1.1 cm
Ring B: D. 2.1 cm, H. of Spiral1.2 cm
Ring C: D. 2.0 cm, H. of Spiral 1.1 cm
Ring D: D. 2.1 cm, H. of Spiral 1.2 cm
GNM: 10-975:65a-d

c. Gold Round Bosses for Shroud Decoration
Vani, mid-5th century B.C.
259 Bosses, D. (max.) 1.3 cm
GNM: 10-975:73

b. Pair of Gold Eagle Appliqués for Garment Decoration
Vani, mid-5th century B.C.
Eagle A: H. 4.9 cm, W. 3.5 cm
Eagle B: H. 4.8 cm, W. 3.5 cm
GNM: 10-975:71a-b

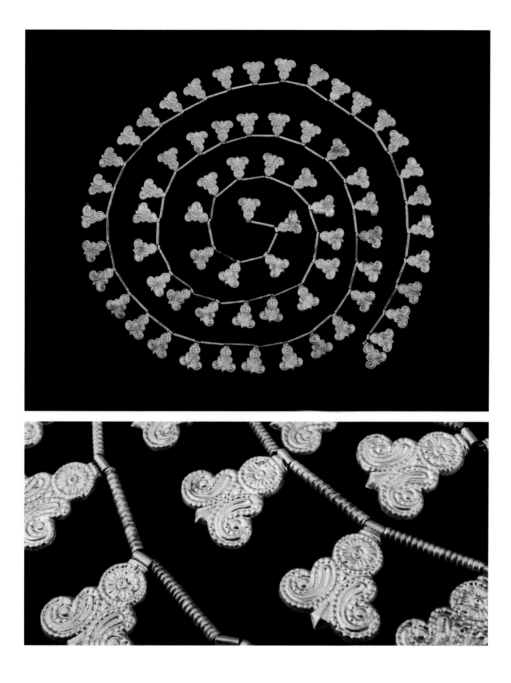

Plate 9

a. Gold Tubular Beads and Stylized Pendants for Shroud
Decoration
Vani, mid-5th century B.C.
L. 156 cm, H. of Pendants 2.3 cm, L. of Tubular Beads 2.0 cm
GNM: 10-975:72

b. Detail of Gold Tubular Beads and Stylized Pendants for
Shroud Decoration

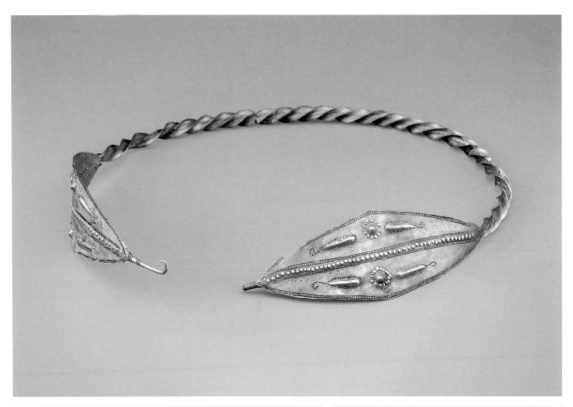

Plate 10

a. Silver Diadem with Twisted Rod and Lozenge-Shaped
Plaques with Geometric Decoration
Vani, mid-5th century B.C.
D. 21 cm, D. from Lozenge to Back of Diadem 18.4 cm
H. of Lozenge-Shaped Plaques 4.2 cm
GNM: 10-975:94

b. Three Flat Silver Bracelets with Engraved Geometric
Ornament and Animal Head Finials
Vani, mid-5th century B.C.
D. of Best Preserved Bracelet 6.0 cm
GNM: 10-975:95

c. Detail of Flat Silver Bracelet with Engraved
Geometric Ornament and Animal Head Finials

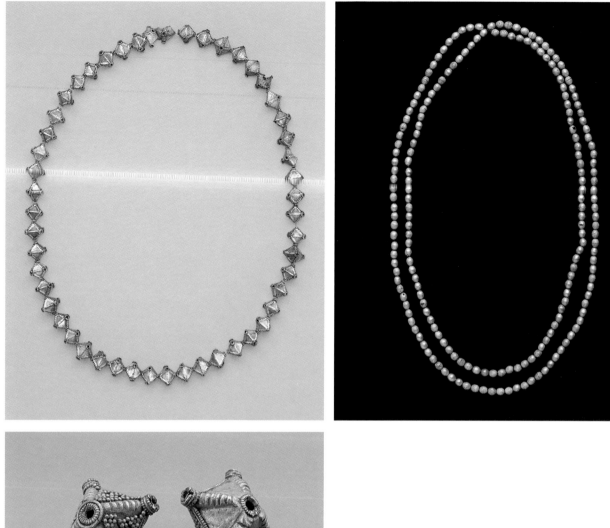

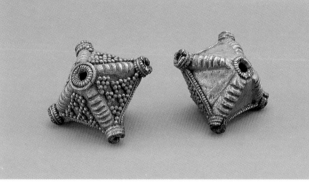

Plate 11

a. Silver Necklace with Bipyramidal Beads
Vani, mid-5th century B.C.
L. 37 cm, Approx. L. of Bead 1.0 cm
GNM: 10-975:83

b. Silver Necklace with Round Beads
Vani, mid-5th century B.C.
L. 146 cm, D. of Bead 0.7 cm
GNM: 10-975:74

c. Pair of Large Silver Granulated Beads
Vani, mid-5th century B.C.
L. 3.9 cm, H. 2.8 cm
GNM: 10-975:84

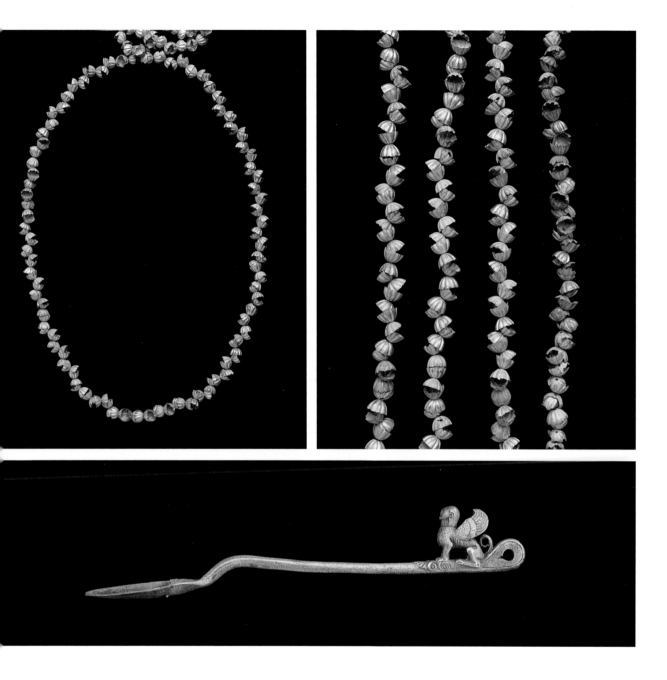

Plate 12

a. Silver Necklace with Fluted Beads
Vani, mid-5th century B.C.
L. 142 cm
GNM: 10-975:79

b. Detail of Silver Necklace with Fluted Beads

c. Silver Spoon with Representation of a Sphinx
Achaemenid (?), mid-5th century B.C.
L. 18.2 cm, D. 3.4 cm
GNM: 10-975:104

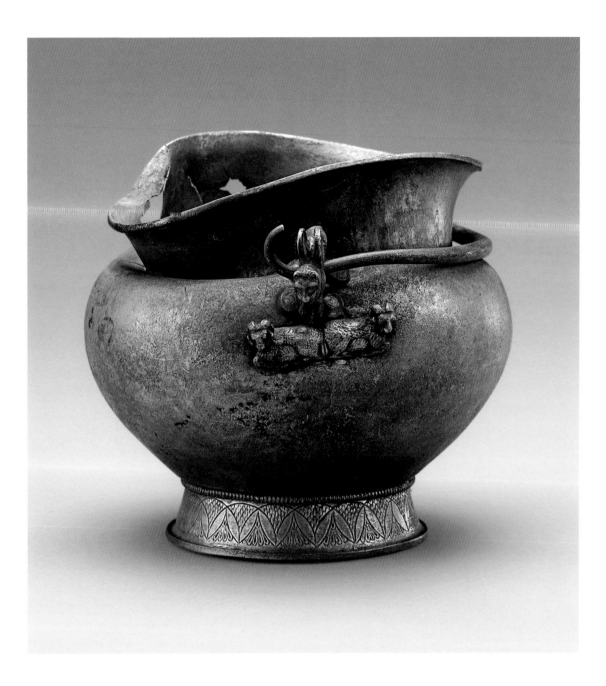

Plate 13

a. Silver Situla with Winged Lions and Recumbant Rams
Vani, mid-5th century B.C.
H. of Situla 13 cm, Situla Rim 11.9 cm
H. of Foot 2.0 cm, D. of Foot 8.8 cm
GNM: 10-975:102

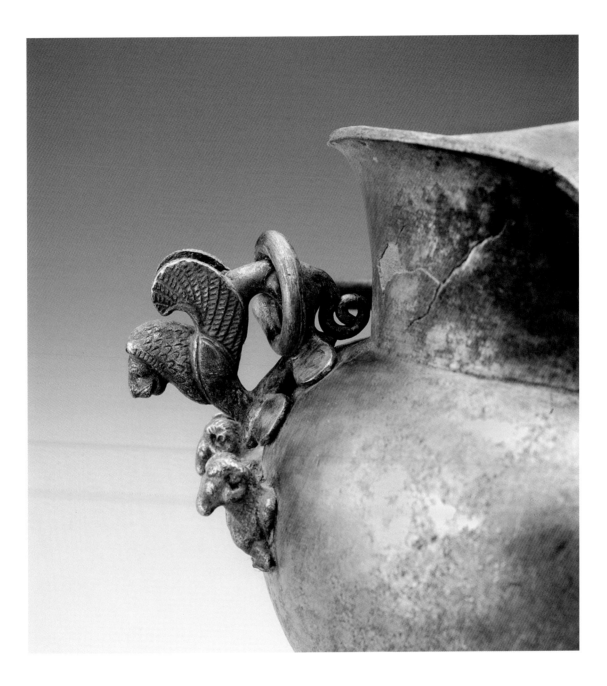

Plate 14

a. Detail of Silver Situla with Winged Lions and Recumbant Rams

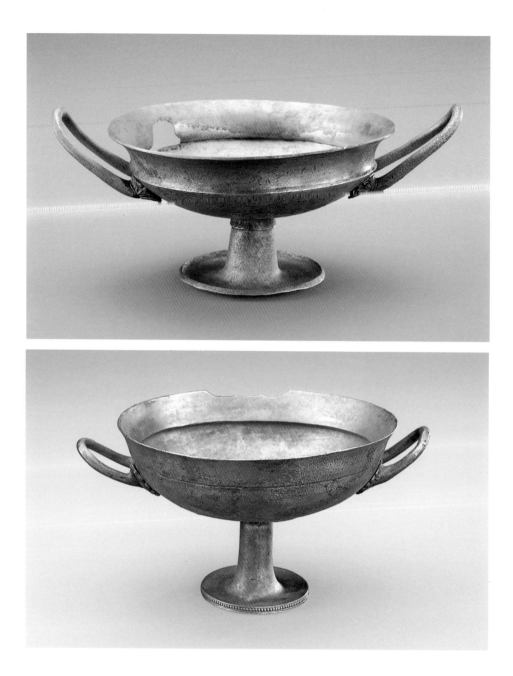

Plate 15

a. Silver Kylix with Gold Gilding Preserved at the Handle
Attic, 450 B.C.
H. 8.0 cm, D. of Lip 13.1 cm, D. of Foot 5.5 cm
GNM: 10-973:99

b. Silver Kylix
Attic, 450 B.C.
H. 6.8 cm, D. of Lip 11.2 cm, D. of Foot 5.9 cm
GNM: 10-973:100

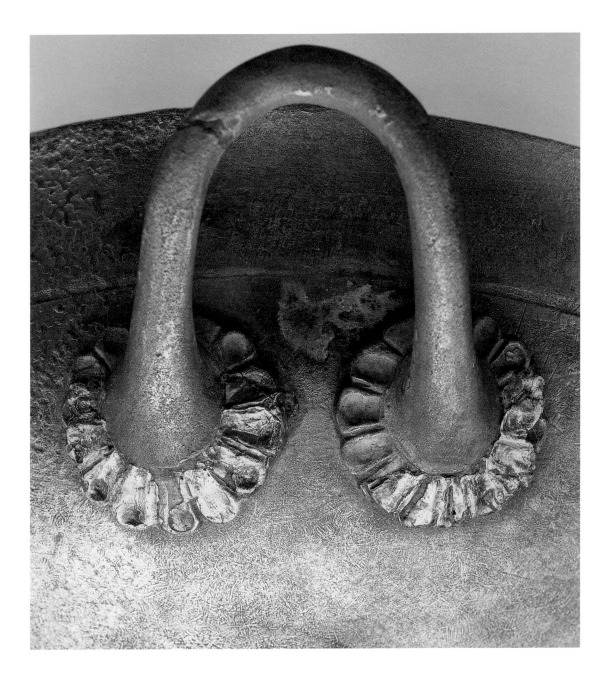

Plate 16

a. Detail of Silver Kylix with Gold Gilding Preserved at
the Handle

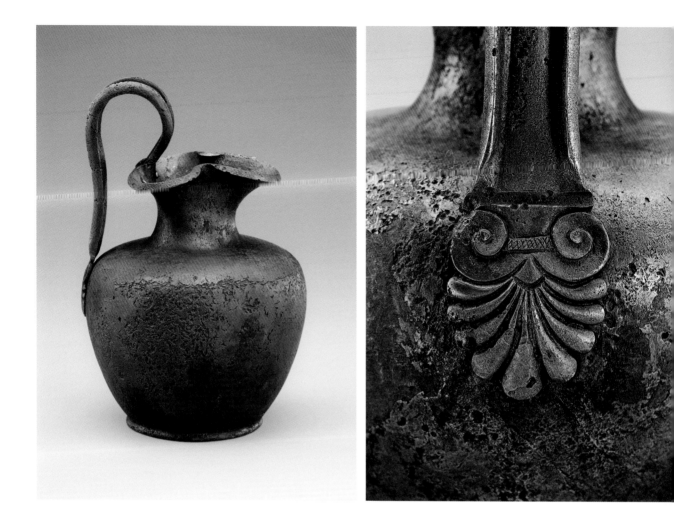

Plate 17

a. Bronze Trefoil Oinochoe with Decorative Palmette
Attic, 475–450 B.C.
H. at Handle 22 cm, L. from Handle 7.9 cm
D. 14.4 cm, D. of Base 9.2 cm
GNM: 10-975:89

b. Detail of Bronze Trefoil Oinochoe with Decorative Palmette

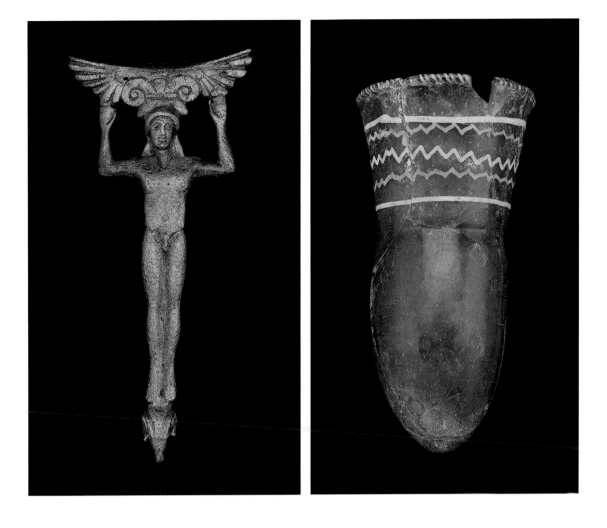

Plate 18

a. Bronze Patera Handle in the Form of a Kouros
Attic, 500-480 B.C.
L. 19 cm, D. 8.3 cm, D. of Top 1.5 cm
GNM: 10-975:97

b. Glass Vessel
Rhodian, 450 B.C.
H. 13.5 cm, D. of Lip 7.5 cm
GNM: 10-975:124

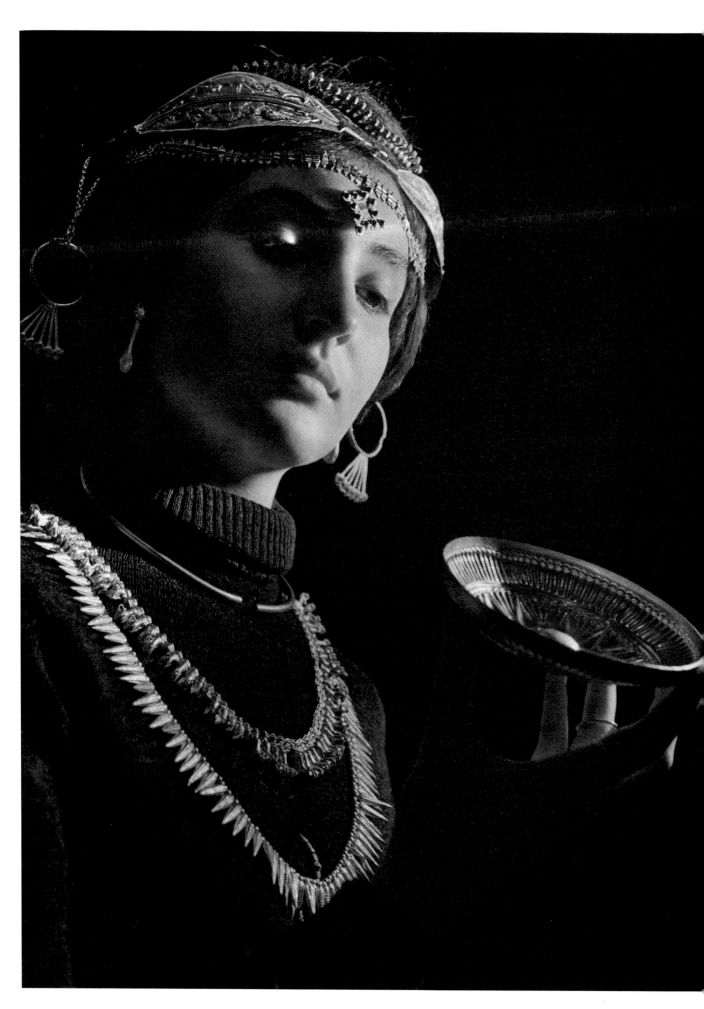

# Grave 6

Excavated in 1961 on the lower terrace of the site, Grave **6** consisted of a rectangular pit covered by a mound of large boulders (fig. 4); the pit itself was cut into bedrock at a depth of 1.5 meters, and its side walls measured 4 x 3.40 meters (p. 52, fig. 2, no. 57). The discovery of iron nails attest to the existence of a wooden roof over the pit. A woman, aged twenty-five (according to bone analysis), was lying on her back in the western part of the grave, arms downward, head to the north. Upon discovery, the deceased was adorned with jewelry only in the head and chest areas (fig. 3). The inventory was comprised of various personal ornaments, most of which were gold: a diadem, four pairs of temple ornaments (two pairs of the type with rays, one pair with equestrians, and one crescent-shaped pair), one single temple ornament with a biconical globule, a torque, five necklaces (three with figured pendants and beads, the fourth with a central rhomboid piece, and the fifth with plain beads), a pectoral suspended from the fibula by a chain, four bracelets with animal-head finials, four signet rings,[25] two eagle-shaped appliqués, two pyramidal pendants, beads of various shapes (biconical, spherical, tubular, cylindrical, cone- and cap-shaped), and three-lobed bosses (fig. 5).[26] A silver diadem, similar in shape to the gold one, was also among the grave goods; its rhomboid plaques are decorated with two almond-shaped bosses and a rosette between them, contrasting with the animal fight represented on the gold diadem.[27]

Of all of the jewelry, the pectoral appears to be the only definitively imported gold personal ornament. Its central trapezoidal plaque is decorated with cloisons that incorporate glass, turquoise, and carnelian. As John Boardman has argued, the plaque may have been produced in Persia in an Egyptianizing manner. What is clear is that at some point, the pectoral was equipped with a fibula and gold chains terminating in pomegranates so that it could ultimately be attached to a Colchian woman's dress.[28]

In addition to the gold jewelry, the grave goods consisted of metal vessels including three *phialai mesomphaloi*. One is made of gold and decorated with almond-shaped lobes and stylized lotus flowers. The other two are of silver— one is plain while the other has almond-shaped bosses and winged goats. Decorated phialai of this type are generally regarded as examples of Achaemenid art.[29]

One definite import is a silver drinking cup. Most likely Achaemenid, the cup has a slightly turned-out rim, horizontally fluted body, and a flat bottom, all stylistic traits of Achaemenid silver from this period.[30]

3. Model wearing a selection of gold ornaments from Grave 6.

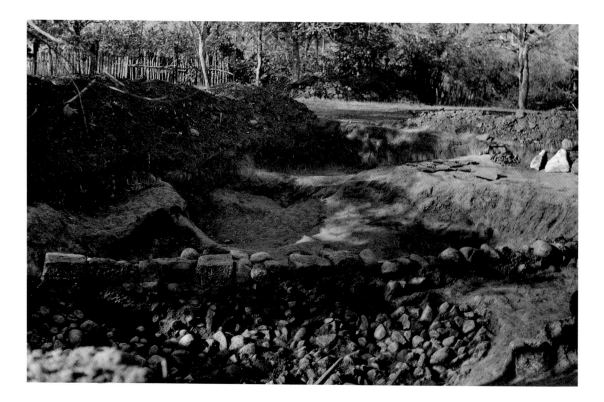

Only the handle and foot are preserved from an elegant silver situla, which in its extant state combines a local shape with ornamentation influenced by East Greek art. Sculptural attachments on the swivel handle represent a lion and two sheep, while the cone-shaped foot is decorated with tongues and lotus flowers.[31]

A handle from a bronze strainer, decorated with a lion's head and a duck's head finial, is thought to be an Athenian import dated to the first half of the fourth century B.C.[32]

Also among the finds were: a gold amulet case, a ladle and a flagon-shaped vessel, both made of silver, an ingot of gold bullion, an amber seal, and a locally made clay jar. In glass were five core-formed polychrome vessels: three amphoriskoi, an oinochoe, and an alabastron. The amphoriskoi, with their twisted instead of stable toes and with an added thread of a different color, are most likely Rhodian imports. The oinochoe may also have been produced in Rhodes, as its stable foot, shaped together with its body, and its disk-like lower handle attachments suggest.[33] Finally, dozens of frit beads that probably once decorated textile(s) were discovered in the eastern part of the grave.

Grave **6** is thought to be later than Grave **11** (mid-fifth century B.C.) on the basis of the gold bracelets whose best parallels are Achaemenid bracelets dated to the first half of the fourth century B.C.[34]

4. Stone mound covering Grave 6 before excavation.

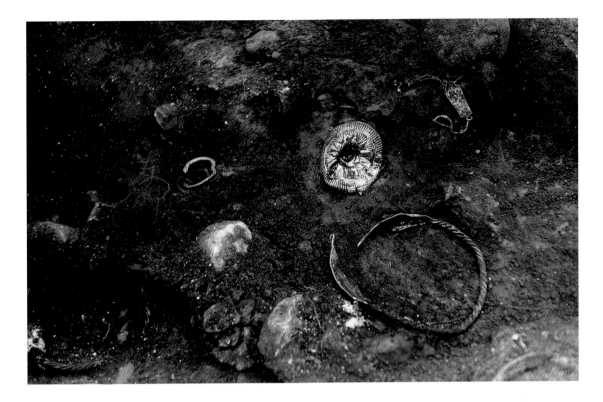

As was the case with Grave **11**, Grave **6** included imports from the Greek world. This is the one of the first times we see glass vessels from Rhodes. The gold pectoral and the Achaemenid-type silver drinking cups are indications of contact with the Persian Empire. Local artisans also continued to be inspired by Eastern decorative motifs, particularly on silver vessels. Yet the vast majority of gold objects continued to be defined by local compositions, styles, and motifs.

5. Detail of grave goods in Grave 6, including the gold diadem, phiale, pectoral, and bracelet.

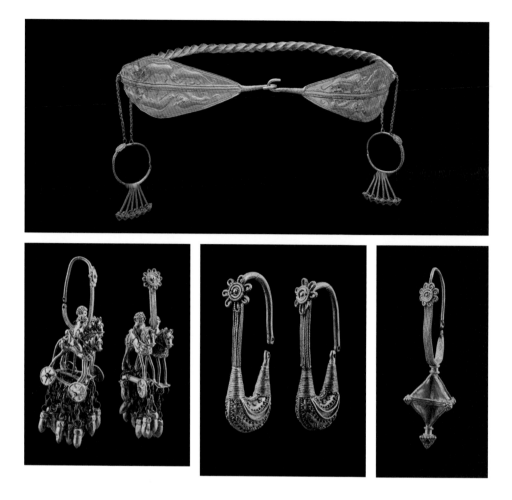

Plate 19

a. Gold Diadem with Animal Combat Scenes and Temple
Ornaments
Vani, first half of the 4th century B.C.
Diadem: D. 24.5 cm, H. of Plaques 4.6 cm
L. of Plaques 12.1 cm. Rings: H. 6.8 cm, D. (max.) 3.8 cm
W. of Pendants on Rings (max.) 3.9 cm, L. of chain 12.0 cm
GNM: 11-974:1 and 11-974:3

b. Pair of Gold Temple Ornaments with Horsemen
Vani, first half of the 4th century B.C.
Ring A: H. 8.2 cm, L. of Chariot 2.4 cm
L. of Horse 2.1 cm, H. of Rider 1.8 cm
Ring B: H. 7.9 cm, L. of Chariot 2.2 cm
L. of Horse 2.1 cm, H. of Rider 1.8 cm
GNM: 11-974:2a-b

c. Pair of Gold Crescent-Shaped Earrings
Vani, first half of the 4th century B.C.
Earring A: H. 3.9 cm, L. of Crescent 1.5 cm
Earring B: H. 3.7 cm, L. of Crescent 1.5 cm
GNM: 11-974:5a-b

d. Single Gold Temple Ornament with Bipyramidal Pendant
Vani, first half of the 4th century B.C.
H. 5.7 cm, W. of Pendant 2.1 cm
GNM: 11-974:6

Plate 20

a. Gold Torque
Vani, first half of the 4th century B.C.
D. 15.4 cm
GNM: 11-974:7

b. Gold Necklace with Bird Pendants
Vani, first half of the 4th century B.C.
L. 36 cm, H. of Pendants 1.2 cm, L. of Pendants 1.5 cm
GNM: 11-974:56

c. Detail of Gold Necklace with Bird Pendants

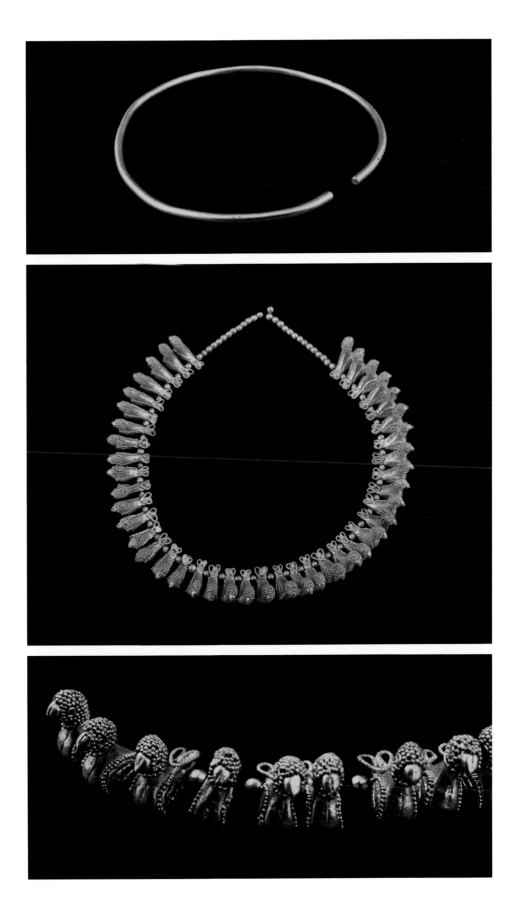

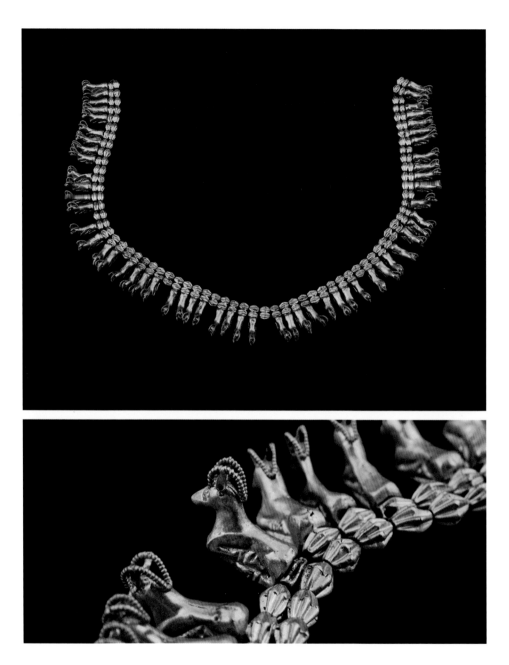

Plate 21

a. Gold Necklace with Gazelle Pendants
Vani, first half of the 4th century B.C.
L. 43 cm, H. of Pendants 1.3 cm, L. of Pendants 2.5 cm
GNM: 11-974:8

b. Detail of Gold Necklace with Gazelle Pendants

Plate 22

a. Detail of Gold Necklace with Central Rhomboid Pendant
Vani, first half of the 4th century B.C.
L. 31.5 cm, H. of Rhomboid Pendant 4.1 cm
H. of Small Pendants 1.2 cm
GNM: 11-974:11/54

b. Gold Necklace with Maize-Like Pendants
Vani, first half of the 4th century B.C.
78 Pendants, 210 Beads
L. 44 cm, L. of Pendants 2.5 cm, D. of Pendants 0.5 cm
D. of Beads 0.3 cm
GNM: 11-974:9

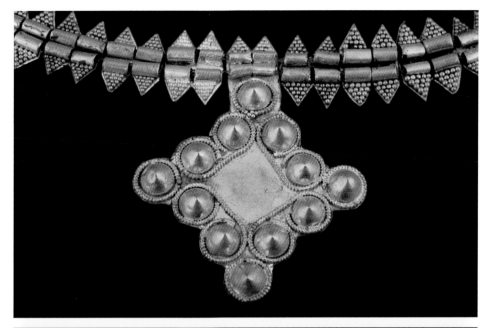

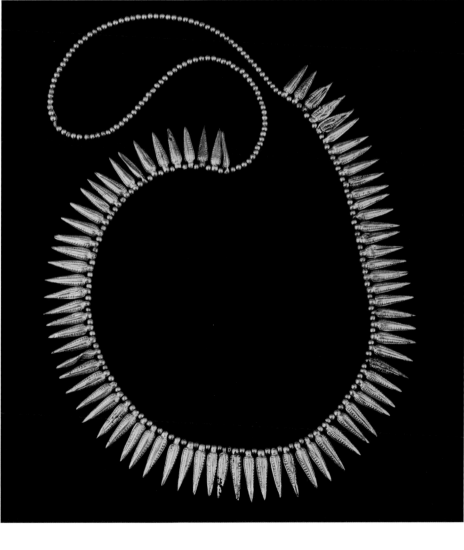

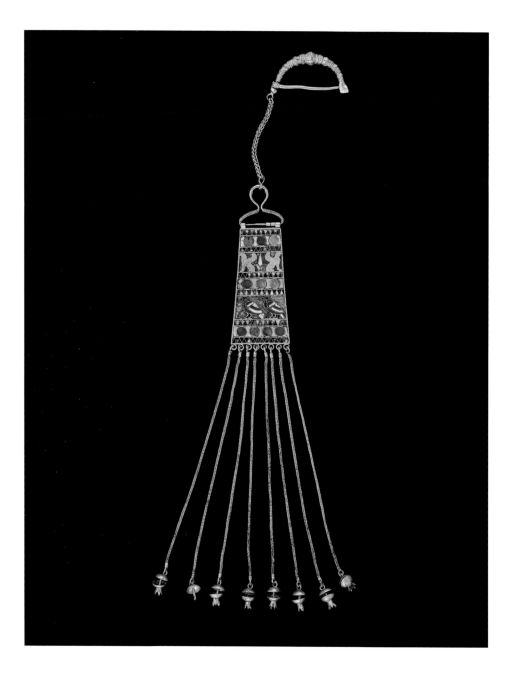

Plate 23

a. Polychrome Pectoral with Griffins and Birds
Achaemenid and Colchian, first half of the 4th century B.C.
H. (max.) 31 cm, H. of Plate 6.2 cm, W. of Plate (max.) 3.3 cm
L. of Chains with Pomegranates 14.1 cm, L. of Chain with
Brooch Clasp 5.0 cm, L. of Brooch Clasp 4.3 cm
H. of Brooch Clasp 2.0 cm, D. of Pomegranates 0.8 cm
GNM: 11-974:13

Plate 24

a. Detail of Polychrome Pectoral with Griffins and Birds

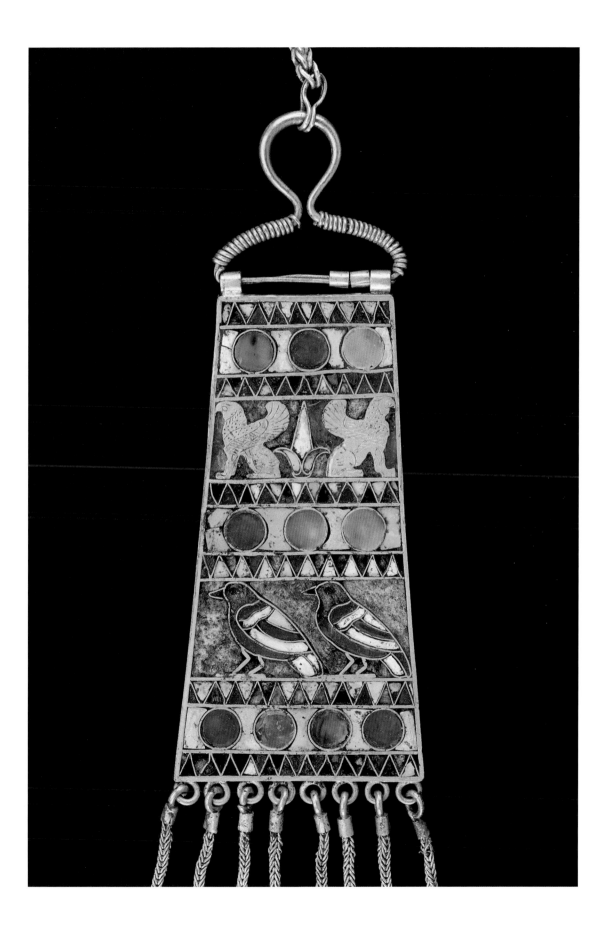

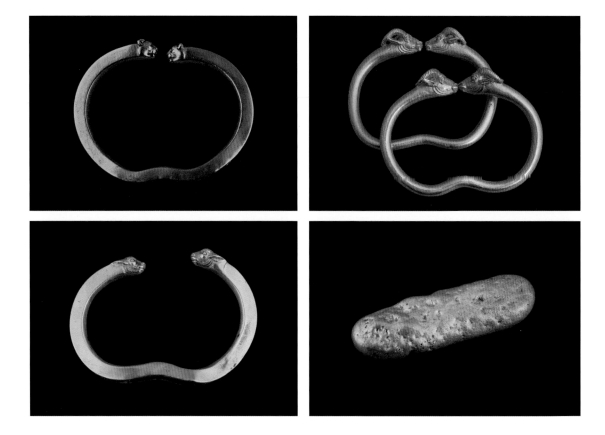

Plate 25

a. Gold Bracelet with Feline Head Finials
Achaemenid, first half of the 4th century B.C.
D. 8.9 cm, D. of Finial 1.0 cm, L. of Finial 1.2 cm
GNM: 11-975:15

c. Gold Bracelet with Calf Head Finials
Achaemenid, first half of the 4th century B.C.
D. 9.5 cm, D. of Finial 1.0 cm, L. of Finial 1.8 cm
GNM: 11-974:15

b. Pair of Gold Bracelets with Gazelle Head Finials
Achaemenid, first half of the 4th century B.C.
Bracelet A: D. 10.1 cm, D. of Finials 1.8 cm, L. of Finials 2.7 cm
Bracelet B: D. 9.9 cm, D. of Finials 1.9 cm, L. of Finials 2.8 cm
GNM: 11-974:14a-b

d. Gold Ingot
Vani, first half of the 4th century B.C.
L. 3.1 cm, H. 1.0 cm, W. 0.6 cm
GNM: 11-974:38

Plate 26

a. Gold Phiale Mesomphalos
Vani, first half of the 4th century B.C.
D. 13.3 cm, H. 3.1 cm
GNM: 11-974:39

b. Gold Round Bosses for Garment Decoration
Vani, first half of the 4th century B.C.
D. 0.8 cm
GNM: 11-974:31

c. Gold Round Bosses for Garment Decoration
Vani, first half of the 4th century B.C.
D. 0.7 cm
GNM: 11-974:32

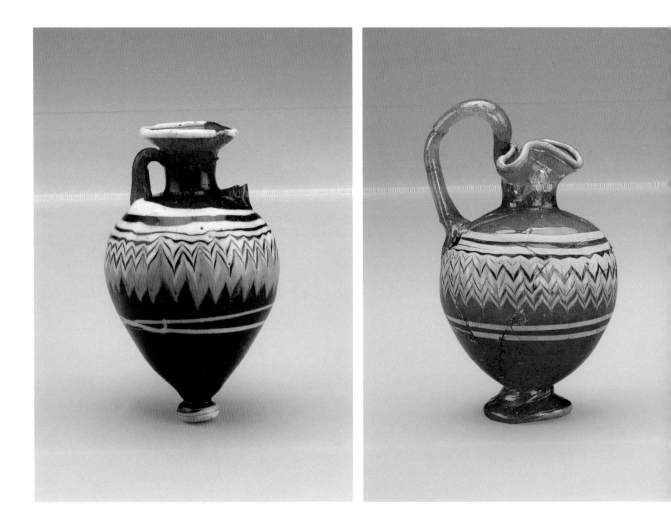

Plate 27

a. Glass Amphoriskos
Rhodian, first half of the 4th century B.C.
H. 8.6 cm, D. of Lip 3.0 cm, D. of Body 5.3 cm
GNM: 11-974:48

b. Glass Trefoil Oinochoe
Rhodian, first half of the 4th century B.C.
H. 11 cm, D. 6.0 cm, D. of Foot 3.3 cm
GNM: 11-974:50

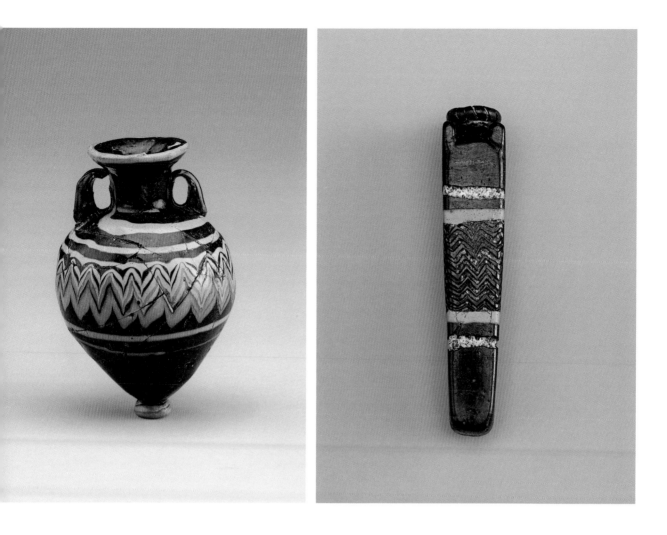

Plate 28

a. Glass Amphoriskos
Rhodian, first half of the 4th century B.C.
H. 8.0 cm, D. 5.3 cm
GNM: 11-974:487

b. Glass Kohl Tube
Rhodian, first half of the 4th century B.C.
L. 7.5 cm, W. 1.5 cm, D. of Rim 1.3 cm
GNM: 11-974:51

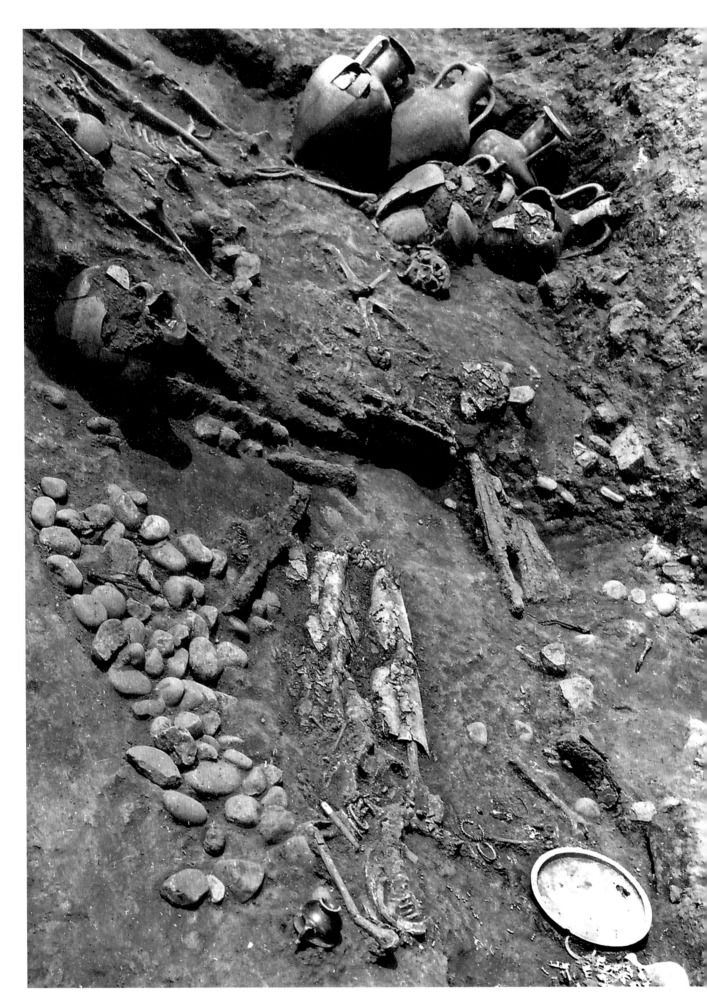

# Grave 9

Excavated in 1969 on the central terrace, Grave **9** is thought to have belonged to a warrior (his armor and other accoutrements are treated below; see fig. 6).[35] A *terminus post quem* of 336 B.C. for the date of the grave is provided by a gold stater of Philip II of Macedon (359–336 B.C.) that was found near the head of the principal deceased.[36] An Athenian black-glazed kantharos and a stamped amphora confirm a date in the third quarter of the fourth century B.C.[37]

The burial consisted of a rectangular, north–south oriented pit-grave (4 x 2 m) that was cut into bedrock and overlaid by a small stone mound (p. 52, fig. 2, no. 45). The pit was divided into two parts: the central grave and a raised platform along the southern wall. Two servants and a dog appear to have been sacrificed and were placed on the platform. In the southeast part of the platform were traces of a wooden wheel, perhaps part of a funerary bier.

The warrior was either buried in a wooden coffin or laid on a wooden funerary couch and placed supine along the north–south axis, head pointing north, his hands positioned in the hip area. Although the wooden construction dis-integrated in the damp soil, iron nails attest to its former presence. Along three walls of the main pit, fifty-three spearheads and two daggers were found. Armor was abundant: at the feet of the deceased lay a badly damaged iron shield under which were iron spearheads. Dozens of bronze and iron arrowheads were scattered all over the main part of the grave while two groups of arrow-heads were in a formalized arrangement near the warrior and were perhaps originally placed in a wooden or leather arrow case. A fragment of sheet bronze with repoussé decoration may in fact be part of this arrow case.

The deceased himself wore bronze thigh-guards and greaves, additional evidence that he was in fact a warrior. Just as other principal deceased found in the graves at Vani, he was adorned with a variety of gold personal ornaments. Instead of the diadems from earlier periods, this deceased wore a headdress formed of clusters consisting of an equestrian and two birds and of spherical and tubular beads. Around his neck was a necklace consisting of crescent-shaped pendants and beads. The deceased also wore a pair of penannular bracelets decorated with knobs (fig. 7), one on each wrist, as well as two signet rings, one of which has a Greek inscription, Δεδατος, presumably the warrior's personal name, while the other shows a spear-clad warrior riding a horse. A single temple ornament with an open-work globule

6. Overview of Grave 9 showing the remains of Dedatos at the center and the remains of two servants on a raised platform along with five amphorae of various types.

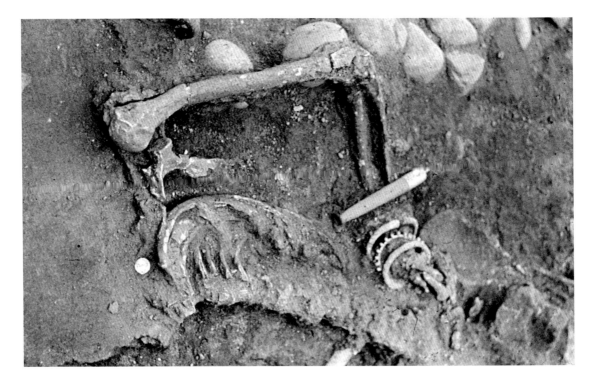

was found near his head.[38] He also wore silver jewelry: a pair of bracelets with dog's-head finials and a single bracelet with beaded terminals,[39] as well as two signet rings and a temple ornament.[40]

Only one of the servants wore jewelry—a necklace of frit beads. In the southwest corner stood five amphorae, among them two Colchian, one Sinopean, and two of the so-called Solokha-I type.[41] Several vessels were also found surrounding the warrior, including a bronze basin most likely from Asia Minor,[42] an Athenian black-glazed kantharos,[43] a red-painted jar, possibly Colchian, a locally produced black-fired bowl, and a Solokha-I type amphora. Finally, a whetstone with gold capping was found at his left forearm.

Taken as a whole, the grave goods from Grave **9** present evidence of increased Greek influence in the local culture by the fourth century B.C. In contrast to Graves **11** and **6**, no Persian or Persian-inspired objects were discovered in Grave **9**. Two examples of the direct Greek influence in this grave are the placement of Charon's obol in the mouth of the deceased for the first time and the discovery of the first object bearing a Greek inscription that has been found in the graves at Vani—the signet ring with "Dedatos" in Greek letters.[44]

7. Detail of left arm of Dedatos with whetstone, bracelets, and Charon's obol above rib cage.

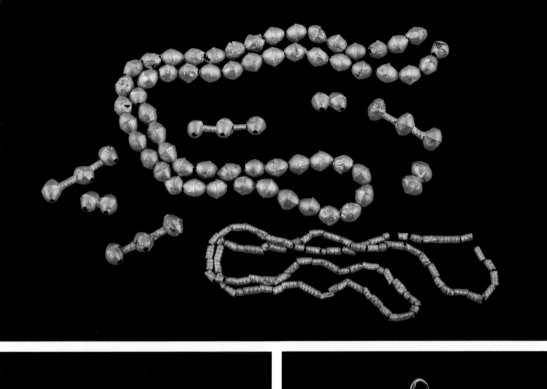

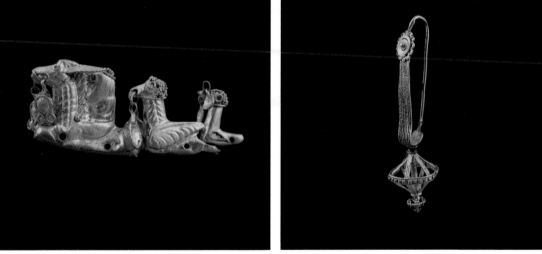

Plate 29

a. Gold Beads of Various Forms for Headdress Decoration
Vani, third quarter of the 4th century B.C.
D. of Spherical Beads (max.) 0.7 cm, H. of Triple Beads 2.3 cm,
H. of Double Beads 1.1 cm, L. of Tubular Beads 0.2 to 0.7 cm
D. of Tubular Beads 0.2 cm
GNM: 10-975:1, Parts B-E

b. Gold Headdress Composed of Horsemen and Birds
Vani, third quarter of the 4th century B.C.
L. per Cluster 5.1 cm, H. of Horsemen 2.0 cm
Depth of Horsemen 1.0 cm
GNM: 10-975:1, Part A

c. Gold Temple Ornament with Openwork Pendant
Vani, third quarter of the 4th century B.C.
H. 7.9 cm, D. 2.2 cm
GNM: 10-975:3

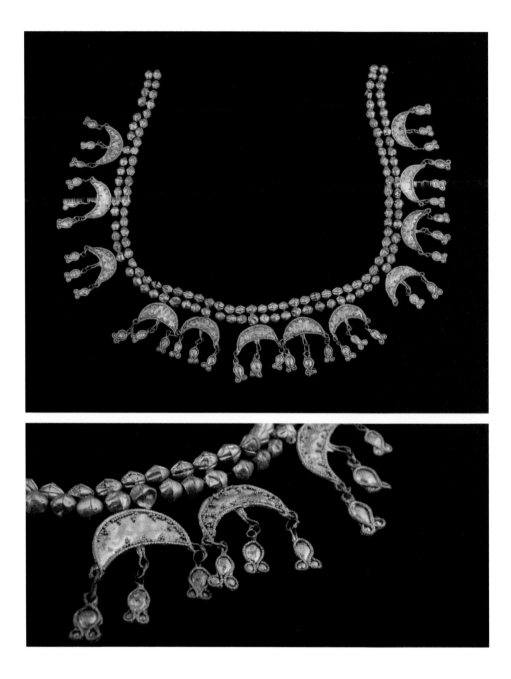

Plate 30

a. Gold Necklace with Crescent-Shaped Pendants
Vani, third quarter of the 4th century B.C.
L. 28.5 cm, H. of Pendants 3.0 cm, D. of Beads 0.5 cm
GNM: 10-975:2

b. Detail of Gold Necklace with Crescent-Shaped Pendants

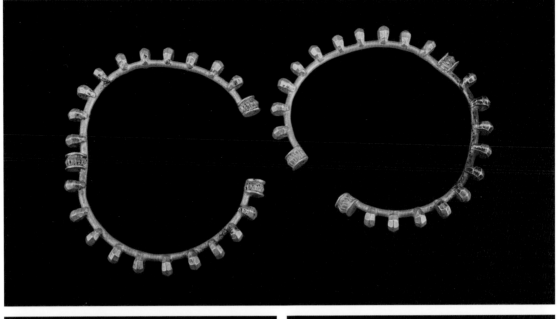

Plate 31

a. Pair of Gold Bracelets with Bosses
Vani, third quarter of the 4th century B.C.
Bracelet A: D. 7.3 cm, D. of Bosses 0.7 cm
Bracelet B: D. 7.3 cm, D. of Bosses 0.7 cm
GNM: 10-975:6a-b

b. Gold Signet Ring with Seated Woman and Greek Inscription
Vani, third quarter of the 4th century B.C.
H. 2.1 cm, D. 2.3 cm, D. of Signet 2.0 cm
GNM: 10-975:4

c. Gold Signet Ring with Horseman
Vani, third quarter of the 4th century B.C.
H. 2.2 cm, D. 2.4 cm, D. of Signet 2.1 cm
GNM: 10-975.5

Plate 32

a. Terracotta Colchian Amphora
Vani, third quarter of the 4th century B.C.
H. 63 cm, D. 34 cm
GNM: 10-975:23

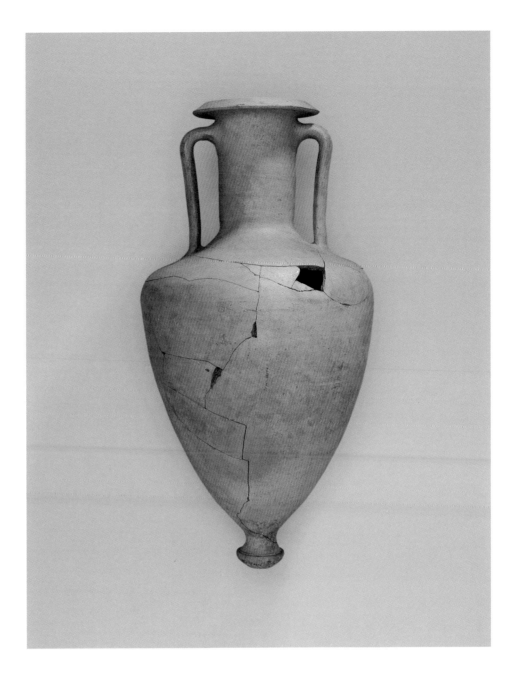

Plate 33

a. Terracotta Amphora of the Solokha Type
Greek, third quarter of the 4th century B.C.
H. 60.5 cm, D. 32 cm
GNM: 10-975:21

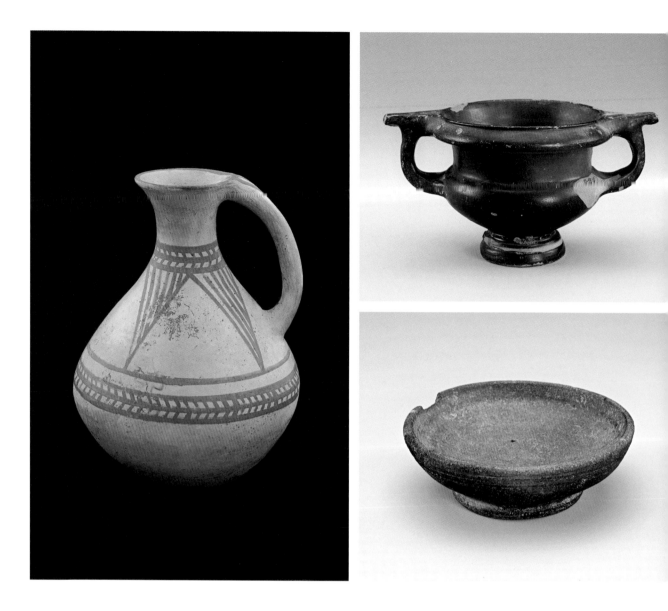

Plate 34

a. Terracotta Red-Painted Juglet
Colchian, third quarter of the 4th century B.C.
H. 16.5 cm, D. of Lip 5.5 cm, D. of Bottom 7.0 cm
GNM: 2:985-627

b. Terracotta Black-Glazed Kantharos
Attic, 350-330 B.C.
H. 8.0 cm, D. of Lip 8.5 cm, D. of Foot 4.5 cm
GNM: 2:985-628

c. Terracotta Black-Fired Bowl
Vani, third quarter of the 4th century B.C.
H. 3.5 cm, D. of Lip 12.5 cm, D. of Bottom 7.2 cm
GNM: 2:985-626

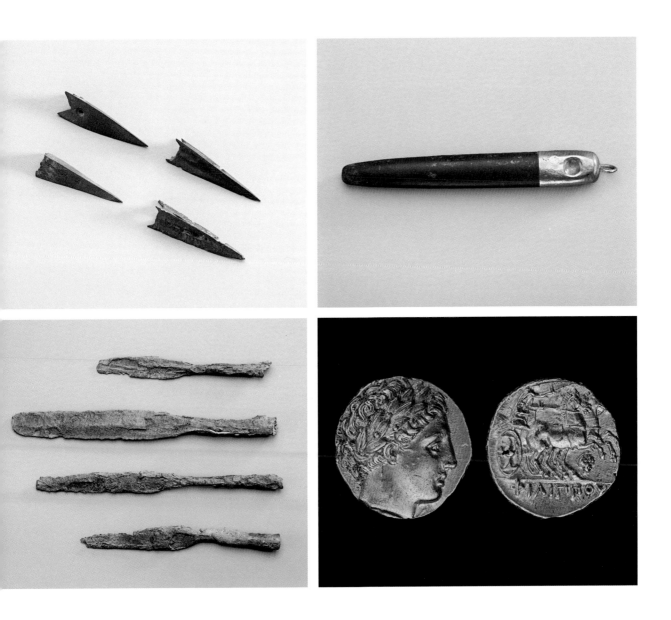

Plate 35

a. Four Iron Arrowheads
Vani, third quarter of the 4th century B.C.
L. 2.5 to 3.0 cm
GNM: 2:985-633a-d

b. Four Iron Spearheads
Vani, third quarter of the 4th century B.C.
L. 30 to 45 cm
GNM: 2:985-629a-d

c. Pebble and Gold Whetstone
Vani, third quarter of the 4th century B.C.
H. 14.4 cm, W. 1.8 cm
GNM: 10-975:8

d. Gold Stater of Philip II of Macedon
Macedonian, 359-336 B.C.
D. 1.6 cm
GNM: 14646

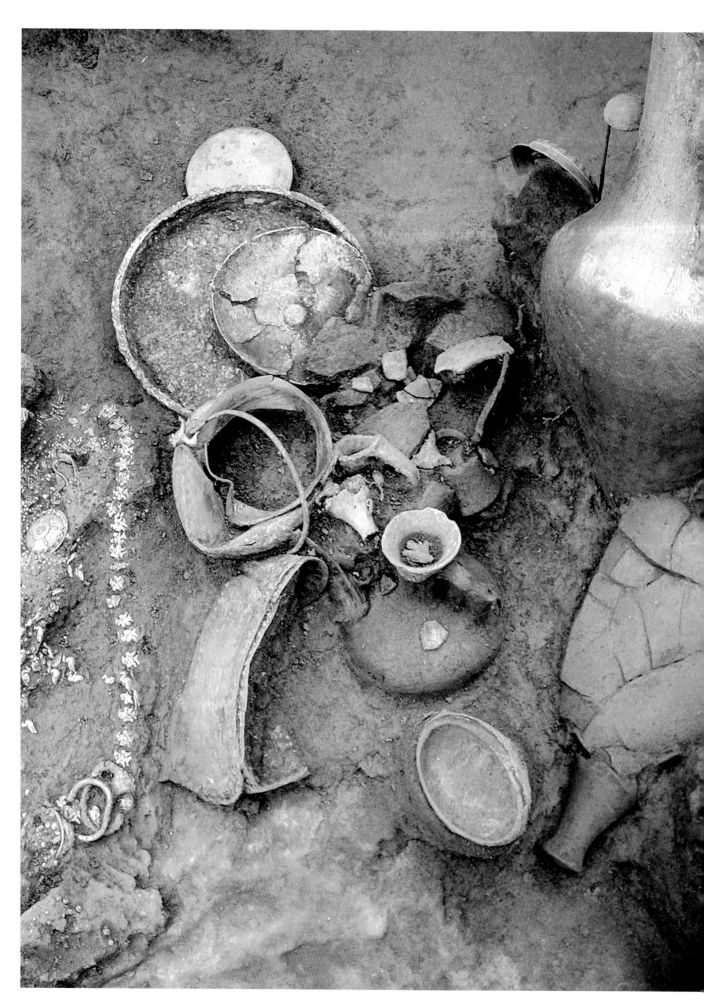

# Grave 24

Excavated in 2004, Grave **24** was located near Sanctuary IV on the eastern part of the upper terrace (p. 52, fig. 2, no. 14). The grave was covered by a pebble mound and consisted of a rectangular pit (3 × 4 m) cut into the bedrock and a platform (H. 1.0 m; W. 0.5 m) made of unhewn sandstone running along the pit's south wall. Iron nails found along the northern edge of the platform and near the pit's west wall indicate the existence of a wooden structure. At a later date, a channel was dug and a wall erected in the northeastern corner of the grave, significantly damaging the grave and some of the grave goods.

From the amount and location of jewelry and the skeletal remains, it seems that the grave held five individuals and a horse. It appears that the principal deceased was buried in the central part of the pit, while two servants were found in the northwest corner. Remains of another servant and the horse were found underneath the grave's platform, and evidence of a fourth servant was found on top of the platform.

The principal deceased was identified by an extremely rich and elaborate arrangement of personal ornaments, including gold jewelry, a dress adorned with gold figural appliqués, and a shroud covered with polychrome glass and gold beads (fig. 8).[45] Most of the gold pieces show definite signs of wear—and sometimes of restoration—indicating that these ornaments were not made solely for funerary rites. Judging by the location of the personal ornaments, one can infer that the body was laid to rest on its back with the head pointing to the south (figs. 9, 10).

A complicated headdress was composed of an openwork clip-like element, eight appliqués in the form of stylized griffins, a forehead band, granulated tubes, and a pair of temple ornaments. The intricate openwork clip is unique in the repertoire of Colchian jewelry and represents at its center a stylized stag surrounded by three smaller, deer-like animals, while the temple ornaments are of the type known from fifth- to fourth-century contexts.[46] Two triangular pendants are known in Colchis from seventh- and sixth-century B.C. contexts.[47] The preserved disposition of elements permits the reconstruction of the forehead band into strings of tubular beads that end in bipyramidal decoration on which chains are hung with pomegranate pendants. In the same area around the head, a silver Panticapaean obol dated to 340–330 B.C., may quite possibly be interpreted as a Charon's obol.[48] This coin provides a *terminus post quem* for the grave.

8. Detail of Grave 24 with goods placed near the principal deceased. At far left, gold ornaments decorating the left upper body of the principal deceased.

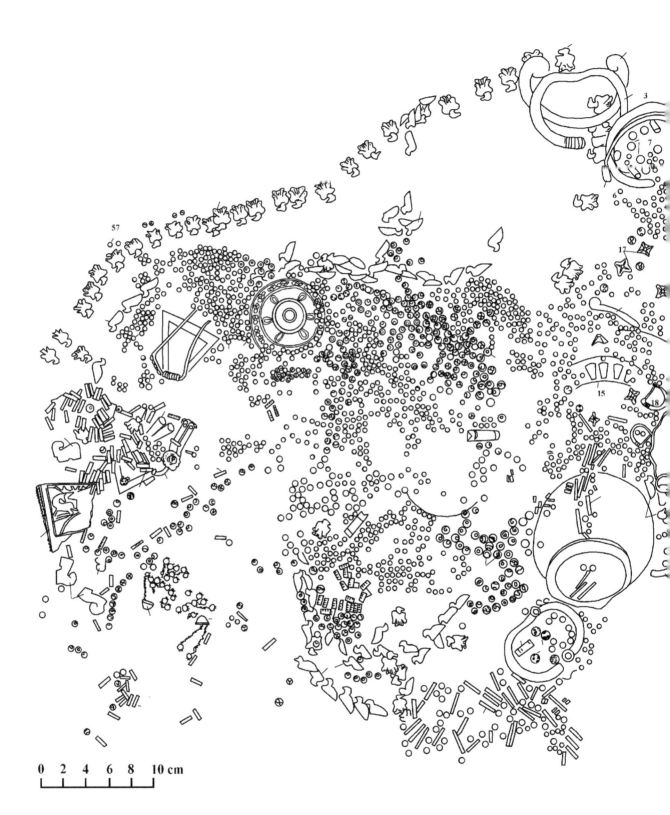

0  2  4  6  8  10 cm

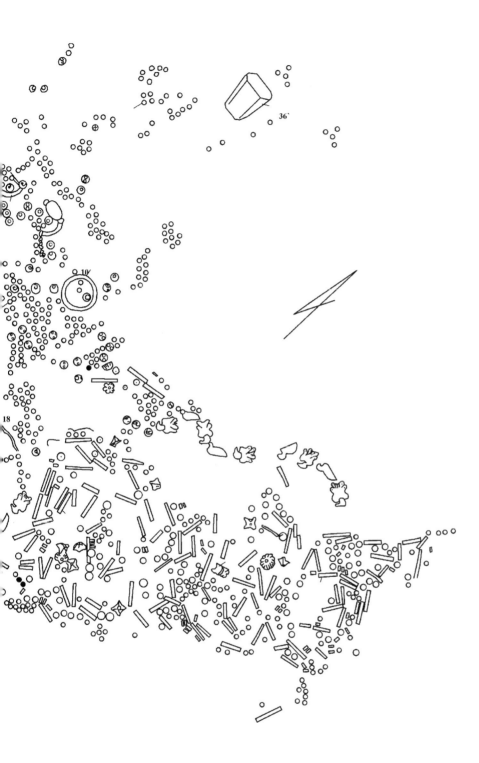

9. Drawing of principal deceased's ornamentation and some grave goods.

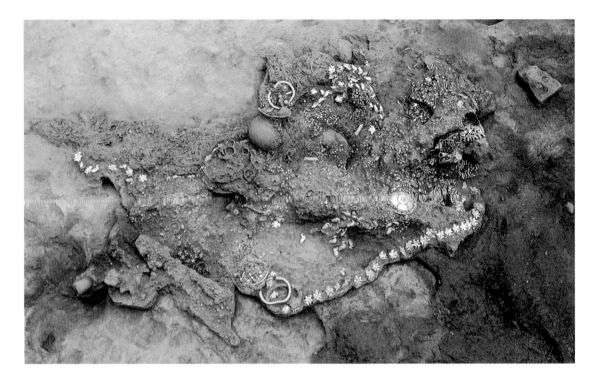

Gold necklaces feature the alternation of beads and pendants. Three necklaces have thus far been reconstructed. The first is comprised of double spiral-shaped pendants hanging from round beads and ending in rectangular plaques. Bird pendants with two disk-shaped plaques hanging from their beaks are a defining element in the second necklace. The third necklace is made up of leaf-shaped pendants decorated with filigree and granulation that alternate with fluted tubular beads.

In addition to the necklaces, multiple pendants were found in the neck and chest areas. Among these were crescent-shaped, cylindrical, and disk-shaped types. Others had stones mounted on them. Of particular interest is a pendant type that is unique to the jewelry finds at Vani. Set on a globule, it shows a female bust flanked by sphinxes.

Of two pairs of gold penannular bracelets, one has animal-head finials; similar bracelets were found in Grave **11**.[49] Another pair is decorated with notched bosses and slight indentations (fig. 11); silver bracelets of this type were also found in Grave **9**.[50]

In the wrist areas, tubular beads, richly decorated with granulation, were found together with faience and jet beads and may have either been sewn onto the edges of the sleeves of the deceased's clothing or comprised a special type of bracelet. Near the right wrist, two gold signet rings, one iron ring, and five silver signet rings were found.

Beads occur in great profusion, mainly in the area of the upper body of the principal deceased; their location suggests that they were primarily

10. Overall view of ornamentation and objects found on the principal deceased in Grave 24.

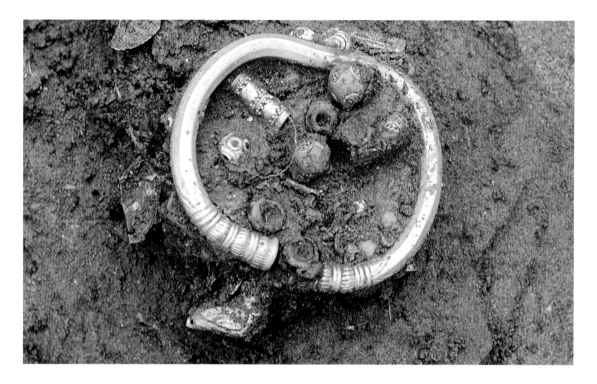

used as shroud decoration. A great range of colors and opacity occur among them—ranges of blue, light brown, yellow, emerald-green, and black, to name a few. Polychrome glass beads are also numerous and various. The largest in number are the so-called eye-beads, which would have greatly added to the coloristic effect of the garment.

In all probability, the glass beads were meant to mimic semiprecious stones. In contrast to the large quantity of glass beads, faience beads constitute a small group. A large number of tiny faience beads were found in the area of the principal deceased, as well as in the servants' areas. Compound eye-beads are comparatively few; and beads made of jet, amber, carnelian, and agate are even fewer.

On the right side of the principal deceased, silver jewelry was discovered consisting of tubular, conical, spherical, and fluted beads. There were also some minute faience beads. On top of the silver jewelry, a gold tubular bead, richly decorated with the finest granulation, was uncovered. Two more of the same type were found along with the glass beads, suggesting that the gold beads also decorated the shroud.

In addition to this overgarment, the deceased's clothing was lavishly embellished with gold elements. Eagle and duck appliqués defined the opening of the neck area, ran down the length of the arms, and covered the ends of the sleeves. Duck appliqués also formed a pattern in the chest area, while a row of alternating ducks and eagles decorated the lower part of the garment. Eagle

11. Detail showing one of the penannular bracelets worn by the principal deceased in Grave 24. Glass beads of various colors as well as a gold tubular bead can be seen at center.

appliqués found upside down indicate that the back side of the garment was also embellished with appliqués. Finally, a circular gold brooch appears to have been pinned on the upper body. When the garments are considered as an ensemble—shroud and appliqués—the polychrome effect would have been magnificent; the beads providing a vast array of color and the gold adding to its brilliance. Thus far, such a display is unique, making Grave **24** the most spectacular burial at Vani.

The four servants also wore jewelry. Instead of gold, however, they wore jewelry of less precious materials. The deceased found on the platform had one or more silver and bronze torques; a bronze ring; an iron bracelet; a silver finger ring; beads of transparent glass and carnelian; and a headdress composed of minute faience beads. The servant found under the platform had a silver torque, a pair of silver penannular earrings, and iron rings. One of the two servants found in the northwest corner of the pit was adorned with a silver torque, an iron torque, and carnelian, faience, and glass beads. The other servant had a silver torque and a pair of silver penannular earrings. Other objects associated with one of these two individuals were iron and bronze bracelets, three bronze finger rings, fragments of a bronze bell and a chain, beads in faience, and eye-beads made of blue glass.

A vast array of both local and imported objects was found surrounding the principal deceased, with imported wares predominating. Perhaps the most spectacular object is a silver belt decorated in repoussé technique. Made of a single strip of sheet silver, it has ends that are rounded and plain,

without any evidence of cast buckles or hooks-and-eyes. Small punched holes around the perimeter of the belt illustrate that either leather or fabric backing was once secured to the belt. Two symmetrical animal processions move from the outer sphinx at each end of the belt toward a central scene, which depicts a banquet. A male figure holding an Achaemenid-type *phiale* in his left hand reclines on a *kline*; he is accompanied by a musician playing the double *aulos* and a wine-bearer carrying a jar and ladle. These serving figures are separated by a *dinos*-like vessel on a stand.

Local pottery consists of one bowl and three jugs, all types that are well known from Colchian contexts dating from the sixth to the fourth century B.C.[51] The majority of terracotta objects, however, are clearly imported from the Greek world. For example, two of the four amphorae that were made in Heraklea Pontica bear englyphic stamps on their necks. One carries the two-line inscription ARX/ELA, suggesting that it was made by Arxelas, a well-known fabricant whose workshop may have started production at the end of the fifth or beginning of the fourth century B.C., with examples dating as late as the 390s to 380s.[52] The second stamped amphora, with an inscription SOTER, can be attributed to another Heraklean fabricant whose amphorae come largely from contexts dated from the end of the 390s through the mid-380s.[53]

In addition to imports from the Black Sea region are those from Attica. A red-figure skyphos belonging to the so-called Fat Boy group has a palestral scene on both sides; belonging to the Bulas Group are squat lekythoi decorated with a

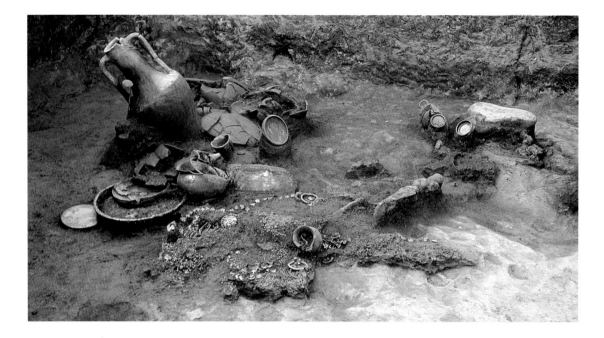

net pattern; and a black-glazed bowl with a stamped ornament is dated to the second quarter of the fourth century B.C.[54]

Grave gifts included both silver and bronze vessels (fig. 12). In silver are five phialai, a ladle, a situla, a vase, and an unguentarium (scent-bottle) decorated with linked florals and a cable pattern. All the phialai are of the so-called Achaemenid type. Three are decorated with a radiating pattern of almond-shaped lobes; on two of them a row of ducks is depicted around the central omphalos, while on the third a hunting scene is represented. The fourth phiale is ornamented with wavy lines, while the fifth is plain, though chains with beads as terminals are suspended from its rim. The fluted handle of the ladle is decorated with two goats on its circular end; they are rendered in a characteristic Achaemenid manner with foreparts sculpted in the round and

hindquarters in relief. The Vani ladle[55] finds its closest parallel in the Ikiztepe tumulus (eastern Lydia),[56] which is dated to the period after the Persian destruction of Sardis; the coin find pushes the date of this tumulus into the first decades of the fifth century. The silver situla is of the type found in Graves **6** and **11**; its handle attachment is in the form of a lion figure that rests on an appliqué shaped like a wild boar; both handle and foot are decorated with engraved patterns. The silver vase seems to be an earlier version of the so-called Achaemenid deep bowls.

Bronze vessels are represented by a phiale, a mirror, a basin, and a beak-spouted oinochoe. The *phiale mesomphalos* is of Greek type, as is the mirror. The basin is flat-bottomed, supplied with a movable ring-handle whose attachment is decorated with a floral pattern. Bronze *podanipteroi* of this type are known from Scythian (Gaimanova Mogila,

12. Overview of the principal deceased in Grave 24 and grave goods found in the surrounding area.

Tolstaya Mogila) and Thracian tumuli (Mogilanska Mogila near Vratsa).[57] The beak-spouted oinochoe is of a type well known in Macedonian, Thracian, Getic, and Scythian contexts.[58]

Of great interest is a stamp seal made of smoky chalcedony. On the rounded face is a scene representing two figures facing one another and dressed in long garments. A spear and two *styli* stand between them on a low dais, while above them is a crescent. Seals of this type were used in Mesopotamia under the Neo-Babylonian kings and thereafter through much of the fifth century B.C.[59]

Finally, in the area between the principal deceased and the servants, an iron spearhead was found and bronze ritual bells were uncovered outside the area of the principal deceased. This type of bell, cylindrical in shape with a small eye-hole and a cutting in the body, is well known in Colchis.

Perhaps the most striking aspect of this burial is the use of an array of polychrome beads combined with gold elements on the principal deceased's shroud, creating, as was noted above, a brilliant multicolored effect not seen in any other grave excavated thus far. The grave also shows the continued practice of adorning the deceased with ornate jewelry and, in this case, dress appliqués that mark the central individual interred in the grave. While some Colchian clay vessels are present, this is also the first time that we see such prominence of imported pottery. The Heraklean amphorae indicate that Vani's trade economy involved Black Sea cities, while a number of Achaemenid objects point to cultural and trade connections with the Persian world. When viewed in its totality, there is a complex combination of indigenous burial practices, including the longstanding tradition of adorning the principal deceased in locally made gold, and the inclusion of imports from several Greek cities and from Vani's powerful eastern neighbors. Clearly, Vani sat at the crossroads of many different cultures.

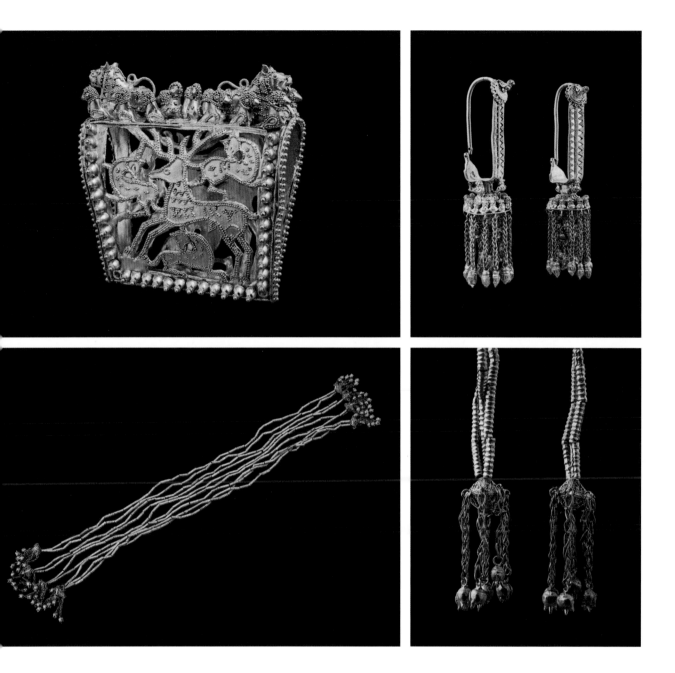

Plate 36

a. Gold Headdress Ornament with Openwork Decoration
Vani, second half of the 4th century B.C.
H. (max.) 6.6 cm, W. (max.) 6.5 cm
GNM: 1-2005/1

c. Gold Diadem Chains with Pomegranate Finials
Vani, second half of the 4th century B.C.
L. (max.) 49 cm, H. of Tubular beads 3.9 cm
D. of Tubular Beads 1.1 cm
GNM: 1-2005/3

b. Pair of Gold Temple Ornaments with Birds, Chains,
and Acorn Finials
Vani, second half of the 4th century B.C.
Ring A: H. 11.6 cm,  D. 3.5 cm
Ring B: H. 11.9 cm, D. 3.6 cm
GNM: 1-2005/8 Part2a-b

d. Detail of Pomegranate Finials from Diadem Chain

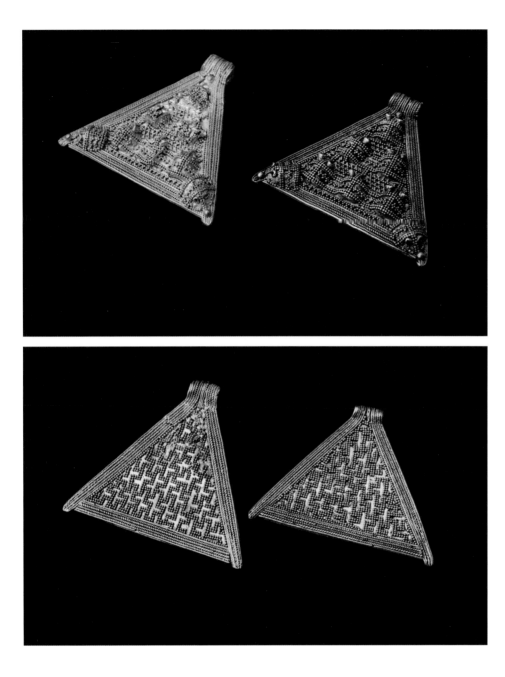

Plate 37

a. Pair of Gold Triangular Pendants
Vani, second half of the 4th century B.C.
Pendant A: H. 4.3 cm, W. of Bottom 4.7 cm
Pendant B: H. 4.1 cm, W. of Bottom 4.6 cm
GNM: 1-2005/Part1a-b

b. Back View of Pair of Gold Triangular Pendants

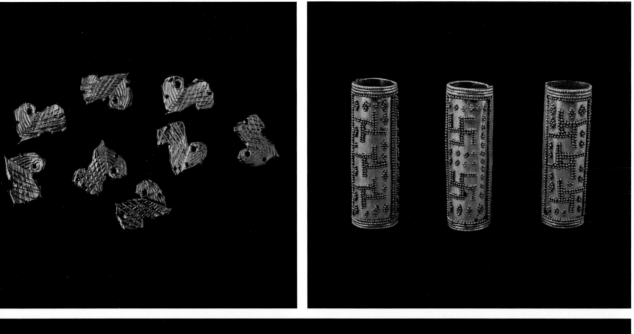

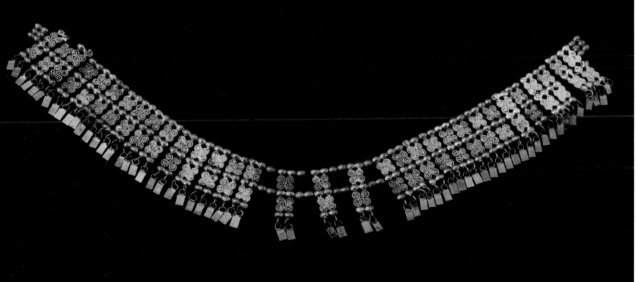

Plate 38

a. Stylized Griffin Appliqués for Headdress
Decoration
Vani, second half of the 4th century B.C.
L. (max.) 2.6 cm, H. (max.) 2.1 cm
GNM: 1-2005/5

c. Multi-Layered Gold Necklace
Vani, second half of the 4th century B.C.
L. 25 cm, H. 2.9 cm, D. of Beads 0.3 cm
GNM: 1-2005/9

b. Three Gold Tubular Beads for Headdress Decoration
Vani, second half of the 4th century B.C.
Bead A: L. 3.5 cm, D. 1.1 cm
Bead B: L. 3.4 cm, D. 1.1 cm
Bead C: L. 3.4 cm, D. 1.1 cm
GNM: 1-2005/2a-c

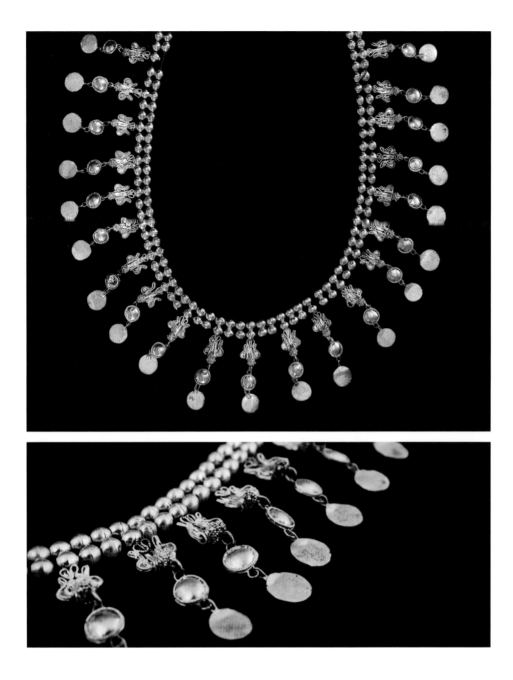

Plate 39

a. Gold Necklace with Bird and Circular Pendants
Vani, second half of the 4th century B.C.
L. 25 cm, H. of Pendants 3.7 cm, D. of beads 0.4 cm
D. of Flat Discs 0.8 cm, D. of Round Circular Discs 0.6 cm
GNM: 1-2005/10

b. Detail of Gold Necklace with Bird and Circular Pendants

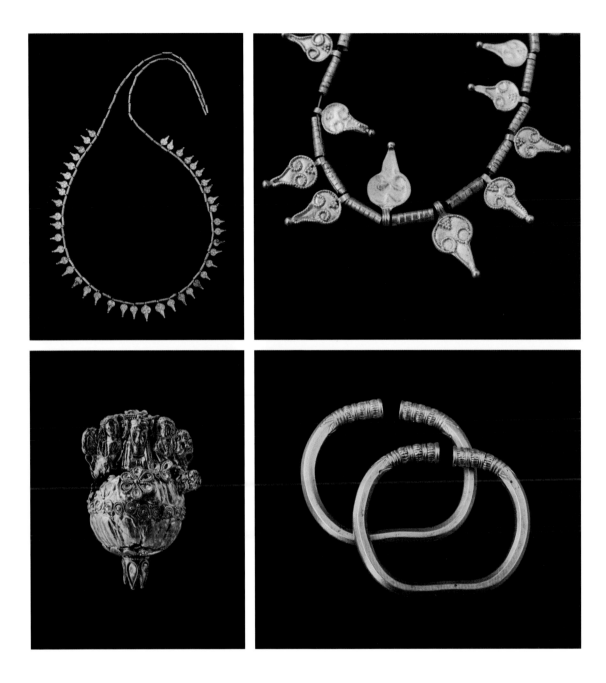

Plate 40

a. Gold Necklace with Stylized Leaf Pendants
Vani, second half of the 4th century B.C.
L. 68 cm, H of Pendants 1.1 cm, W. of Pendants
0.6 cm, L. of Tubular Beads 0.8 cm
D. of Tubular Beads 0.2
GNM: 1-2005/11

b. Detail of Gold Necklace with Stylized Leaf Pendants

c. Gold Pendant with Female Bust and Two
Sphinxes
Vani, second half of the 4th century B.C.
H. 4.1 cm, D. 2.3 cm
GNM: 1-2005/28

d. Pair of Gold Bracelets with Engraved Decoration
Vani, second half of the 4th century B.C.
Bracelet A: W. 6.7 cm, H. 5.4 cm
Bracelet B: W. 6.6 cm, H. 5.5 cm
GNM: 1-2005/18a-b

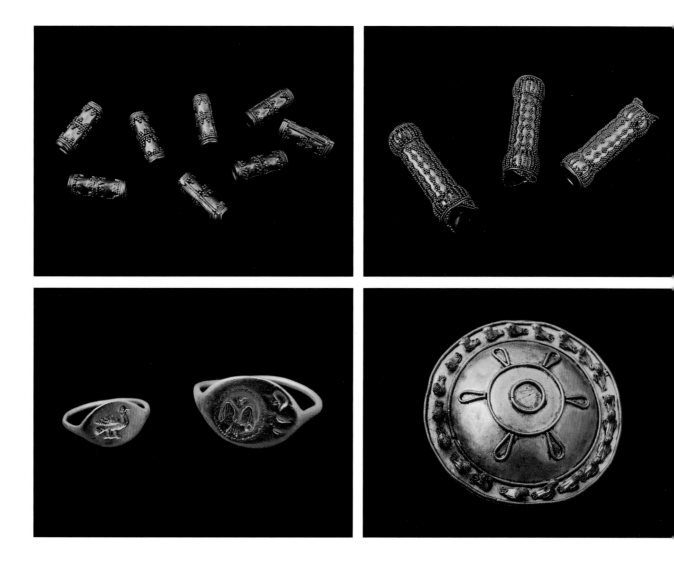

Plate 41

a. Eight Gold Tubular Beads for a Bracelet
Vani, second half of the 4th century B.C.
L. 1.6 cm, D. 0.6 cm
GNM: 1-2005/17

b. Three Gold Tubular Beads
Vani, second half of the 4th century B.C.
L. 3.2 cm, D. 1.0 cm
GNM: 1-2005/21

c. Gold Signet Ring with Duck and Gold Signet Ring
with Tropaeum
Vani, second half of the 4th century B.C.
Ring with Duck: D. 2.4 cm, Ring with Tropaeum: D. 2.4 cm
GNM: 1-2005/36 and 37

d. Gold Round Brooch with Birds
Vani, second half of the 4th century B.C.
D. 6.7 cm
GNM:1-2005/38

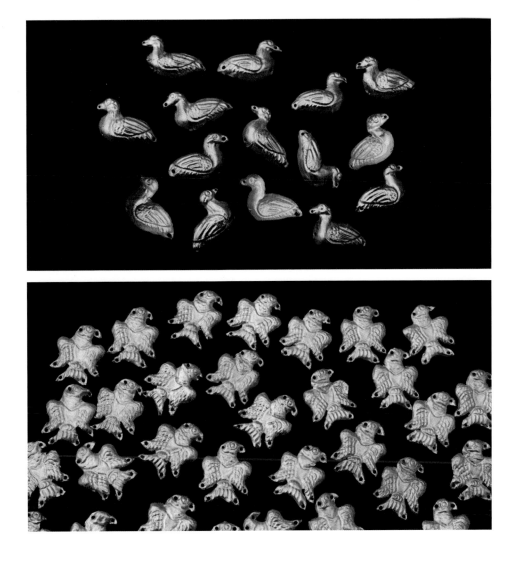

Plate 42

a. Gold Duck Appliqués for Garment Decoration
Vani, second half of the 4th century B.C.
H. 1.5 cm, L. 1.8 cm
GNM: 1-2005/20

b. Gold Eagle Appliqués for Garment Decoration
Vani, second half of the 4th century B.C.
H. 2.1 cm, L. 1.7 cm
GNM: 1-2005/29

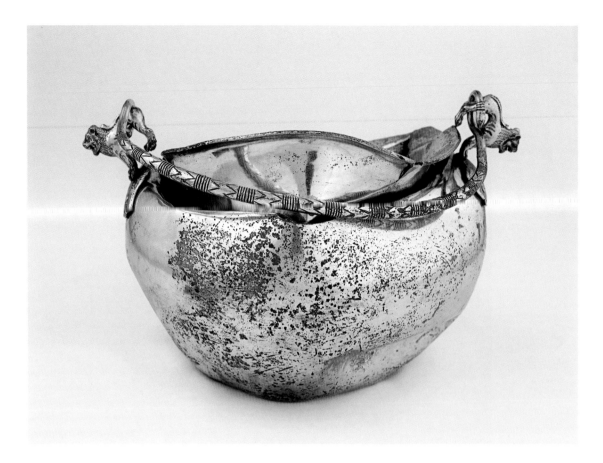

Plate 43

a. Silver Situla with Lions and Boars
Colchian, second half of the 4th century B.C.
H. 13.5 cm, D. 19.5 cm
GNM: 24-2006/1

Plate 44

a. Detail of Silver Situla Showing Lion

b. Detail of Silver Situla Showing Boar

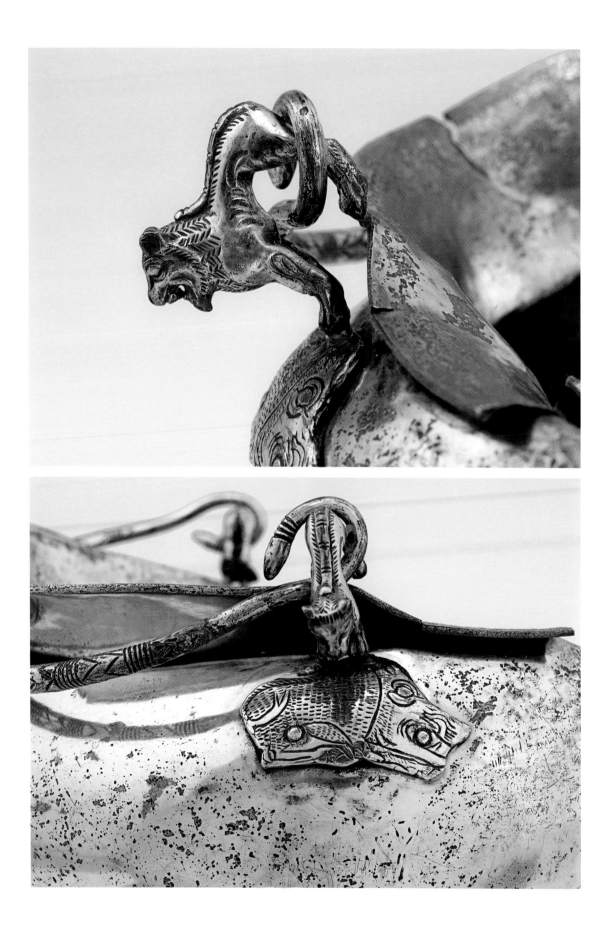

191

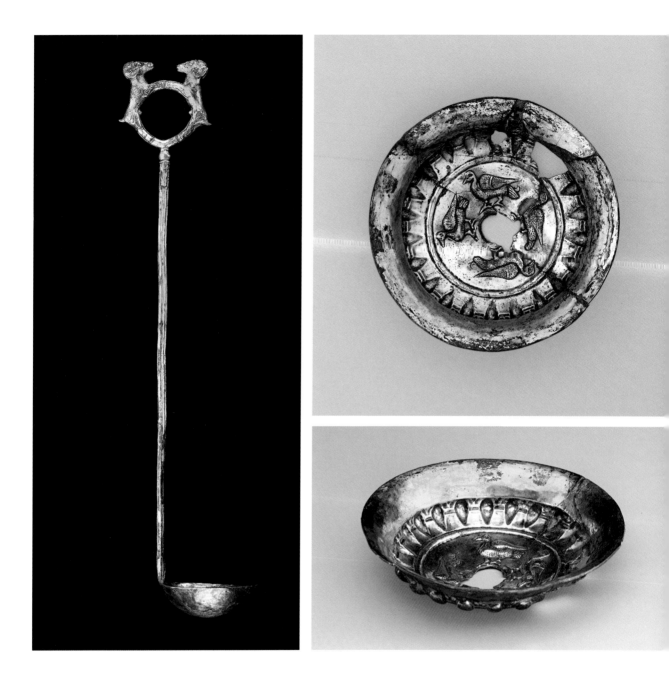

Plate 45

a. Silver Ladle with Rams
Colchian, second half of the 4th century B.C.
L. 25.1 cm, D. 4.6 cm
GNM: 24-2006/7

b. Silver Phiale with Ducks
Colchian, second half of the 4th century B.C.
H. 3.2 cm, D. 12.5 cm
GNM: 24-2006/3

c. Side View of Silver Phiale with Ducks

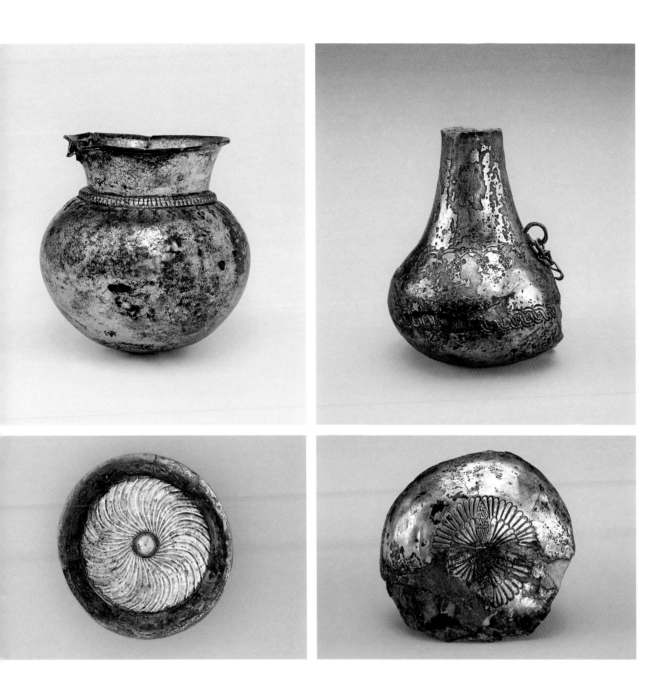

Plate 46

a. Silver Vessel with Geometric Decoration at Neck
Colchian, second half of the 4th century B.C.
H. 9.3 cm, D. at Widest Point 31 cm
D. of Lip 7.4 cm, D. of Body 9.9 cm
GNM: 24-2006/9

b. Silver Phiale with Wave-Like Pattern
Colchian, second half of the 4th century B.C.
H. 3.1 cm, D. 12.5 cm
GNM: 24-2006/4

c. Silver Unguentarium with Cable Pattern at Lower Body
Colchian, second half of the 4th century B.C.
H. 7.4 cm, D. at Widest Point 5.8 cm
GNM: 24-2006/8

d. Detail of Bottom of Silver Unguentarium

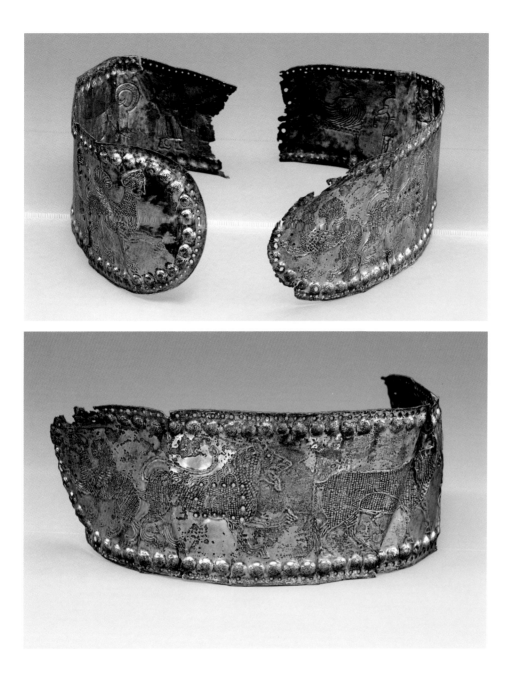

Plate 47

a. Silver Belt with Animal Procession and Banqueting Scene
Colchian and Achaemenid influence, second half of the 4th century B.C.
H. 10.8 cm, L. 85.2 cm
GNM: 24-2006/28

b. Detail of Silver Belt Showing Animal Procession

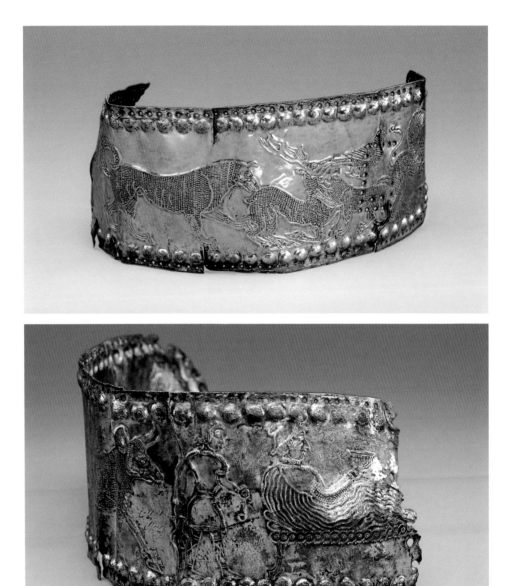

Plate 48

a. Detail of Silver Belt Showing Animal Procession

b. Detail of Silver Belt Showing Banqueting Scene

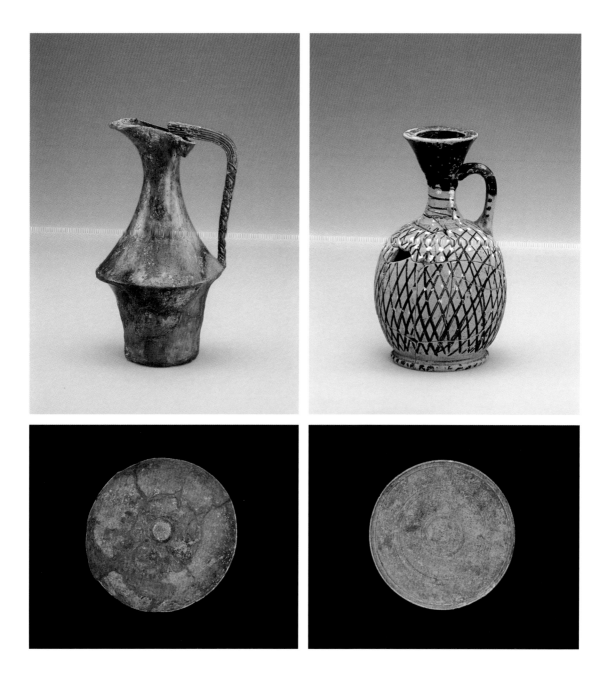

Plate 49

a. Bronze Beaker
Macedonian (?), 350 B.C.
H. 20 cm, D. of Body 10.9 cm, D. of Bottom 6.3 cm
GNM: 13-2007/1

c. Bronze Phiale Mesomphalos
Attic, 350 B.C.
D. 21 cm, H. 4.6 cm
GNM: 13-2007/3

b. Terracotta Net-Patterned Lekythos
Attic, 390 B.C.
H. 11.5 cm, D. of Body 23.8 cm, D. of Foot 5.3 cm
GNM: 13-2007/11

d. Bronze Mirror
Greek (?), second half of the 4th century B.C.
D. 15.5 cm, H. 0.3 cm
GNM: 13-2007/4

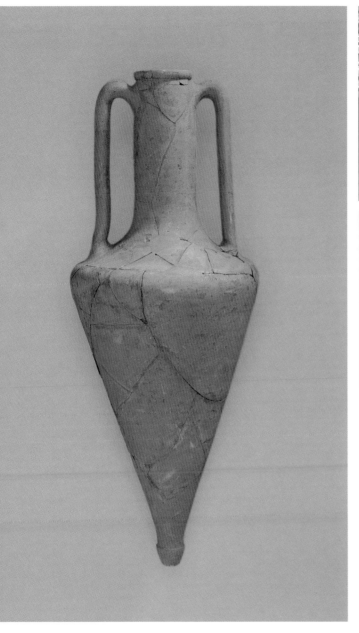

Plate 50

a. Terracotta Heraklean Amphora
Heraklea Pontica, second half of the 4th century B.C.
H. 91 cm, D. 34.5 cm
GNM: 13-2007/13

b. Polychrome Beads for Shroud Decoration
Vani, second half of the 4th century B.C.
L. of Blue Glass Strand 694 cm
L. of Blue/Green Glass Strand 76 cm
L. of Translucent Green Glass Strand 825 cm
L. of "Eye" Beads Strand 766 cm
L. of Brown Translucent Glass Strand 152 cm
L. of Opaque Yellow Glass Strand 122 cm
L. of Glass Paste Beads Strand 688 cm
GNM: 13-2007/17-21, 27, 52

c. Calcedon Neo-Babylonian Seal
Mesopotamian, second half of the 4th century B.C.
H. 3.1 cm, W. 2.5 cm
GNM: 13-2007/53

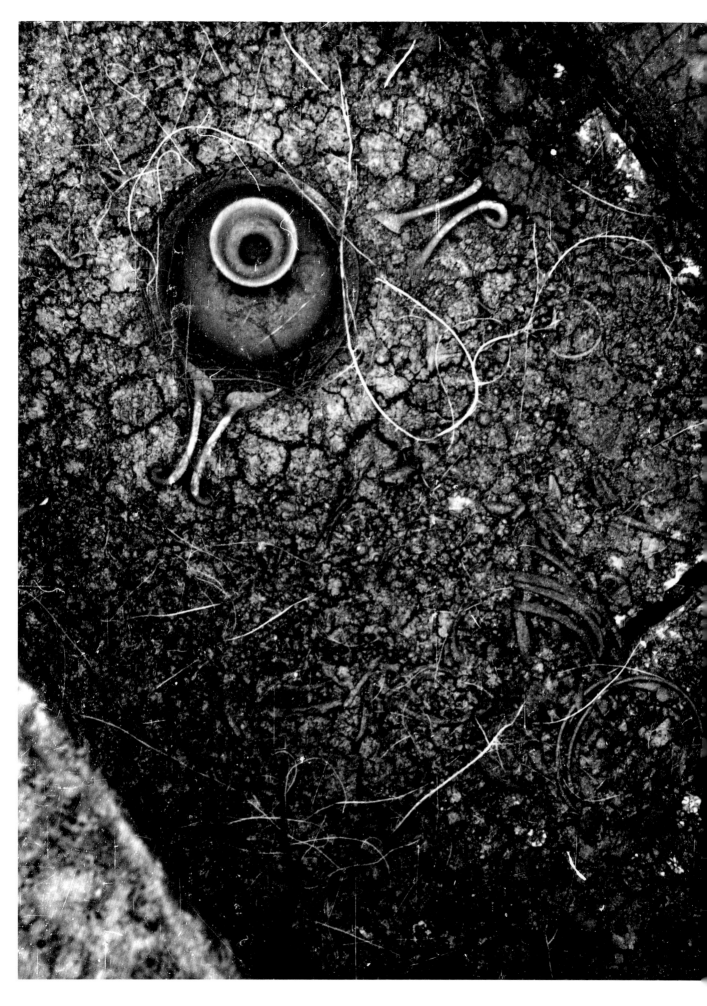

# Grave 4

Dated to the first half of the third century B.C., Grave **4** was found in 1948 on the upper terrace of the site, near its northern extremity (p. 52, fig. 2, no. 7).[60] It is thought to be a part of a U-shaped sanctuary (Sanctuary I) and a group of graves (2–4). Unlike all the other graves discussed thus far, the grave consisted of a cist built of sandstone slabs with a floor made of a whitish limestone slab (fig. 14). The cist (Depth: 0.42 m; L. 0.88 m; W. 0.47 m) was covered with a small mound of pebbles. The deceased was placed in a crouched position on the right side, with the head to the east. Another unusual aspect of Grave **4** is that it proved to belong to a female child, aged three or four, who, based on her gold jewelry, was most likely the daughter of one of the ruling families of Colchian society.

The child was adorned with a headdress decorated with rows of gold rosettes, and wore a garment decorated with gold thread, bosses, beads, sandwich-gold glass, glass, and frit beads. She also wore gold jewelry, including a torque, earrings, a pair of bracelets, and a necklace composed of gold, glass, sandwich-gold glass, carnelian, agate, and frit beads.[61] Aside from these personal ornaments, a silver kylix dated to the first half of the third century B.C. was found and was instrumental in dating the grave (fig. 13).[62]

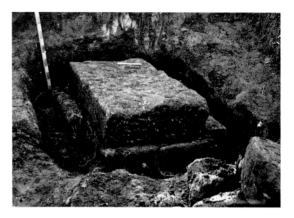

In conclusion, it is worthwhile pointing out that some of the jewelry worn by the child included semiprecious imported stones, such as carnelian and agate. The incorporation of this material into necklaces reflects influence from the Hellenistic world.

13. Detail of Grave 4 with silver kylix in situ.

14. Overview of Grave 4, a cist grave.

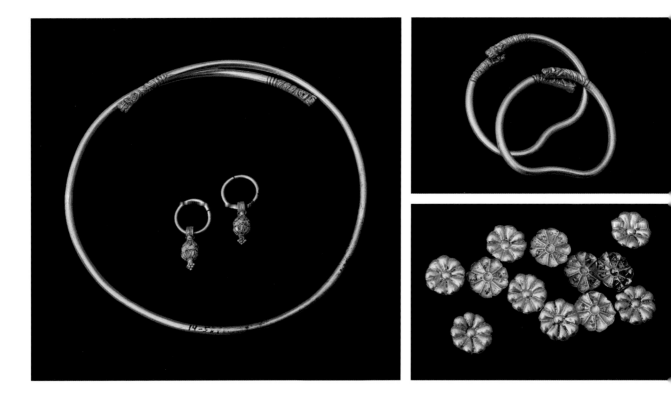

Plate 51

a. Gold Torque with Lion Head Terminals
Vani, first half of the 3rd century B.C.
D. 10.7 cm, D. of Finials 0.3 cm
GNM: 14-57.1

Pair of Gold Earrings with Steatite Pendants
Vani, first half of the 3rd century B.C.
Earring A: H. 2.8 cm, D. of Ring 1.4 cm, D. of Pendants 0.6 cm
Earring B: H. 2.8 cm, D. of Ring 1.4 cm, D. of Pendants 0.7 cm
GNM: 14-57.3

b. Pair of Gold Bracelets with Lion Head Terminals
Vani, first half of the 3rd century B.C.
Bracelet A: D. 4.0 cm, D. of Finials 0.3 cm
Bracelet B: D 4.4 cm, D. of Finials 0.3 cm
GNM: 14-57.2a-b

c. Gold Rosettes for Headdress Decoration
Vani, first half of the 3rd century B.C.
D. 1.4 cm
GNM: 14-57.4

Plate 52

a. Cluster of Gold Thread
Vani, first half of the 3rd century B.C.
W. 4.1 gr
GNM: 1-985.1008

b. Silver Kylix
Attic, first half of the 3rd century B.C.
H. 11.3 cm, D. 13.7 cm, D. of Foot 5.4 cm
GNM: 14-57.7

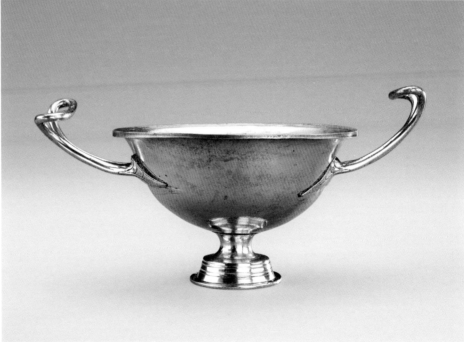

## Notes

**1.**

As of late autumn 2007, no graves pertinent to Vani's earliest phase, ca. 700–500 B.C., or its latest, ca. 250–100 B.C., have been found.

**2.**

Bold numbers indicate graves that are included in the exhibition.

**3.**

N. V. Khoshtaria, "Archaeological Excavations at Vani," Caucasian and Near Eastern Studies 2 (Tbilisi, 1962): 65–79 [in Russian, with an English summary].

**4.**

Funerary rites of the Black Sea area in the Classical and Hellenistic periods will be a topic of the 12th Symposium dedicated to the ancient history and archaeology of the Black Sea region, to be held in Vani in 2010.

**5.**

Analogies for the interment of horses and servants can be found, in fact, in the necropolises of Sairkhe and Itkhvisi, though the grave goods in the latter pale in comparison with the richness of those found at Vani and Sairkhe. See J. Nadiradze, Sairkhe: An Ancient Town of Georgia (Tbilisi, 1990), 22–97 [in Georgian, with summaries in Russian and English]; Y. Gagoshidze, "A Grave from Ikshvisi," Herald of S. Janashia State Museum of Georgia 25-B (1968): 31–45 [in Georgian, with a Russian summary]; Y. Gagoshidze, N. Gogiberidze, and G. Makharadze, "The Itkhvisi Necropolis," Archaeological Journal 4 (2006): 38–46 [in Georgian, with an English summary].

**6.**

In one case (Grave **24**), the platform was made of sandstone clods; in Grave **9**, ten centimeters above the main burial, two servants and a dog were laid to rest. See below and note 13.

**7.**

V. Tolordava, "North-eastern Slope of the Central Terrace (Results of Excavations in 1975–1979)," in Vani VIII (Tbilisi, 1986), 83 [in Georgian, with a Russian summary].

**8.**

In Greek myth, Charon ferried the souls of the dead across the River Styx; payment was one bronze coin (obol).

**9.**

V. Tolordava, Funerary Rites in Georgia of the Hellenistic period (Tbilisi, 1980) [in Georgian, with a Russian summary].

**10.**

Fortunately, these graves were intact. Two were secondary individual graves, representing jar-burials arranged in rectangular rock-cut pits. The occupant of Grave 2 was a thirty-year-old, who was identified as female on the basis of the inventory; the metal vessels that accompanied her had been deliberately broken before the grave was furnished. Grave 3 held a man, aged between twenty-five and thirty-five; he was identified as male by the skeletal remains, which conformed to the composition of grave goods—mostly spearheads and fragmentary scale armor. A cultural layer in the surrounding area contained traces of conflagration and animal bones (pigs and cows). N. V. Khoshtaria dated the graves to the third century B.C. and believed that the deceased were priests. Typologically, Grave **4** differed from Graves 2 and 3 in that it was a cist-grave. For the details, see Khoshtaria, "Archaeological Excavations at Vani," 65–79; N. V. Khoshtaria, "History of Archaeological Study of Vani," in Vani I (Tbilisi, 1972), 81–95; and N. V. Khoshtaria, "Excavations on the Upper Terrace of the Hill in 1947-1959," in Vani IV (Tbilisi, 1979), 115–34 [in Russian]. Between these graves a ritual burial of an iron figurine was found, while the U-shaped sanctuary contained a ritual burial of a bronze male figurine, both discussed in our essay "Religious Ritual: Bronze and Iron Figurines from Vani" in this volume.

**11.**

On the basis of a Sinopean hemidrachma, Grave 19 is dated to the first half of the third century B.C. See O. Lordkipanidze, R. Puturidze, N. Matiashvili, V. Tolordava, M. Pirtskhalava, A. Chqonia, G. Kvirkvelia, and G. Inauri, "The Vani Archaeological Expedition," in Field Archaeological Investigations in 1986 (Tbilisi, 1991), 73–74, pls. 177-78 [in Russian].

**12.**

Grave 16 also showed evidence of a wooden construction; funerary goods, including 80 Colchian triobols, help to date the grave to ca. 350–300 B.C. See D. Kacharava and Z. Mzavanadze, "Report of Works Carried Out on the Upper Terrace in 1980," in Vani VIII, 15–25.

**13.**

All burials in this group (Graves 20-**24** and 26) are four-sided pits cut into the bedrock; in the better-preserved graves, the pits were, as a rule, filled with large-sized pebbles. The distribution of large metal nails around the perimeters of the larger graves indicates the presence of wooden constructions. Within the group a variety of burial formalities were practiced. Grave 22 proved to be a collective burial, containing at least four occupants of the same rank. By contrast, a principal deceased of undeterminable sex was identified in Grave **24**, accompanied by four servants. The small dimensions of Grave 26 presuppose the existence of only one occupant; and the cist-burial in Grave 20 differed from all the rest. See D. Kacharava, D. Akhvlediani, and G. Kvirkvelia, "Vani in the Fourth and the First Half of the Third Century B.C.," Iberia-Colchis. Researches on the Archaeology and History of Georgia in the Classical and Early Medieval Period 3 (Tbilisi, 2007): 58–59 [in Georgian, with an English summary]. Four of these six graves had already been robbed in antiquity. Seven Colchian silver coins, small jewelry, details of scaled breast-guards, and fragments of iron weapons

could well have been part of the original inventory of Grave 21 (completely robbed). Analogous material was found in the context of burial goods dated to the end of the fourth and the first half of the third century B.C. On the preceding, see Kacharava and Mzavanadze, "Report of Works Carried Out on the Upper Terrace in 1980," in *Vani VIII*, 21, 32, cat. nos. 79, 80, 83. Grave 20 was absolutely empty, while in Graves 23 and 26 some of the funerary gifts were preserved: noteworthy is a clay jar designed with red paint over cream-colored *engobe* (slip), known from Vani's late-fourth-century Graves **9** and 19. See O. Lordkipanidze, R. Puturidze, V. Tolordava, and A. Chqonia, "Archaeological Excavations at Vani in 1969," in *Vani I*, 208, fig. 176; O. Lordkipanidze, R. Puturidze, N. Matiashvili, et al., "Archaeological Investigations of the Vani City Site," in *Field Investigations in 1987* (Tbilisi, 1995), 96, pl. 182.1 [in Russian]. In addition, the remains of a human skull and a horse skeleton were uncovered on the floor of the pit grave 23. Only a portion of the grave goods from Grave 26 seems to be preserved, none of which could be well dated. See also note 6 above.

**14.**
D. Kačarava, G. Kvirkvélja, and O. Lordkipanidzé, "Les contacts entre les grecs et les populations locales de la Mer noire. Chronologie et typologie," in *La Mer noire, zone de contacts, Actes du 7e Symposium de Vani* (Paris, 1999), 75–88.

**15.**
A. Chqonia, *Gold Ornaments from the Ancient City Site of Vani = Vani VI* (Tbilisi, 1981), cat. nos. 17, 19–21, 23, 25–26 [in Georgian, with English and Russian summaries].

**16.**
Lordkipanidze, Puturidze, Tolordava, and Chqonia, "Archaeological Excavations at Vani in 1969," in *Vani I*, 230–31, nos. 36–37 (deceased no. 2); 231–33, nos. 38–42 (deceased no. 3); 233, no. 43 (deceased no. 4).

**17.**
O. Lordkipanidze, "The Vani Site (Excavations, History, and Problems)," in *Vani I*, 9 [parallel texts in Georgian and Russian]; Lordkipanidze, Puturidze, Tolordava, and Chqonia, "Archaeological Excavations at Vani in 1969," in *Vani I*, 239.

**18.**
O. Lordkipanidze, "Toreutics," in *Vani VII* (Tbilisi, 1983), 89–90, cat. no. 402, pl. 39 (patera); 90, cat. no. 403, pl. 39 (oinochoe); 90, cat. nos. 405, 406, pl. 40 (kylikes).

**19.**
E. Gigolashvili, "Silver Situlae from Vani," *Dziebani* 4 (1999): 53–55, figs. 1–2 [in Georgian, with an English summary]. Similar silver situlae were found in Graves **6** and **24**.

**20.**
Lordkipanidze, "Toreutics," in *Vani VII*, cat. no. 404, pl. 40; O. Lordkipanidze, "Aryballe attique en argent provenant de Vani," *Arkheologia Polona* 14 (1973): 89–93; J. Boardman, "Perceptions of Colchis," in *The Black Sea Area in the 7th–5th Centuries B.C., Proceedings of the Fifth International Symposium Dedicated to the Ancient History of the Black Sea Area* (Tbilisi, 1990), 197; F. Gigolashvili, "Silver Aryballos from Vani," *Dziebani* 8 (2001): 49–52 [in Georgian, with an English summary].

**21.**
D. Kacharava, "Painted, Black-glazed and Plain Pottery," in *Vani VII*, 48, cat. no. 157, pl. 17.

**22.**
Geese: N. I. Burchak-Abramovich, "Concerning Domesticated Birds of Ancient Vani," in *Vani I*, 255–57 [in Russian]. Animals: A. Tsitsishvili, "Animal Bone Remains, Found during Archaeological Excavations of Vani," in *Vani I*, 249–50.

**23.**
Lordkipanidze, Puturidze, Tolordava, and Chqonia, "Archaeological Excavations at Vani in 1969," in *Vani I*, 228, pl. 184a, 185.

**24.**
This is also the case for silver jewelry of this type found next to the principal deceased in Grave **24**, while in Grave 22 they were found in a group near a pot containing gold jewelry.

**25.**
M. Lordkipanidze, "Gems," in *Vani VII*, 92–93, cat. nos. 415–18.

**26.**
A. Chqonia, *Gold Ornaments from the Ancient City Site of Vani*, cat. nos. 2, 5, 6, 14–16, 18, 22, 24, 27, 28, 31, 35, 36, 40, 43–49, 51, 54–56, 62, 63, 65, 66, 68, 70, 71, 334; A. Čkonia, "À propos des bracelets en or trouvés à Vani," in *La mer Noire, zone de contacts*, 165–67.

**27.**
A. Čkonia, "Les diadèmes en argent. Traditions et emprunts dans l'orfèvrerie colchidienne," in *La mer Noire, zone de contacts*, 159–64.

**28.**
J. Boardman, "A Jewel from Vani," in *Autour de la mer Noire: Hommage à Otar Lordkipanidzé* (Besançon, 2002), 19–22.

**29.**
The gold phiale belongs to the *Blütenkelchphialen* group of H. Luschey; the decorated silver one to his group of "Phialen mit einreihigen Buckeln." See E. Gigolashvili, "Phialai Mesomphaloi from a Richly Furnished Burial of the Vani City Site," in *Essays on the Archaeology of Colchis in the Classical Period, Dedicated to the 70th Birth Anniversary of Professor Otar Lordkipanidze* (Tbilisi, 2001), 33–36 [in Georgian, with an English summary].

**30.**
E. Gigolashvili, "Les coupes en argent de Vani," in *Le Pont-Euxin vu par les Grecs: Sources écrites et archéologie. Symposium de Vani (Colchide), septembre–octobre 1987*, ed. T. Khartchilava and É. Geny (Paris, 1990), 279–80.

**31.**
Gigolashvili, "Silver Situlae from Vani," 53–55. Similar objects were found in Graves **11** and **24**.

**32.**

E. Gigolashvili, "Strainers from Western Georgia (Tsiteli Shukura, Pichvnari, and Vani Burials)," *Iberia-Colchis. Researches on the Archaeology of Georgia in the Classical Period* 1 (Tblisi, 2003): 29–32 [in Georgian, with an English summary].

**33.**

M. Pirtskhalava, "Glass Vessels," in *Vani VII*, 79–83, 85–86, cat. nos. 392–95 [in Georgian, with a Russian summary].

**34.**

O. Lordkipanidze, "The Vani Site (Excavations, History, Problems)," in *Vani I*, 9 and 18, note 59.

**35.**

Lordkipanidze, Puturidze, Chqonia, and Tolordava, "Archaeological Excavations at Vani in 1969," in *Vani I*, 202–11.

**36.**

G. Dundua and G. Lordkipanidze, "Coin Finds from Vani," in *Vani III* (Tbilisi, 1977), 121, cat. no. 25 [in Georgian, with a Russian summary].

**37.**

Lordkipanidze, "The Vani Site (Excavations, History, Problems)," in *Vani I*, 25.

**38.**

Chqonia, *Gold Ornaments from the Ancient City Site of Vani*, cat. nos. 10, 72, 87, 177, 274.

**39.**

A similar bracelet, made of gold, was found in Grave **24** (see below).

**40.**

Badly corroded iron finger rings were also found.

**41.**

R. Puturidze, "Pottery Containers," in *Vani VII*, 10–11, cat. nos. 38–40, 48.

**42.**

Lordkipanidze, "Toreutics," in *Vani VII*, 91, cat. no. 410.

**43.**

Kacharava, "Painted, Black-glazed, and Plain Pottery," 39, cat. no. 164.

**44.**

O. Lordkipanidze, "The Vani Site (Excavations, History, and Problems)," in *Vani I*, 26–27; see also D. Braund, *Georgia in Antiquity: A History of Colchis and Transcaucasian Iberia, 550 B.C.–A.D. 562* (Oxford, 1994), 136.

**45.**

More than 1,300 gold and hundreds of silver jewelry pieces, including beads and small tubes, have been counted. Beads made of glass, faience, carnelian, jet, and amber amount to more than 17,000 pieces.

**46.**

Nadiradze, *Sairkhe: An Ancient Town of Georgia*, vol. 1, 37, pl. IV.1.

**47.**

J. Gagoschidze, "Materialen zur Geschichte der Goldschmiedekunst im alten Georgien," *Boreas* 20 (1997): 132.

**48.**

D. B. Shelov, *Bosporan Coinage of the 6th-2nd Centuries B.C.* (Moscow, 1956), 104, 114 [in Russian]. A gold ingot was found next to the coin in the area of the principal deceased.

**49.**

Chqonia, *Gold Ornaments from the Ancient City Site of Vani*, 47, 109, pl. 26b.

**50.**

Lordkipanidze, Puturidze, Tolordava, and Chqonia, "Archaeological Excavations at Vani in 1969," in *Vani I*, 208, fig. 170a.

**51.**

O. Lordkipanidze, E. Gigolashvili, D. Kacharava, V. Licheli, M. Pirtskhalava, and A. Chqonia, *Colchian Pottery of the 6th-4th Centuries B.C. from Vani = Vani V* (Tbilisi, 1981), 33–38, 42–43 [in Gerogian, with Russian and English summaries].

**52.**

S. Y. Monakhov, *Grecheskie amfory Prichernomorye. Kompleksy keramicheskoi tary* (Saratov, 1999), 162 [in Russian].

**53.**

Monakhov, *Grecheskie amfory*, 160, 214–15, 223.

**54.**

B. A. Sparkes and L. Talcott, *Black and Plain Pottery of the 6th, 5th and 4th Centuries B.C.*, Athenian Agora 12 (Princeton, 1970), 128 ff.

**55.**

D. Kacharava, "A Silver Ladle from Vani," in *Shota Meskhia 90. Jubilee Volume Dedicated to the 90th Anniversary of Shota Meskhia* (Tbilisi, 2006), 351–64 [in Georgian, with Russian and English summaries].

**56.**

I. Özgen and J. Öztürk, *The Lydian Treasure* (Istanbul, 1996), 85, no. 30.

**57.**

M. Treister, "Macedonian Metal Vessels in the Royal Scythian Burials: On the Scytho-Macedonian Contacts in the Third Century B.C.," in *The Black Sea Area in the Hellenistic World System*, ed. D. Kacharava and G. Kvirkvelia, *Journal of the Otar Lordkipanidze Centre for Archaeological Studies of the Georgian Academy of Sciences, Supplement 13* (Tbilisi, 2005), 106 [parallel texts in Georgian and English].

**58.**

M. Pfrommer, "Italien–Makedonien–Kleinasien. Interdependenzen spätklassischer und frühhellenistischer Toreutik," *Jahrbuch des Deutschen Archäologischen Instituts* 98 (1983): 242 ff.

**59.**

P. R. S. Moorey, *Cemeteries of the First Millennium B.C. at Deve Hüyük, near Carchemish, Salvaged by T. E. Lawrence and C. L. Wooley in 1913*, BAR International Series 87 (1980), 112, cat. nos. 469, 470.

**60.**

Khoshtaria, "Archaeological Excavations at Vani," 65–79; Khoshtaria, "History of Archaeological Study of Vani," in *Vani I*, 81–95; Khoshtaria, "Excavations on the Upper Terrace of the Hill in 1947–1959," in *Vani IV*, 115–34.

**61.**

For the gold jewelry, see Chqonia, *Gold Ornaments from the Vani City Site*, cat. nos. 73, 79, 92, 131, 158, 179, 254, 283; for the beads, see E. Gigolashvili, "Beads," in *Vani* VII, 106–11, cat. nos. 429–30, 437, 471, 475–76.

**62.**

N. Matiashvili, "Metal Vessels," in *Vani III*, 108–9, figs. 105–8; O. Lordkipanidze, "Toreutics," in *Vani VII*, 91, cat. no. 411.

# Checklist of Additional Objects

## Bronze and Iron Figurines

1. Bronze Figurine no. 2
Vani, 3rd century B.C.
H. 25 cm
GNM: 1-2007/1
(p. 100-101, figs. 4a, b)

2. Iron Figurine no. 3
Vani, 3rd century B.C.
H. 24.5 cm
GNM: 1-2007/2
(p. 102-103, figs. 6a, b)

3. Bronze Figurine no. 6
Vani, 3rd century B.C.
H. 18 cm
GNM: 2:985-992
(p. 105-106, figs. 9, 10)

4. Bronze and Gold Figurine no. 7
(Statuette of a Satyr)
Greece and Vani, 3rd century B.C.
H. 21 cm
GNM: 13-2007/54
(p. 96, fig. 1; p. 108, fig. 11)

## Viticulture and Dionysos

5. Bronze Appliqué of a Pan
Asia Minor, second half of the
2nd century B.C.
H. 13cm; W. 9.8 cm
GNM: 10-975/186
(p. 41, fig. 16; p. 118, figs. 5a, b)

6. Bronze Appliqué of a Youthful Satyr
Asia Minor, second half of the
2nd century B.C.
H. 12.4 cm; W. 10.5 cm
GNM: 10-975/186
(p. 118, figs. 6a, b)

7. Bronze Appliqué of a Maenad
Asia Minor, second half of the
2nd century B.C.
H. 12 cm; W. 12 cm
GNM: 10-975/186
(p. 120, figs. 7a, b)

8. Bronze Statuette of a Nike
Asia Minor, second half of the
2nd century B.C.
H. 22 cm; W. 19 cm
GNM: 10-975/186
(p. 122-123, figs. 10a, b)

9. Bronze Statuette of an Eagle
Asia Minor, second half of the
2nd century B.C.
H. 18.6 cm; W. 15 cm
GNM: 10-975/186
(p. 121, fig. 9)

10. Three Pairs of Bronze Griffin Claws
Asia Minor, second half of the
2nd century B.C.
H. 7.3 - 8.4 cm; W. 7.3 - 8.1 cm
GNM: 10-975/186
(p. 121, fig. 8)

## Graves
**Grave 22 – second half of 4th
century B.C. (circa 330 B.C.)**

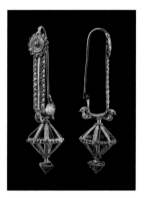

11. Pair of Temple Ornaments with
Openwork Pendants*
Ring A: H. 8.14 cm; D. 2.23 cm
Ring B: H. 8.10 cm; D. 2.18 cm
GNM: 31-2006/12a-b

12. Pair of Temple Ornaments/ Earrings
Decorated with Birds and Chains with
Acorn Finials
Ring A: H. 10.1 cm; D. 2.1 cm
Ring B: H. 10.0 cm; D. 2.0 cm
GNM: 31-2006/18a-b
(p. 88, fig. 13)

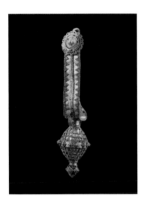

13. Temple Ornament with Spherical
Pendant*
H. 7.0 cm; D. 1.6 cm
GNM: 31-2006/22

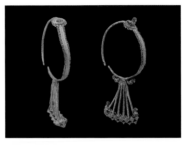

15. Pair of Circular Temple Ornaments
with Radial Pendants
Ring 21: H. 8.2 cm; D. of Hoop 4.8 cm
Ring 19: H. 8.5 cm; D. of Hoop 4.7 cm
GNM: 31-2006/21 & 19

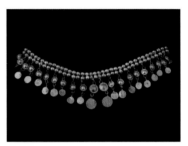

17. Section of Necklace with Circular
Pendants*
L. 17 cm; L. of Pendants (max) 3.1 cm
GNM: 31-2006/31

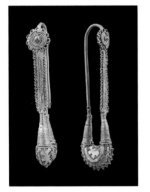

14. Pair of Crescent-shaped Temple
Ornaments*
Ring 20: H. 5.5 cm; D. of Rosette 1.0 cm
Ring 23: H. 5.7 cm; D. of Rosette 0.8 cm
GNM: 31-2006/20 & 23

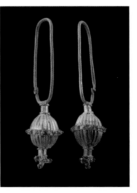

16. Pair of Earrings with Spherical,
Fluted Pendants*
Earring A: H. 5.6 cm; D. 1.4 cm
Earring B: H. 5.7 cm; D. 1.4 cm
GNM: 31-2006/5a-b

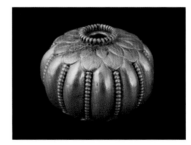

18. Melon Bead with Leaf Pattern
H. 2.5 cm; D: 3.4 cm
GNM: 31-2006/13

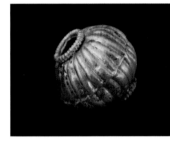

19. Melon Bead
H. 2.0 cm; D. 2.2 cm
GNM: 31-2006/26

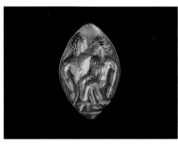

22. Signet Ring with Erotic Scene*
H. of Ring 2.1; Signet 2.1 x 1.4 cm
GNM: 31-2006/27

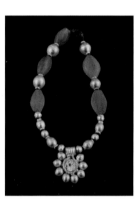

25. Section of a Necklace with Carnelian
Beads and Central Pendant
L. 9.5 cm; H. of Pendant 1.9 cm
GNM: 59-978/3

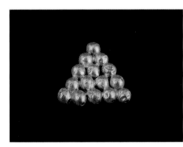

20. Triangular Spacer Bead*
H. 1.6 cm; W. (bottom) 1.8 cm
GNM: 31-2006/9

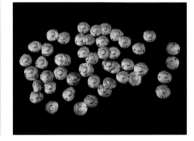

23. Circular Appliqués for Garment
Decoration*
D. 1.0 cm
GNM: 31-2006/11

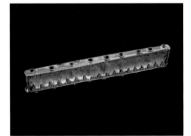

21. Rectangular Spacer Bead*
L. 6.3 cm; W. 1.0 cm
GNM: 31-2006/25

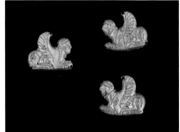

24. Three Sphinx Appliqués*
H. 1.5 cm; W. 1.8 cm
GNM: 31-2006/30

Grave 2 – 3rd century B.C.　　　**Other Objects**

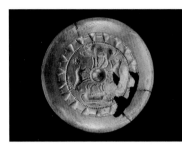

26. Phiale with Animal Procession
D. 17 cm; H. 4.0 cm
GNM: 14-57/11

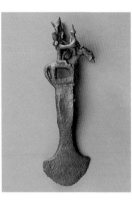

28. Bronze Axehead
8th century B.C.
H. 24 cm
GNM: 2:985-40

32. Iron Head of Battering Ram or
Trypanon
Vani, 2nd century B.C.
L. 109 cm; H. 45 cm
GNM: 2:985-24

29. Red-Figure Column Krater by the
Orchard Painter
Attic, 470-460 B.C.
H. with Handles 29.2 cm
Lent by the Metropolitan Museum of
Art, Harris Brisbane Dick Fund, 1934
Met: 34.11.7
(p. 22, fig. 1)

**Grave 13 – 3rd century B.C.**

27. Necklace with Carnelian and
Onyx Beads
L. 30 cm
GNM: 69-975/1
(p. 89, fig. 14)

30. Buckle with Herakles fighting
Nemean Lion*
3rd century B.C.
D. 5.9 cm
GNM: 24-29/1
(p. 93, fig. 17)

31. Bronze Torso of a Youth
Vani, 2nd century B.C.
H. 105 cm; W. 45 cm
GNM: 2:996-43
(p. 45, figs. 20a, b)

* Only Exhibited at the Arthur M.
Sackler Gallery

# Bibliography

Akhvlédiani D., "Les tuiles estampillées de Vani", in T. Khartchilava and É. Geny (eds.), *Le Pont-Euxin vu par les Grecs*, 283–86.

Amashoukéli N. and G. Kipiani, "Problèmes de restauration et de conservation des monuments de Vani", in T. Khartchilava and É. Geny (eds.), *Le Pont-Euxin vu par les Grecs*, 287–88.

Asatiani N. and A. Bendianachvili, *Histoire de la Géorgie* (Paris 1997).

*Au pays de la toison d'or. Art ancien de Géorgie soviétique* (Paris 1982).

Balandier C., "Les défenses de la terrasse Nord de Vani (Géorgie). Analyse architecturale", in D. Kacharava, M. Faudot, and É. Geny (eds.), *Pont-Euxin et Polis. Polis Hellenis et Polis Barbaron*, 245–64.

Beridze V. *et alii*, *The Treasures of Georgia* (London 1984).

Blázquez J.M., "The Sanctuary-City of Vani and Its Parallels in the West", in D. Kacharava, M. Faudot, and É. Geny (eds.), *Pont-Euxin et Polis. Polis Hellenis et Polis Barbaron*, 235–44.

Boardman J., "Art history on the Black Sea coast: donors and receptors", in O. Lordkipanidze and P. Lévêque (eds.), *Sur les traces des Argonautes,* 215–218.

Boardman J., "A jewel from Vani", in D. Kacharava, M. Faudot and É. Geny (eds.) *Autour de la Mer Noire: Hommage à Otar Lordkipanidzé*, 19–22.

Bokhochadze, A., *Viticulture and Wine-making in Ancient Georgia According to Archaeological Romaine* (Tbilisi 1963) [in Georgian].

Braund D., *Georgia in Antiquity, 500 B.C.–550 A.D.* (Oxford 1994).

Braund D., "Georgia in Classical Myth and History", O.Z. Soltes (ed.) *National Treasures of Georgia* (London 1999), 74–76.

Burney C.A. and D.M. Lang, *The Peoples of the Hills: Ancient Ararat and Caucasus* (London 1971)

Čkonia A., "L'orfèvrerie de la Colchide antique sur le site de Vani", T. Khartchilava and É. Geny (eds.), *Le Pont-Euxin vu par les Grecs*, 261–66.

———, "Colchian Jewelry from the Vani City Site", in A. Calinescu (ed.) *Ancient Jewelry and Archaeology* (Bloomington 1996), 45–50.

———, "À propos des bracelets en or trouvés à Vani", in O. Lordkipanidze and P. Lévêque (eds.), *La mer Noire, zone de contacts,*165–67.

———, "Le culte de la Grande Déesse dans l'orfèvrerie colchidienne" in O. Lordkipanidze and P. Lévêque (eds.), *Religions du Pont-Euxin*, 115–28.

———, "À propos de l'esportation de l'or colchidien", in M. Faudot, A. Frayesse, and É. Geny (eds.), *Pont-Euxin et Commerce. La Genèse de la "Route de la Soie"*, 263–72.

———, "Les diadème en argent. Traditions et emprunts dans l'orfèvrerie colchidienne" in O. Lordkipanidze and P. Lévêque (eds.), *La mer Noire, zone de contacts*, 159–64.

———, "L'artisanat d'art dans le développement des villes colchidiennes-Vani", in D. Kacharava, M. Faudot, and É. Geny (eds.), *Pont-Euxin et Polis. Polis Hellenis et Polis Barbaron*, 265–70

Deppert-Lippitz B., "Interrelations between Greek jewellery on the 6th and 5th centuries B.C. and gold finds from the Black Sea Region" in O. Lordkipanidze and P. Lévêque (eds.), *Sur les traces des Argonautes,*195–202.

Dundua, G., "Were coins minted in Vani?" *Herald of the Georgian Academy of Sciences* 2 (1974), 152.

Dundua G., and G. A. Lordkipanidze, "Hellenistic coins from the site of Vani, in Colchis (western Georgia)", *Numismatic Chronicle* 19 (1979), 1–5.

Faudot M., A. Frayesse, and É. Geny (eds.), *Le Pont-Euxin et Commerce. La Genèse de la "Route de la Soie," Actes du IXe Symposium de Vani (Colchide) – 1999* (Besançon 2002).

Gigolašvili E., "The silver situale from Vani", in M. Faudot, A. Frayesse, and É. Geny (eds.), *Le Pont-Euxin et Commerce. La Genèse de la "Route de la Soie",* 277–81.

———, "Les coupes en argent de Vani" in T. Khartchilava and É. Geny (eds.), *Le Pont-Euxin vu par les Grecs*, 279–282.

Gorbunova K.S., "Archaeological Investigations on the Northern Shore of the Black Sea in the Territory of the Soviet Union, 1965–1970", *Archaeological Reports* 18 (1971–72), 48–59.

Hind J.G.F., "Greek and Barbarian People on the Shores of the Black Sea", *Archaeological Reports* 30 (1983–84), 71–97.

———, "Archaeology of the Greek and Barbarian People around the Black Sea", *Archaeological Reports* 39 (1992–93), 82–112.

Inaouri G., "Le territoire de Vani. Un compte rendu des recherches archéologique", in T. Khartchilava and É. Geny (eds.), *Le Pont-Euxin vu par les Grecs*, 249–252

Kacharava D., "Bronze Figurines from Vani," *Dzeglis megobari* 63 (1983), 33–34 [in Georgian, with summaries in Russian and English].

———, "Archaeology in Georgia 1980–1990 (post-Prehistoric to Pre-Medieval)", *Archaeological Reports* 37 (1990–91), 79–86.

———, "L'importation de céramique peinte et de céramique noire lustrée à Vani (VIe–IVe siècles)", in T. Khartchilava and É. Geny (eds.), *Le Pont-Euxin vu par les Grecs*, 275–78.

———, "A Bronze Figurine from Vani," *Journal of Georgian Archaeology* 1 (2004), 225–27.

———, "Recent finds at Vani. Hommage à P. Lévêque", *Dialogues d'histoire ancienne* Supplement 1 (2005), 291–309.

Kacharava D., D. Akhvlediani, and G. Kvirkvelia, "Vani in the 4th and the first half of the 3rd century B.C.", in *Iberia-Colchis, Researches on the Archaeology and History of Georgia in the Classical and Early Medieval Period*, III (Tbilisi 2007). [in Georgian, with an English summary]

Kacharava, D., M. Faudot and É. Geny (eds.), *Autour de la Mer Noire: Hommage à Otar Lordkipanidzé* (Besançon 2002).

———, *Pont-Euxin et Polis. Polis Hellenis et Polis Barbaron. Actes du Xe Symposium de Vani–23–26 septembre 2002* (Besançon 2005).

Kacharava D., G. Kvirkvélja, and O. Lordkipanidze, "Les contacts entre le Grecs et les populations locales de la mer Noire. Chronologie et typologie" in O. Lordkipanidze and P. Lévêque (eds.), *La mer Noire, zone de contacts*, 65–100

Khartchilava T. and É. Geny (eds.), *Le Pont-Euxin vu par les Grecs: sources écrites et archéologie. Symposium de Vani (Colchide), septembre-octobre 1987* (Paris 1990).

Khoshtaria N.V., "Archaeological excavations at Vani", *Caucasian and Near Eastern Studies* 2 (1962), 65–79. [in Russian, with an English summary]

Kipiani G., "L'architecture des Ve–IVe siècle à Vani" in T. Khartchilava and É. Geny (eds.), *Le Pont-Euxin vu par les Grecs*, 267–268

———, *Pagan temples of Colchis and Iberia and problems of the origin of Christian architecture* (Tbilisi 2000). [in Georgian, with a Russian summary]

Kvirkvelja G., "La région de Vani aux VIIIe-Ve siècle" in T. Khartchilava and É. Geny (eds.), *Le Pont-Euxin vu par les Grecs*, 253–56.

———, "A New Bronze Statuette from Vani", in *Iberia-Colchis: Collected Papers on the Archaeological Studies of Georgia of the Classical Period* 2 (Tbilisi 2005), 187–88. [in Georgian, with an English summary]

Lang D., *The Georgians* (Bristol 1966).

Lévêque P., "La Colchide dans l'élan de la colonisation grecque," in C. Antonetti (ed.), *Il dinamismo della colonizzazione greca* (Naples, 1997), 11–23.

Licheli V., *Ancient Vani. Industrial District*, (Tbilisi 1991). [in Georgian, with summaries in Russian and English]

———, "The Black Sea-Vani-Samtskhe: the Spreading Route of Black-glazed Pottery" in O. Lordkipanidze and P. Lévêque (eds.), *La mer Noire, zone de contacts*, 101–106.

Lordkipanidze D., O. Bar-Yosef, M. Otte (eds.), *Early humans at the gates of Europe. Proceedings of the first international symposium Dmanisi, Tbilisi (Georgia) September 1998* (Liège 2000).

Lordkipanidze G. A., "Altars of Vani City-Site" in M. M. Kobylina (ed.) *History and Culture of the Classical World* (Moscow 1977),104–12. [in Russian]

———, *Colchis during the VI–II centuries B.C.* (Tbilisi 1978).

Lordkipanidze M.N., "Colchian seal-rings of the 5th–3rd centuries B.C. and problems of interrelations with Greek workshops", X*IIIe Congrès international du Comité "Eirene". Dubrovnik, 7–12 Octobre 1974* (Tbilisi 1975). [in Georgian with Russian and French summaries]

———, "Les bagues-cachets dès Ve–III siècle savant notre éra de la Colchide", Antiquité-vivante 1–2 (Skopje 1975).

Lordkipanidze, N. *The Representation of the Myth of the Argonauts in Early Greek Art* (Tbilisi 2004). [In Georgian]

Lordkipanidze O., "Monuments of Graeco-Roman culture on the territory of ancient Georgia", *Archeologia* 17 (1966), 49–79.

———, "Colchis in the early antique period and her relations with the Greek world", *Archeologia* 19 (1968), 15–44.

———, "La civilisation de l'ancienne Colchide aux V–IV s. (à la lumière des plus recentes découvertes archéologiques)", *Revue archéologique* (1971), 259–88.

———, "New archaeological finds at Vani (ancient Colchis)", *Annales archéologiques Arabes Syriennes* 21 (1971), 177–83.

———(ed.), *Vani I: Archaeological Excavations, 1947–1969* (Tbilisi 1972). [in Georgian, with Russian summaries]

———, "La Géorgie et le monde grec", *Bullettin de correspondence hellénique* 98 (1974), 897–948.

———(ed.), *Vani II: Archaeological Excavations* (Tbilisi 1976). [in Georgian, with Russian summaries]

———(ed.), *Vani III: Archaeological Excavations* (Tbilisi 1977). [in Georgian, with Russian summaries]

———, "L'archéologie géorgienne. Récentes découvertes, problèmes et perspectives" *Sovietskaja Archeologia* 3 (1977), 5–23.

———(ed.), *Vani IV: Archaeological Excavations* (Tbilisi 1978). [in Georgian, with Russian summaries]

———(ed.), *Vani V: Archaeological Excavations* (Tbilisi 1979). [in Georgian, with Russian summaries]

———, *La Colchide antique. Mythe et archéologie* (Tbilisi 1979). [in Russian]

———(ed.), *Vani VI: Archaeological Excavations* (Tbilisi 1981). [in Georgian, with Russian summaries]

———, "New archaeological discoveries in Vani", *Pamyatniki Kultury* (1981–83), 467–481.

———(ed.), *Vani VII: Archaeological Excavations* (Tbilisi 1983). [in Georgian, with Russian summaries]

———, "La Géorgie à l'époque hellénistique", *Dialogues d'Histoire Ancienne* 9 (1983), 197–216.

———, "The Greco-Roman world and ancient Georgia (Colchis and Iberia)", *Modes de contacts et processus de transformation dans les sociétés antiques. Actes du colloque de Cortone (24–30 mai 1981)* (Rome 1983), 123–44.

———(ed.), *Vani VIII: Archaeological Excavations* (Tbilisi 1986). [in Georgian, with Russian summaries]

———, "The fortifications of ancient Colchis (Eastern Black sea littoral)" in P. Leriche and H. Tréziny (eds.), *La fortification dans l'histoire du monde grec. Actes du colloque international, La fortfication et sa place dans l'histoire politique, culturelle et sociale du monde grec (Valbonne, décembre 1982)* (Paris 1986), 179–84.

———, "A new find in Vani", *Vestnik Drevnej Istorii* 190 (1989), 178–82. [in Russian, with an English summary]

———, "On the cult of Herakles in Colchis", in M.M. Mactoux and É. Geny (eds.), *Mélanges Pierre Lévêque,* IV: *Religion* (Paris 1990), 277–288

———, "Pour le 40e anniversaire de l'expédition archéologique de Vani" in T. Khartchilava and É. Geny (eds.), *Le Pont-Euxin vu par les Grecs*, 239–242.

———, "Vani dans la structure du royame colchidien" in T. Khartchilava and É. Geny (eds.), *Le Pont-Euxin vu par les Grecs*, 289–94

———, "Vani: an ancient city of Colchis", *Greek, Roman, and Byzantine Studies* 32 (1991), 151–95.

———, *Archäologie in Georgien, Von der Altsteinzeit zum Mittelalter* (Weinheim 1991).

———, "A bronze statue from Vani, Georgia", *Ancient Civilizations from Scythia to Siberia* I.2 (1994), 230–34.

———, "Recent discoveries in Georgia", *Ancient Civilizations from Scythia to Siberia* I.2 (1994), 124–69.

———, "Vani: ein antikes religiöses Zentrum im Lande des Goldenen Vlieses (Kolchis)", *Jahrbuch des Römisch-Germanischen Zentralmuseums Mainz*, 42.2 (1995), 353–401.

———, *Vani: une Pompéi géorgienne* (Paris 1995).

———, "La geste des Argonautes dans les prèmieres épopées grecques sous l'angle des premiers contacts du monde grec avec le littoral pontique" in O. Lordkipanidze and P. Lévêque (eds.), *Sur les traces des Argonautes,* 21–46.

———(ed.), *Vani IX: Archaeological Excavations (Analytical Bibliography: 1850–1995)* (Tbilisi 1996). [in Georgian and English]

———, "Georgian Goldwork in the Classical Period" in O.Z. Soltes (ed.) *National Treasures of Georgia* (London 1999), 68–73.

———, "The Golden Fleece: Myth, Euhemeristic Explanation and Archaeology" *Oxford Journal of Archaeology* 20.1 (2001), 1–38.

———, *At the Dawn of Ancient Georgian Civilization* (Tbilisi 2002). [in Georgian]

Lordkipanidze, O. and P. Lévêque (eds.), *Sur les traces des Argonautes. Actes du 6e symposium de Vani (Colchide) 22-29 septembre 1990* (Paris 1996).

———eds)., *La mer Noire, zone de contacts. Actes du VIIe Symposium de Vani (Colchide), 26-30 septembre 1994* (Besançon 1999).

———(eds.), *Religions du Pont-Euxin. Actes du VIIIe Symposium de Vani, Colchide, 1997* (Besançon 1999)

Lordkipanidze O., and T. Mikeladze, "La Colchide aux VIIe-Ve siècles. Sources écrites antiques et archéologie" in T. Khartchilava and É. Geny (eds.), *Le Pont-Euxin vu par les Grecs*,167–88.

Lordkipanidze O., R. V. Puturidze, and N. N. Matia vili, "Les fouilles de Vani en 1973-1974" *Kratkie soobshcheniya, Instituta arkheologii* 151 (1977), 39–48.

Manvelichvili A., *Histoire de la Géorgie* (Paris 1951).

Matiashvili N., "Contribution à l'étude des croyances religieuses des Colches à l'époque pré-hellénistique" in T. Khartchilava and É. Geny (eds.), *Le Pont-Euxin vu par les Grecs*, 269–72.

———, *Questions of the History of Colchis in the Hellenistic Period* (Tbilisi, 2005). [in Georgian]

Mattusch C.C., *Classical Bronzes. The art and craft of Greek and Roman Statuary* (Ithaca 1996).

McGovern, P. *Ancient Wine: The Search for the Origins of Viniculture* (Princeton 2003).

Mepisashvili R. and W. Tsintsadse *The Arts of Ancient Georgia* (London 1979).

Pirtskhalava M., "La céramique colchidienne de Vani aux Vie-IVe siècles" in T. Khartchilava and É. Geny (eds.), *Le Pont-Euxin vu par les Grecs*, 257–60.

Poutouridze R., "Les vases céramiques
de Vani aux Ve–IVe siècles" in
T. Khartchilava and É. Geny (eds.),
*Le Pont-Euxin vu par les Grecs*, 273–274
Soltes O.Z., "The Meeting of Pre-
Christian Civilizations in Georgia'" in
O.Z. Soltes (ed.) *National Treasures of
Georgia* (London 1999), 77–82.

Tolordava V., *Burial rites in Georgia of
the Hellenistic period* (Tbilisi 1980).
[in Georgian, with a Russian summary]

Tolordava V., "Un complexe cultuel
des VIIIe–VIIe siècles à Vani" in
T. Khartchilava and É. Geny (eds.),
*Le Pont-Euxin vu par les Grecs*, 243–48.

Tolordava, V., "Vani Cult-ritual complex
of the 8th–7th centuries B.C.
(chronological issues)" in *Essays on the
Archaeology of Colchis in the Classical
Period, Dedicated to the 70th Birthday of
Prof. Otar Lordkipanidze* (Tbilisi 2001),
37–47. [in Georgian, with an English
summary]

Vickers M., "Metrological Reflections:
the Georgian Dimension" in O.
Lordkipanidze and P. Lévêque (eds.),
*La mer Noire, zone de contacts*, 117–28.

Wasowicz A., "Vani en Géorgie:
urbanisme grec et traditions
colchidiennes", *Archeologia* 43
(1992),15–33.

# Photography and Drawing Credits

Unless otherwise noted below or in the captions, imagery for *Wine, Worship, and Sacrifice: The Golden Graves of Ancient Vani* has been provided by photographers and illustrators from The Otar Lordkipanidze Center for Archaeological Research, Georgian National Museum: Marlen Avaliani, Guram Bumbiashvili, Amiran Kiladze, Gabriel Salniker, Valeri Salniker, Tamar Sakhvadze, and Baadur Mchedlishvili.

**Medea's Colchis**
Fig. 1: The Metropolitan Museum of Art

**Vani, Rich in Gold**
Fig. 2: National Parliamentary Library of Georgia
Fig. 20a, b: Freer and Sackler Galleries
Fig. 21: Michael Vickers

**The Archaeology of Vani**
Fig. 11: Freer and Sackler Galleries

**Religious Ritual: Bronze and Iron Figurines from Vani**
Fig. 1: Freer and Sackler Galleries

**Viticulture and Dionysos in Hellenistic Vani**
Figs. 5–10: Freer and Sackler Galleries

**The Golden Graves of Ancient Vani**
Plates 10–18, 23, 24, 27, 28, 32–35, 43–50, 52: Freer and Sackler Galleries

**Checklist of Additional Objects**
Objects 26, 28, 32: Freer and Sackler Galleries

Olbia

CRIMEA

Pantikapaion

Istria

*Black Sea*

Sinope

Herakleia Pontica

MACEDONIA

ASIA MINOR

ATTIKA

IONIA

Athens

Miletos

RHODES

THE LEVANT

CRETE

CYPRUS

*Mediterranean Sea*

Cyrene

EGYPT